Christmas

To John & Diane
Because you know,
care and understand

Love,

Ted & Joannie.

Guido Molinari
*Mutation sérielle
vertrouge* 1966,
Acrylic on canvas,
81 × 98 in Coll: Art
Gallery of Ontario

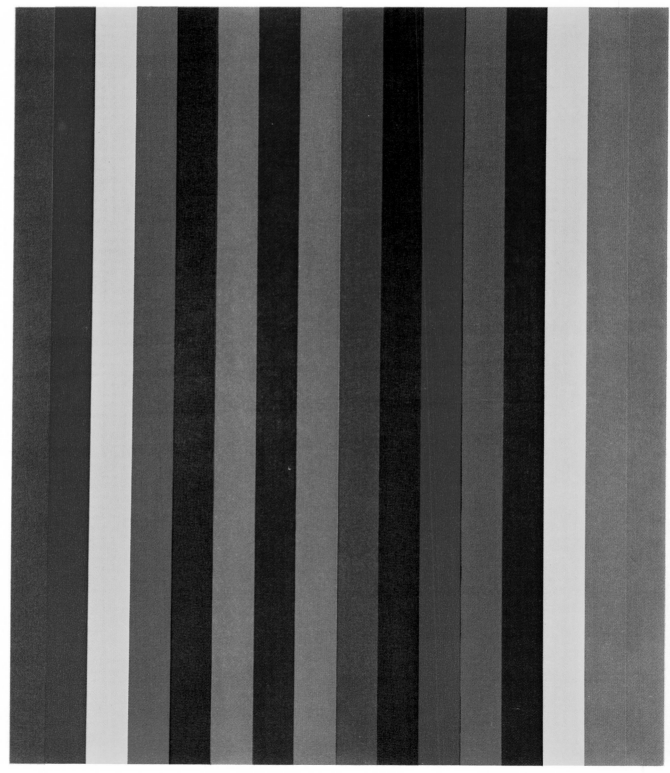

CANADIAN ART TODAY

edited by
William Townsend

1970

Published by Studio International
37 Museum Street, London W.C.1
and printed by W & J Mackay & Co Ltd Chatham Kent
Not available for sale in USA
First edition March 1970
Reprinted August 1970

Acknowledgements

Studio International wishes to thank the following for their valuable help in the preparation of this publication: The Canada Council, The National Gallery of Canada, the Art Gallery of Ontario, The Vancouver Art Gallery, the Musée d'art contemporain, London Ontario Public Library and Art Museum, Mrs Elizabeth R Cruickshank, Mr and Mrs Jack Gordon, Mr and Mrs J R Longstaffe, Mr Kurt Von Meir, Mr David Milne, Mr David Mirvish, Mr Michael Walls, the Bau-Xi Gallery, Douglas Gallery, Dunkelman Gallery, Galerie Godard Lefort, A J Govinchuck, Isaacs Gallery, Laing Gallery, Carmen Lamanna Gallery, Norman Mackenzie Art Gallery, Taras Masciuch, mathieu, Mazelow Gallery, David Mirvish Gallery, Galerie de Montréal, Gallery Moos Ltd, Pollock Gallery, Galerie Sherbrooke, the owners of the copyright of the *Refus global*, Photographes Associés Place Bonaventure, Ayriss, Ayriss-Reeves, John Braun, Click Camera Centre, Dommasch, John Evans Photography Ltd, John A Ferrari, Kerr, J S Markiewicz, Roy G W Robel, Rugoni, Nik Semenoff, Peter Thomas, Tommy Thompson & Company Ltd, Robert Title, Department of Transport, Edmonton International Airport and the National Film Board of Canada, Ron Vickers Ltd, Tom Wakeyama, William Bros Photographers Ltd, Michiko Yajima, Cara Operations Ltd.

Thanks

Even to be in a position to agree to edit this publication I was bound to be under an obligation to many people whom I cannot here thank individually. To the Canada Council I owe thanks for assisting me, with a grant in 1968, to keep in touch with the Canadian scene and, with a further grant last year, to collect information and material. To the Directors of the National Gallery of Canada, the Art Gallery of Ontario, the Vancouver Art Gallery and of other public galleries and to their colleagues I have for years been indebted for many kindnesses and much help. Without naming them again I must thank those among them who contribute to this issue and who have done much more than write their articles and choose their illustrations; I am grateful to them all for being generous with time and advice. In addition I owe particular thanks to Mr Guy Viau, Deputy Director, and to Mr Brydon Smith, Curator of Contemporary Art, of the National Gallery of Canada, and to Dr Hubbard's secretary, Miss Helen Chisholm, who helped me with my researches on a recent visit to Ottawa; to Miss Janine Smiter and her secretary, Miss Naomi Panchyson, of the Art Gallery of Ontario, whom I troubled with many inquiries; to Mr David Silcox and his secretary, Mrs Paulette Charette, of the Canada Council, who have likewise provided me with photographs, information and assistance of many kinds; to Mrs Anne Brodzky, Editor of *artscanada*. I am grateful to the owners and directors of private galleries for their readiness to lend generously from their collections of photographs and to have works specially photographed for me; particularly to Mrs Ben Dunkelman, Mrs Mira Godard, Mrs Helene Mazelow, Mr Avrom Isaacs, Mr Carmen Lamanna, Mr Yves Lasnier who spent half a weekend telephoning on my behalf, Mr David Mirvish and Mr Walter Moos. Then there are the artists from whom I have asked for information, photographs or permission to reproduce. I thank them all for their co-operation but I am grateful to many of them for more than a good professional relationship. I wish to record the help in preparing this issue that has come from talk and entertainment with Iain Baxter, Jack Bush and Harold Town; from discussions last year with Yves Gaucher and Guido Molinari; from long letters from Eli Bornstein, Ted Godwin and Ken Lochhead; from Roy and Monica Kiyooka who put up with me so long and looked after me in Montreal. The friendship they and others have offered to the inquirer is for me an inextricable part of the Canadian scene.

I would like here to acknowledge an indebtedness to the writings of two persons not directly concerned with this publication but to whom anyone interested in Canadian art is bound at some time to turn; to Mr Barry Lord and Mr J Russell Harper.

In London, thanks to Diana Meynell for co-ordinating the work at this end; and to my daughter Charlotte for keeping an eye open for me at the Vancouver end.

Finally, thanks to Mr Antony Mackay Miller for the time and the interest he has devoted to the layout of this publication and his patience in the matter of various inexpert and extravagant requests I have made.

William Townsend

Roy Kiyooka, who has designed the cover

Contents

Contributors

Eli Bornstein	Head of Department of Fine Art, University of Saskatchewan, Saskatoon. Founder and editor of *The Structurist*
Jack Bush	Painter. Toronto
Greg Curnoe	Painter/film maker/writer/member of the Nihilist Spasm Band/ citizen of London, Ontario
R H Hubbard	Chief Curator, the National Gallery of Canada
Andrew Hudson	Painter and writer. Formerly art critic of *The Washington Post*
Roy Kiyooka	Painter and poet. Calgary–Regina–Vancouver–Montreal–Vancouver
Dennis Reid	Assistant Curator, the National Gallery of Canada
Doris Shadbolt	Senior Curator, the Vancouver Art Gallery
David Silcox	Fine Arts Representative, the Canada Council
Pierre Théberge	Assistant Curator of Canadian Art, the National Gallery of Canada
David Thompson	Formerly art critic of *The Times*
Harold Town	Painter and writer. Toronto
Charlotte Townsend	Art critic of *The Vancouver Sun*
William Townsend	Painter. Professor of Fine Art, University of London

Notes
by way of introduction and dedication

William Townsend

Over the past eighteen years I have been able to visit Canada about as many times. Above all the experience is that of witness of a remarkable phenomenon; something now more solid than phenomenon. At first the Canadian art scene did not excite me much; nor was the London scene exciting in 1951; of course, any country's art has interest—you had to look hard for anything else. Canada itself was the excitement—its not unexpected configuration, its totally unexpected visual impact, all the way across. Canada has changed enormously since then, but not into anything else. Canadian art however has changed into something else as though out of the chrysalis.

Home from my first visit I made a few novice generalizations. 'The condition of the visual arts is one of neglect.' Only artists, teachers, a few gallery directors operating on a shoe-string, one or two pioneer dealers, seemed blameless then. Today such comment would be magnificently untrue. 'There is as much native talent there as anywhere but I found the thought of what might happen to the really gifted student a depressing one.' In fact the gifted students of that time were to be the first generation that could make for itself, seize or have offered, the opportunities to advance into a situation comparable with that in countries of long-established artistic traditions. They are the art establishment of Canada today who justify this publication. 'The reception of the Massey Report offers some hope', I added. Published in 1951, the report of the 'Royal Commission into the Condition of the Arts' over which Vincent Massey presided did make a difference. It prepared the way for more adequate provision for the public galleries, for the creation of the Canada Council and the replenishment of every trickle of support the arts were already receiving. It revealed a niggardly state of affairs. The National Gallery of Canada was managing on a staff of four persons. Its Director and his three colleagues were required, by statute as it were, to be heroes. It was housed in the top floors of the National Museum in Ottawa; stiflingly hot in an Ottawa summer. I remember stumbling down through six floors after half an hour to get my breath back in the park. West of Toronto there were no works of modern European art to be seen until Winnipeg got a Dufy in 1954, Chagall and Vlaminck next year; nor public galleries of more than local significance. Away from the National Gallery major travelling exhibitions could be shown only in Montreal and Toronto; orchestras and theatrical companies were in

similar plight; there was nowhere to perform. A public in Eastern Canada might be provided for but the rest of the country was seriously deprived. Canadians were told, through the Massey Report, that they could hardly consider themselves civilized until something was done about it and surprisingly this was not received with resentment. Old history is invoked here to contrast with an utterly changed scene. Medium sized cities now have auditoria as large as London's Festival Hall and Centennial year of Confederation was celebrated by the building of art galleries, concert halls, theatres, culminating in the huge new complex of the centre for the performing arts in Ottawa. You ask yourself now how they are to be filled, if not surrendered to conventions of real estate and insurance executives or folk jamborees of high-school bands. There is a touch of dutiful mania about it, guilt-absolving perhaps, like a minor access of cathedral building. But this is a wry joke pointing the difference between our art scene and that of Canada today. While ours, whatever its vitality and density, is most aptly described as cramped, where resources of public interest, space and money become increasingly hard to tap unless justified on grounds of education, entertainment or therapy, that of Canada is in all ways expanding. Young Canadian artists do not need to live as expatriates. Those that come to London like it, but they now go back. There is of course more money and that, says Mordecai Richler, a greater authority than me, is 'the stuff that really excites this country's most artistic types'. There are other reasons now and, from my experience, I think Richler slanders his countrymen whose artists are not the rich Canadians, though public money has made it possible for them to live and work as artists where a couple of decades ago it was harassingly difficult. It is, I would say, non-artistic types who grow feverish about playing the market in art.

Whatever pronouncements were made by me or anyone else in the last twenty years had in any case little more than academic interest. In England we have suffered an almost total lack of confrontation with the works that could give an indication of the surging development of the arts in Canada. What New York has done for its artists, what Bryan Robertson was able to do for the Australians, no one has done in London for Canadian art. Riopelle is known, but as part of Paris, and it has been left to the initiative of a private dealer to introduce to London the

solitary artist of stature, living in Canada, now familiar here. I refer to the Waddington Gallery's three shows of Jack Bush. Les Levine has held an exhibition, from New York, and this year we have two exhibitions, invited by Bryan Robertson while he was still director of the Whitechapel Gallery, by a young sculptor, Robert Downing, and a leading painter, Yves Gaucher.

In 1924, at the Wembley Exhibition, the Group of Seven made a hit. An exhibition in 1938 at the Tate, 'A Century of Canadian Art', did not alter the view. That success is enshrined in the Phaidon Press book *Canadian Painters* by D W Buchanan (1945). The idea that art in Canada was obsessively concerned with celebration of dramatically un-peopled landscape in a style tending to the posterish lasted here for forty years. A similar fixation in Canada itself inhibited any warmth in acknowledging modern art of other kinds.

In 1964 the National Gallery of Canada and the Tate Gallery made an attempt to correct this state of affairs. The exhibition, conceived quite logically as retrospective of the twenty-five years of Canadian art which we had missed, failed to reveal the liveliness of a new scene. It was an establishment show a little too late.

There was no need for that caution. I had lately travelled the whole country and seen something quite different, but it was no new conclusion that Canadians were tardy in presenting themselves. No bad mark for this; certainly not in the long run; even something one liked about them. They were self-questioning, often enough came to a very good answer but faltered when it came to announcing it. Perhaps it was Mayor Drapeau, inspirer of Expo 67, who altered this. All sorts of people came back from Montreal surprised that the spirit in the arts was not one of provincialism, caution, conservative protestantism, conservative catholicism or of unresisting tagging along after the USA. Canadians, who were themselves there in international competition, saw this too.

The exhibition 'Canada Art d'aujourd'hui' at the Musée d'Art Moderne in Paris (and elsewhere on the continent) in the same year, was the first this side of the Atlantic to show Canada no longer as a provincial consumer but as a contributing part of the international scene. In 1968 Richard Demarco and the Canada Council provided a similarly representative exhibition in Edinburgh. Guido Molinari won a painting prize in Venice. Critics went to these places; London still has to be satisfied with their reviews. In the same year Richard Hamilton and William Turnbull made first visits to select painting and sculpture for 'Canadian Artists '68', organized at the Art Gallery of Ontario. Hamilton wrote, 'The result is an exhibition of indisputable importance; it reveals that certain Canadians can scarcely be matched anywhere (I am thinking particularly of Molinari and Kiyooka)'. Turnbull remarked, 'It must be obvious to anyone seeing this exhibition that in no time the world will be experiencing the impact of Canadian Art'.

I crossed Canada for the first time up the St Lawrence to Montreal and on by train; an essential experience, worth the four or five days. The steam locomotives survived, they announced their arrivals and departures by a sound of antique splendour from huge brass bells. A landscape of stunningly endless extension changed every thousand miles into something dramatically different but as endless. The train stopped for longish intervals from time to time; passengers paraded the platforms and watched the ice-boxes being replenished; it was arrival after arrival, frontier after frontier. Canada seemed like one country only in someone else's imagination. Striking as the changes in scenery were, they were no more striking than the change in the sense of the past. It seemed possible to read this like a graph desending from east to west, not merely the physical testimony but the importance such a sense—that major factor in European attitudes to anything one can think of—possessed for people. The appearance of Quebec was almost ludicrously intact and old due to the slow fossilization there, all through the nineteenth century and without distraction, of a baroque style of architecture and an almost equally protected way of life. By the time one reached Calgary there was no sense of the past at all and little past unless a cowboy one. There were people alive who remembered the railroad going through. It was about as old as the *Boy's Own Paper*.

I was going to teach for the summer at the Banff School of Fine Arts, which was being built up by Donald Cameron on the ideal of university extension so that the people of Alberta need not be without art. The painting department had been set up in the thirties by H G Glyde who, fresh from England, swept up in the tide of the Group of Seven, became one of the founders of art education in Alberta and more to the point, one of the

first generation to make the case there for living as an artist at all. Not far away in Calgary, Maxwell Bates, then 45, lately returned to his native province from his studies with Beckman, was to become the 'old man' of modern art in Alberta, as Marion Nicoll, at the art school (then the Institute of Art and Technology) was to become its grand lady. The art school in Calgary was already one of the best in an area as big as Western Europe; it had students later to become influential but it had few competitors. The students at Banff were of all those sorts which could not commit themselves full-time to the arts; some who wished to and teachers, amateurs, well-off kids from the east; it might seem irrelevant to a serious development in the arts but in fact was a focus for intent people from all the Western provinces who had nowhere else to go to meet artists. As there were no works of authoritative quality to be seen in the West, most of my students had never seen one at all; they were disconcertingly ignorant in this respect and, if they hadn't seen bad reproductions, quite unspoiled. One could wonder whether it was right to be a missionary for Western culture as established; couldn't something quite different start up just out of living here, with nothing to hinder it? All not-wanted Europe left behind for good? Of course not. Jock Macdonald who was there at Banff was experimenting already with 'automatisme' and towards a different mainstream. In Montreal the *Refus global* was three years old; Borduas, thrown out of his job, was still at work there; Agnès Lefort in her pioneer gallery exhibited anything at the risk of defacement and the battle for 'modern art' was on. In Banff students enjoyed the reward of unconditioned talent, they had attack, no precedents inhibited them from having a go. One of the things that made one not too discouraged after all; that starry-eyed enthusiasm that has made Canadian art take some big jumps; an innocence that could match the sophisticated militancy of Montreal artists subverting the repressive traditions of their Province at the other end of the country. This out-of-phase development of Canadian art in various parts of the country has been admirably charted by Russell Harper, in his recent history of Canadian painting, with the gifts of social anthropologist as much as those of art historian. But in the last few years, these diversities have switched together, greater mobility, increasing wealth, communications, public conscience contributing to more than a mechanical gathering together of provincialisms. Creative artists have accepted a Canadian internationalism and a great anxiety has been abandoned; that anxiety for a Canadianism in art, an identifiable character as pre-requisite, about and against which we had to argue so often. This is no longer a topic among artists. They would agree with Jackson Pollock who said for America, in 1944: 'The idea of an isolated American painting . . . seems absurd to me, just as the idea of creating a purely American mathematics or physics seems absurd. And in another sense, the problem doesn't exist at all, or if it did, would solve itself; an American is an American and his painting would naturally be qualified by that fact, whether he wills it or not. But the basic problems of contemporary painting are independent of any country.' Canadian artists, remaining Canadians, now offer contributions to these problems.

'The most important person in the field of the visual arts, both in our opinion and his own, is the individual artist . . . consequently, our first concern is for his needs', wrote David Silcox of the Canada Council. Elsewhere, David Thompson praises the work of the Canada Council and the favour it enjoys among artists—which is, in my experience, unanimous. More than any other single institution it has woven the network of movement across the country that is one of the most powerful unifying factors in the Canadian scene. In effect this is how the scene is made one. The wrong kind of loneliness, not the right kind of solitude, was deterrent to the progress of artists and of public understanding; that has been exorcised.

What David Silcox claims for the Canada Council seems to apply to the public galleries as well. I get the impression, almost weird for an artist, that their administrators, whatever their other functions, are really more interested in artists and what they are doing than in management. For the major galleries have gone out of their way to discover and promote the younger and more experimental artists. Participation of this kind becomes yearly more vital as they accept the challenge of showing the art that dealers can't deal with, environmental, ephemeral, concept-art or what not—not productive of objects easy to sell or even objects for sale at all. No more convincing illustration could be offered than the complex of offices into which the ground floor of the National Gallery of Canada was re-structured last Spring, a corporation-headquarters-environment exhibition for

N. E. Thing Co., plus showroom for its Product Department and President's office in which Iain Baxter, his feet upon the table, lolled ambiguously as boss, as public consultant and as exhibit.

Besides the institutions concerned by definition with the arts, the Department of Transport has administered a huge scheme of patronage through commissions for murals and sculptures in airports. This too has been a unifying process in that artists have been asked to work in a province other than that in which they lived. Some results have been in the Heathrow category, perhaps more interesting than nothing, but there have been notable successes from artists with a chance of proving themselves on a scale unlikely for them—Jack Shadbolt at Edmonton, Eli Bornstein at Winnipeg, Ronald Bloore at Dorval, among them.

A few corporations have been good patrons, a few private individuals in a princely way. But few. Then there is not yet an informed buying public for an exacting contemporary art to mediate between the artist and the philistine, though perhaps in Toronto such a public is on the way to being numerous enough to sustain artists. Jack Bush tells me he has enjoyed only two years as a full-time painter since, at 58, he could afford to leave commercial art; Claude Breeze, who for half-a-dozen years now has rightly enjoyed a national reputation as one of the most original younger artists in the country, recently confessed to having sold only four paintings to private buyers in Vancouver where he lives (*Vancouver Sun*, 13 July 1969).

So the dealers have had the usual task of creating a market for their own artists but in a situation where there was no market to speak of for the work of any contemporary artists. You couldn't argue if they claimed to share the idealism of the Canada Council. Harold Town's account acknowledges the debt of Toronto artists to pioneer dealers there. Among Montreal dealers are two of the most distinguished allies of Canadian painters in Mira Godard and Yves Lasnier. And there must be at least five other cities where, in the last five years, dealers have opened galleries that are much more than shops, where the artists meet, which are, in so vast a country, focal points of national importance.

Since the decay of the Quebec tradition of church carving and devotional sculpture and of the totem-carving of the Haida Indians painting has been the art of Canada. Until very recently there were few sculptors whom one could regard as any more than honourable in their attempts to break with an effete beaux-arts tradition. Even that tradition had barely existed west of Toronto. Dorothy Cameron has been the heroine as well as the midwife of modern Canadian sculpture. Except as gesture her gallery in Toronto, devoted to sculpture, was perhaps a few years premature, perhaps there was not so much to show that deserved such enthusiasm and with what there was she unluckily affronted not only taste but the mores of a public which in part might be described as tight-lipped and loud-mouthed at the same time. Subsequently justifying her faith, Dorothy Cameron assembled remarkable exhibitions in 'Sculpture '67' and, this year, 'People in the Park' introducing young sculptors whose vitality is on a par with that of the painters. It is early to back winners among them, but William Turnbull's reply to my question was: 'The under 35 scene is as promising as anywhere in the world'. I wish Dorothy Cameron had been able to comment on this scene here. It is only through a mistake of my own that she does not.

I would protect Canadian art from the assumption that it is a sub-area of modern American art, or that it is still an offshoot of French and English founding traditions that for a long time provided the authority. There is clearly no need to be either and I would quite expect Canadians not to be tied to binary programming. They are just the people to believe that there are other answers besides yes and no; that they are dealing with affairs that shouldn't be posited that way.

Whatever its tensions Canada is a fortunate country, released from the disabilities of isolation and dependence and not yet victim of the crisis in moral attitudes that penalizes affluence—affluent though it is. It has an art scene of its own, admirably balanced in its components, with no one too strong for the others, with a due measure of trust between them. It is surprising how well they sort it out—individuals and institutions. This is of course the good art situation in which the necessary anti-artist can also make his case and from which new definitions can arise. It is presided over by the enlightened, erudite and charming Director of the National Gallery of Canada, Miss Jean Sutherland Boggs, to whom I venture to dedicate this publication.

November 1969

a letter and 6 salutary poems *Roy Kiyooka*

montreal
july 21
1969
 : concern
dear Will,
 ing
poems. here are
6 salutary ones, written
between 62 & 68:
a sampling, then of
relevant occasions, chosen
from many

.

. . . if you do
use them, at all, use
all-of-them. (they form
a coherence, of sorts.)

follow
my layout (if possible),
& the way
the poems are lined-up,
exactly.

check, & double-check
for errata, etc.

.

as for 'the cover'

1. use 2 of my colors
 plus black or
2. use 1 of my colors
 plus black but
no color that is not
part of the cover-design.

.

William, will there be
time for proofs
for the cover, & the poems?

.

(it was most pleasant to
have you with us.
plan to do it again, in
vancouver. when . . .

sincerely,

12

1

for Marken, upon graduating

.

the way you
light-up the walls with
whiteness

(blinding
the daubs with
your lustre,

you need no
illumination from
lugubrious

masters only
the chance to
shine!

2

for Wilhelm (his Women

.

O Wilhelm, with what skill
you put her bush
where her mouth should be—

. . . and her lips, Wilhelm
where, o where—
did you put her lips ?

3

for Anne

.

the issue,
issuing of a magazine
its guts is
again
 Light. light shed
on 'particulars' of sight/ sound.

 no one can ask
 more
 of a Trudeau

 or
 Anne Brodzky.

let it fall—
a nimbus about your shoulders:

 incandescence is
 ALL

4

for Vincent

.

sunflower sun
flower flowering
sun
 black crows
 black
 crows
 black

 crows

.

night flowers
in your eyes

kah . kah . kah

sunflowers
in your hands

kah . kah . kah

plastic flowers
from your severed ear

kah . kah . kah

.

ah Vincent, your sun
flowers in
a thousand Hiltons:

flower-power
for nuptial beds. a gleam in
the black crow's eye

5

for Gaston Lachaise

.

Gaston Lachaise you
who knew her by her orifices,
called her La Montage

tell them who would harm her how you made
bronze sing her praises
how the shine in her hair left its traces
on her sculpted form

and Gaston add this
'her tears' will wash the dirt out of
any man's eyes

6

a Hymn for Stanley Spencer

.

o Giotto of Padua
patron saint of painters
bless his paradise
of 'angels and dirt'

provide a halo
for him to wear among
the blessed ones
you have honored, who honor us .

faithful one,
teach us who rage, crazed
by conflagrations
to be still

in our confusions
provide us
in wild profusion:
dirt and angels

to tame our doubting eyes

13

Canadian Art: Thoughts of an Outsider

David Thompson

'*Critics in the United Kingdom and the United States have in the past tended to treat the arts in Canada with that gentle indifference usually shewn to the quiet sister of the family until she is discovered to have done a surprising thing.*'
—David Silcox, catalogue introduction to the exhibition *Canada 101*, Ediburgh, 1968.

Surprise, one is rather ashamed to admit after the event, seems nearly always to be the visitor's reaction. It is a fairly recent thing, because the phenomenon that causes it is fairly recent, and it is bound to become less frequent very soon. But the fact remains that artists and critics from other countries do not expect to find in Canada what they do find there at the moment, and to most of them the discovery is an eye-opener. I have compared notes now with a good many of those from the UK who, like myself, have recently accepted some generous Canadian invitation to cross the Atlantic, select an exhibition, act as juror somewhere, lecture or just tour the country and look around, and I have found the pattern of response is nearly always the same. It starts from blank ignorance of the real artistic situation in Canada, aggravated by preconceptions which are completely out of date (a hazy picture of provincialism, coloured at best by assumptions about United States influence, at worst by memories of the Group of Seven). As William Turnbull had occasion to note when he flew out last year to be one of the three jurors for the *Canadian Artists 68* show in Toronto, 'There is a tendency nowadays to assume that the media keep one fully informed of all that is happening, but what I have seen during the past two weeks proves this to be a fallacy.'

What one discovers is a ferment of activity and enthusiasm, a keenly intelligent and highly informed awareness spread right across the country, a very catching sense of optimism and get-up-and-go (Centennial Year and the success of Expo 67 obviously achieved all that is claimed for them in giving a fillip to national pride), and a distinctly un-provincial outlook in most artistic matters except for a guilt-complex about being provincial in the past. The persistence of this guilt-complex is characteristic, even when it is evident in nothing more than a compensatory satisfaction at being more in the swim of things now. Without being falsely modest, Canadians are not pushers of their own merits, and the Canadian version of their recent artistic history often gives the impression that they have only just emerged from the backwoods as far as involvement in the mainstream of modern art is concerned. Yet dates and events (to go no farther back than the *Refus global*, 'Automatisme' in Montreal, *tachisme* in Toronto, and Emma Lake) in fact bear honourable comparison with developments in most other countries since the war. The real impediment until recently has not so much been lack of awareness and experiment, as chronic isolation in a country where the population is still surprisingly small for the size of the territory, and where distances between one centre and the next remain formidably vast.

Canadian modesty, if that is the word for it, is a not insignificant factor in the present artistic situation. One apect of it is something which I find hard to define but which seems to have struck most British observers I know and to contribute not a little to their enthusiasm. It is a certain atmosphere about the art-scene as a whole which seems refreshingly free from the more blatant tensions and factionalism of art-politics. It is, in fact, something bigger than the immediate concerns of the art-scene itself. It is national, and can be felt most clearly by the very proximity of frightening strain and crisis—political, social and cultural—in the United States. There the mid-twentieth century seems fraught with menace. In Canada it still seems bright with promise, and the result is a kind of optimism reflected in the attitude of Canadian artists towards art itself. I am making big and subjective assumptions, and it would be easy to be cynical about them, if cynicism didn't seem out of place. It is early days, one could say: wait for the rat-race to begin. If it hasn't begun yet, wait for the international recognition, the day which everyone pronounces is just around the corner, when Canadian art hits the big-time and makes its expected impact on the world outside, and see what happens then.

This is obviously the loaded question: will it make that impact, and what will be the effect? At the moment, Canadian art is just approaching that turning-point between newly-won self-confidence and the possibly different kind of confidence that comes when the publicity-machine starts to roll. In the past eighteen months or so, two major exhibitions of Canadian art, officially sponsored, have crossed the Atlantic both as emissaries and as scouts into unknown territory. One toured Europe under the aegis of the National Gallery; the other, invited to Edinburgh by the Festival Society at the instigation of Richard Demarco, was organized by the Canada Council.

They were, of course, selected by Canadians—reflections of official Canadian views about Canadian art as deemed fit to be seen abroad. Significantly, though, major 'representative' exhibitions of this kind held within Canada itself have time and again in recent years been selected by outsiders. It is as though Canadians could not trust their own judgement, or continually sought and needed reassurance about the unprecedented suggestion that they might have native talent as good as anyone else's. And only 'experts' from abroad, for some reason, could be expected to pass objective judgement. I hope, myself, that this phase of deferring to foreign opinion is now more or less over: it needs to be. Apart from the obvious fact that visiting jurors and so-called 'impartial' selectors have to make their choice without sufficient inside knowledge, my own impression is that Canadians themselves, if left to it, are far more acute and stringent judges than anyone else of what is really worthwhile in Canadian art. They are obsessed as it is by 'international' standards, and if the best in American art sets those standards—as, on the whole, it must do—no one is better placed than the Canadians to know what those standards are and to have a healthy respect for them.

At the same time, one can understand how, when Canadian art finally succeeds in making the international scene and is recognized as having done so, it is almost bound to lose something of that character which makes it at the moment so stimulating. It is now going through a phase which London (London, England, that is) experienced in the early sixties and which New York experienced a decade before that—a phase of self-discovery and new-won confidence in the ability to do something significant of one's own. Among artists this makes for a feeling of intense solidarity and mutual respect. It is a creative atmosphere of that kind which precedes, but rarely long survives, worldly success. And at this crucial stage, Canadian artists have been notably lucky in their impresarios, the official and institutional art-world. They have had their share of public incomprehension and obstructive philistinism in high places: who hasn't? There is a lot about Canada which is doggedly conservative. But on the whole one is amazed and curious at the amount of imaginative sympathy and ready support given to Canadian artists by the three main kinds of Canadian institution empowered to supply it. There are, in the first place, the universities. In Vancouver alone, the University of British Columbia and the controversially *avant-garde*

Simon Fraser University mount exhibitions and projects as fast as artists can supply the ideas; they provide vital stimulus both as patron and intellectual forum. Secondly, the major public galleries, led by the National Gallery in Ottawa, the Art Gallery of Ontario in Toronto, and the Vancouver Art Gallery, have been notably active in giving major one-man shows to Canadian artists and, perhaps even more importantly, in organizing the regular Biennials and group-exhibitions on a national scale which have done a great deal to break down the isolation of artists and create a new sense of corporate achievement. Thirdly, there has been the role of the Canada Council, whose most remarkable feat seems to me the *rapport* it has established with artists themselves on something much nearer a personal level of trust and co-operation than the usual relationship managed between official bodies and those they subsidize. It hands out bursaries, backs exhibitions, organizes conferences and buys generously for its own collection of Canadian art, but it is in the little things that the promptness and informality of its procedures count most—the fare to get an artist to the other side of Canada to attend the opening of an exhibition, the cheque by return of post towards the expenses of a project held up for lack of materials. The Council, like the cultural situation it fosters, is relatively young, which helps (founded in 1957 but most active since 1965, when its subsidy for the visual arts was virtually quadrupled), and its policies have been a decisive factor in bringing coherence and solidarity to an art scene which has no single geographical centre.

Geography, combined in a bi-lingual nation with political constitution, contributes a lot to the internal diversification of what is thought of collectively as 'Canadian art'. It effects, for example, all relationships with the United States. Not till one travels in Canada does one fully appreciate to what an extent cultural alignments tend to run north and south, that is to say between Canadian centres and centres in the States immediately to the south of them, rather than east and west across Canada itself. The formidable barrier of the Rockies aligns Vancouver much more closely with San Francisco and Los Angeles in a single 'West Coast culture' than with Toronto. Toronto, in a province which recently returned a surprising 40 per cent poll in favour of political amalgamation with the States (perhaps understandable when you look at Ontario's position on the map), is closely aligned with New York: several of its leading artists in

fact live and work there most of the time. Montreal, on the other hand, is the capital of French Canada, and has developed as a result in an independent way, with certain expected European affiliations stronger there than elsewhere in Canada. These three centres at present constitute a triumvirate more significant in their separate spheres of influence than in the hegemony of any one of them. Montreal is the easiest to identify with the idea of a 'school' and a 'style' (although this is misleading in practice), and to my mind it possesses Canada's most formidable concentration of important individual artists. Toronto, on the other hand, is a larger, livelier, more diversified and cosmopolitan art centre as such, although the diversity of its allegiances give it an unsettled character and an uncertain identity and level of achievement. Vancouver, by contrast, is equally diverse, but is a younger, smaller, more closely-knit artistic community, deriving much of its highly individual character from the very fact of being a bouncing new arrival on the national scene, combined with the West Coast, Los Angeles-orientated modernity of its ideas. Yet Canadian art cannot be tied down to three main centres. It is made up of an even more intricate pattern of interchange between these and a network of smaller pockets of activity, taking in Winnipeg, Regina, Calgary, London, Halifax and scores of remote schools and campuses. London, Ontario, is the outstanding example of a small regional art scene so lively that it makes 'regionalism' one of the factors that cannot be overlooked in any over-all picture of current Canadian achievement, and a factor which has nothing to do with 'provincialism'. The decentralization of artistic activity in Canada creates, at one level, a problem of national identity. At another, it supplies that identity, in a way which may turn out to be an asset already in danger of being lost in most other countries.

I have deliberately been dodging, to a certain extent, the question that underlies all impressions of the general art scene in Canada as they strike an outside observer, as distinct from impressions about the art it produces. About the former, I think most visitors tend to be enthusiastic. They are not only surprised, they are very impressed. If I seem, though, to be suggesting an artificial-sounding distinction between situation and product, it is because all one's responses are being nudged by Canadians themselves towards a kind of judgement which I don't think is necessarily the most important. It is not merely a question of 'Is Canadian art any good?' I wouldn't be bothered to write this article if I thought it wasn't. It is a question, with its implied competitiveness, of 'Is Canadian art good enough by international standards?' International standards, nowadays, are of two kinds—the real kind, which is only set at any one time by the individual achievement of three or four particular artists of major stature: and the artificial kind, which is a matter of juries, awards, money and power politics. The latter kind has swollen to proportions in the last few years which are luckily beginning to show signs of its own collapse: it has bedevilled the values of post-war art long enough for its basic irrelevance to have become blatant. Given enough foresight on the part of its own official promoters, Canada might well find itself in the enviable position of being the first country since the war to have a cultural efflorescence on its hands which is best served by opting out of cultural power politics. But to answer the basic question more directly, my own feeling is that although Canada has at least half a dozen artists, whose work would command the highest respect anywhere, and should certainly be better known, they are not of towering world stature, nor is there yet behind them the body of achievement which is going to re-orientate any of the current directions of mainstream art. As that only happens about twice a century anyhow, it is not greatly important. Canada's enormous asset given the awareness, intelligence and energy which are already characteristic of its art, is its ability to identify with both American and European achievement. What its art still needs is depth and what I can only call a certain resonance deriving from experience. The only general Canadian experience of the kind I mean is one of landscape, where the pitch has been rather unfairly queered by the Group of Seven. Otherwise there is only Montreal's tradition of French culture, which is in fact reflected in a kind of breadth and depth in its best painting which are not to be found elsewhere in Canada. Most current art has, whether directly or obliquely, an urban basis, but the urban experience is skin-deep to most Canadians. Even their biggest cities have not been cities for long enough yet, and the result is a certain assumption of urban attitudes in art (which is unavoidable) which cannot be felt through with the same conviction that they can in, say, the States. None of this, however, seriously detracts from the larger impression that Canadian art is now something to be reckoned with, and that its comparatively recent acceleration of self-awareness and energy has created a situation of exceptional interest.

Canadian Painting: The Forerunners

R H Hubbard

A French critic reviewing the exhibition of paintings by James Wilson Morrice held last year in Paris described Canada as 'un pays sans tradition picturale', and Morrice as having transplanted modern art into Canada from the forcing-beds of France. The latter judgement, taken to mean that Morrice was the Canadian pioneer of 'pure painting', is true; the former, as research into the history of Canadian art over the past twenty-five years makes clear, is entirely false. Painting, never queen of the arts in the colony of New France, nevertheless began in 1670 with the visit to Quebec of Frère Luc, an artist of the Recollect Order and a pupil of Simon Vouet in Paris. A tradition, tenuous enough at times, grew from this small beginning, developed during the English colonial period, and has flowered in the period from Confederation in 1867 to the present day. Along with basic ingredients taken from French and English art (and some American influences as well) Canadian painting embraces a strong folk-art tradition which has produced aesthetic results of real interest over a period of three hundred years.

Seen against this general background, Morrice appears as an exotic figure, and even more so when he is considered in the light of nineteenth-century painting in Canada. Victorian art shows even in this remote setting, a surprisingly wide spectrum of style. Early in the period French Classicism fused with folk-art to produce a distinct flavour in the portraits of Antoine Plamondon (1804–95) and Théophile Hamel (1817–70). Then followed at mid-century the Romantic Realism of Cornelius Krieghoff (1815–72) and Paul Kane (1810–71) creators of a picturesque mode of painting the Canadian scenery and people. This was succeeded in the seventies and eighties by the factual realism of John A Fraser (1838–98) and the early Homer Watson (1855–1936), to be followed in its turn by the academic refinement of Horatio Walker (1858–1938) and William Brymner (1855–1925). So great was the cultural lag between Europe and Canada that little or no evidence of Impressionism appeared before 1900.

Thus Morrice's immediate background in the Montreal of 1890, which he left in order to settle in Paris, was a *fin-de-siècle* elegance in art which was ill-suited to life in the New World. In one sense he simply carried forward the colonial attitude to art, by substituting his seductive blend of Whistler, Intimism, and Fauvism (*On shipboard, c.* 1900–3) for the older borrowed styles of Europe. The Canadian public was woefully unprepared for this innovation, made during his periodic visits to Montreal, and his stay-at-home contemporaries were much less radical in outlook. Maurice Cullen (1866–1934) and Aurèle Suzor-Coté (1869–1937) reflected Impressionism; and Ozias Leduc (1864–1955) in his later phase combined Symbolism and a decorative Impressionism. Morrice's real importance, apart from the intrinsic quality of individual pictures with their gliding tones and their charm of colour and composition, lies in the influence he had on the next generation of artists, particularly on two key figures, John Lyman (1886–1967) and A Y Jackson (1882).

Jackson, a Montrealer by birth, introduced Morrice's influence into Toronto when he settled there in 1913. (He also brought with him the effects of his training under several minor Americans and at Julian's in Paris.) But for several years before his arrival a group of young artists had already been forming in Toronto. Most of them worked in commercial art studios and were imbued with Art Nouveau design as applied to the graphic arts. (*Studio*, which in those days was still full of Art Nouveau, appears to have been their favourite reading matter.) J E H MacDonald (1873–1932) was the eldest among them and the guiding hand. With Lawren Harris (1885), who had studied in Berlin, he was affected by the Northern brand of stylization in landscape (*Jugendstil*) after seeing an exhibition of Scandinavian painting at Buffalo in 1912. At about the same time MacDonald and the self-taught Tom Thomson (1877–1917) began sketching in the forests of northern Ontario. Thomson, after being inspired by Jackson, disclosed a remarkable talent in his brilliant series of small sketches and a few larger pictures; but he was drowned in 1917 after barely four years of full-time activity (*Forest undergrowth II*, 1915–16.)

In 1920 the survivors—MacDonald, Harris, and Jackson along with Frederick Varley (1881–1969), Arthur Lismer (1885–1969), Franklin Carmichael (1890–1945), and Franz Johnston (1888–1949) held their first exhibition in Toronto as the Group of Seven. During its official career of thirteen years the Group of Seven made a strong bid to establish themselves as Canada's national school of painting. They interpreted the most characteristic landscape of the whole country, that of the rugged North, in terms of its brilliant colours and sweeping contours. Their influence was great upon the artists of their own generation, extending as far as the West Coast to spark a remarkable if late development on the part of Emily Carr (1871–1945) towards grandeur and symbolism in painting. They also succeeded in imprinting their style upon the

national consciousness to the extent that their pictures are now avidly collected as classics of Canadian art. They were in large part responsible for the survival of representational art as a relatively strong force until today, the most distinguished representatives being the poetic symbolist Jean-Paul Lemieux (1904) (*La visite*, 1967), and the 'Magic Realist' Alex Colville (1920) (*Dog, boy and the St John River*, 1959).

Meanwhile two contemporaries of the Group of Seven had held themselves apart from the latter's poster-like style, preferring to practise more individual if less popular styles. David Milne (1882–1953) worked in New York during the period of Maurice Prendergast and Ernest Lawson (the two Canadian-born members of The Eight) and exhibited in the Armory Show of 1913. He then painted in seclusion in a number of villages in New York State and later in Ontario, in a manner as linear and sensitive as handwriting. (*Window, c.* 1930.)

John Lyman, on the other hand, was a friend of Morrice and a pupil of Morrice's friend Henri Matisse. In the face of ignorant opposition he brought the influence of contemporary Paris to bear on Montreal. This influence was, however, extremely late in having its effect, as it was not until the thirties that Lyman gave up his exile in Europe and Bermuda (*Landscape, Bermuda*, 1913), returned to Montreal, and in 1939 gathered together a group of younger painters in the Contemporary Art Society.

One member of the CAS was Goodridge Roberts (1904), Paul-Emile Borduas (see below) was another, who had grown up in the older traditions of Canada—his uncle was the nature poet Sir Charles G D Roberts—and had been trained in New York under Max Weber. His landscape paintings (*Landscape near Lake Orford*, 1945), combined naturalism with monumentality in an unobtrusive manner; as Jacques de Tonnancour has written, 'son paysage dort dans le temps'. As a complete contrast the work of Alfred Pellan (1906) came as a tempest in the calm waters of Montreal. Pellan, who had been associated with the Surrealists in Paris during the thirties, returned to Montreal in 1940 to become one of the main instigators of the cultural resurgence of French Canada. He pioneered in mural painting and theatre design. Not only by the forcefulness of his paintings, with their riotous forms and colours (*Floraison, c.* 1945), but by his conquest of the conservative Ecole des Beaux-Arts in Montreal he raised up a whole new generation of artists in various media. This movement in the forties was also given added propulsion by Fernand Léger and Père Marie-Alain Couturier (who revolutionized religious art in France), both of whom spent periods of time in Montreal during the Second World War. The leadership of painting in Canada, so long held by English Canadian artists in Toronto, now definitely shifted to the French element in Montreal.

In the light of subsequent developments, however, the most significant movement in Montreal was that of the Automatistes, whose leader was Paul-Emile Borduas (1905–60). Originally an assistant to Ozias Leduc in the painting of mural decorations in churches, he turned to Surrealism after reading André Breton and exhibited his first abstract-surrealist paintings in 1942. A diminutive man enormously endowed with spiritual energy, he soon attracted a number of young painters. By 1948 the group had published their manifesto, *Refus global*. The immediate result of this radical document, which struck at the roots not only of art but of society in obscurantist Quebec of the day, was Borduas' dismissal from a provincial government teaching post.

At this point he was only making his mark with such paintings as *Sous le vent de l'île* (*c.*1948, National Gallery of Canada, Ottawa), a composition whose burgeoning forms and glowing colours suggest vernal growth in nature. (In theory, however, Automatic painting proceeded directly from the subconscious mind, and titles were added after a picture was finished.) A period of great personal anguish ensued for Borduas. Destitute and alone, he forsook Canada for New York in 1953. There in spite of the language barrier, he came into contact with the work of Franz Kline, de Kooning, and Jackson Pollock: and his painting took on a new brilliance and effervescence (*La grimpée*, 1956), that contrasted with the rich sombreness of the Montreal period. In 1955 he made his final move, to Paris. Here he simplified his forms to the point of single bold motifs. (*3 + 4 + 1*, 1956.)

Recognition, in the form of purchases in any number, came only just before his death. His tragic career showed that as late as 1960 expatriatism (shades of Morrice) was still necessary if the independent Canadian painter was to survive, let alone work in security and with confidence.

The same was evidently true of Jean-Paul Riopelle (1923), who became the best known Canadian artist in the rest of the world during the fifties. With several other young painters (Marcel Barbeau, Jean-Paul Mousseau, Fernand Leduc) he got his start in Montreal in the circle of Borduas. His earliest works were in the melancholic manner of the Automatistes, though they betrayed something of the physical energy that dominates his personality. By 1948 Riopelle had settled in Paris and was in contact with painters like Sam Francis and Mathieu. The *tachiste* works of this period are compounded of thick blobs of paint in intense colours, overlaid with exciting flashes of white. Sometimes these canvases suggest a dark forest with light filtering through the trees, sometimes a landscape seen from the air: perhaps nature is too deeply ingrained in any artist raised in Canada to be wholly absent even from an abstract expressionist. For me, Riopelle's best work dates from 1953 and 1954, the period of such medium-sized works as *Knight watch* (1953) and the giant-sized *Pavane*, with their ultimate richness of colour and texture. Since then his style has lightened in tone and (to me) in impact. Along with the works of the Abstract Expressionists in New York, his work has become a foil for more recent movements.

The essential contribution of Pellan, Borduas, and Riopelle was to bring Canadian art fully abreast of the times.

1969

Ted Godwin *Tartan for Phyllis* 1969,
elcavite on canvas, 7 × 4 ft 6 in

Overleaf:

Top. Paul-Emile Borduas *La grimpée* 1956, oil on canvas, 23½ × 28½ in
Coll: The National Gallery of Canada

Bottom left. Jean Paul Riopelle *Knight watch* 1953, oil on canvas, 38 × 76¾ in
Coll: The National Gallery of Canada

Bottom right. Tom Thomson *Forest undergrowth 11* 1915–16, oil on canvas,
47¾ × 33 in. Coll: The National Gallery of Canada

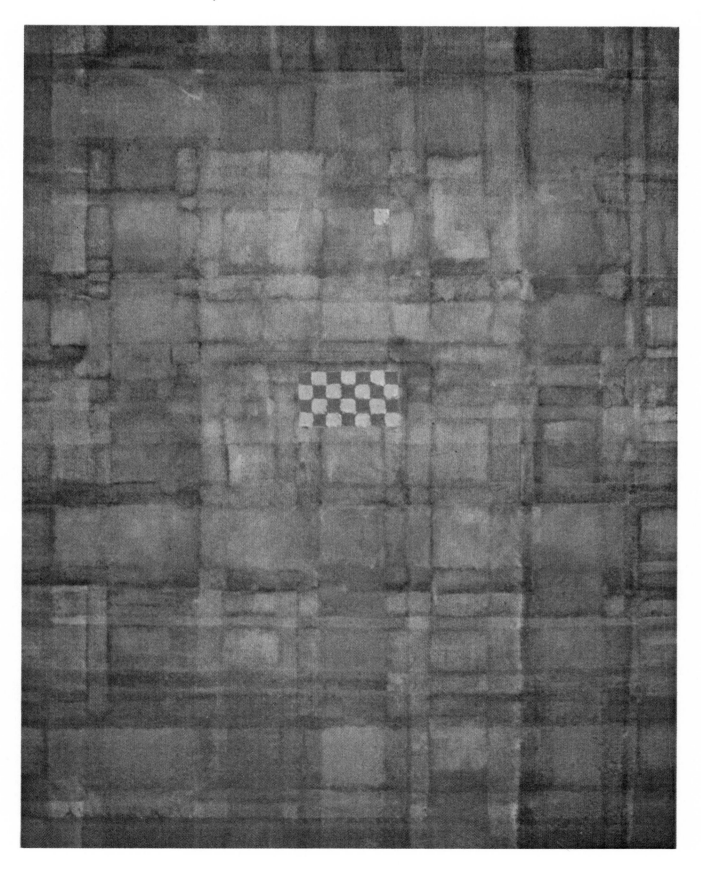

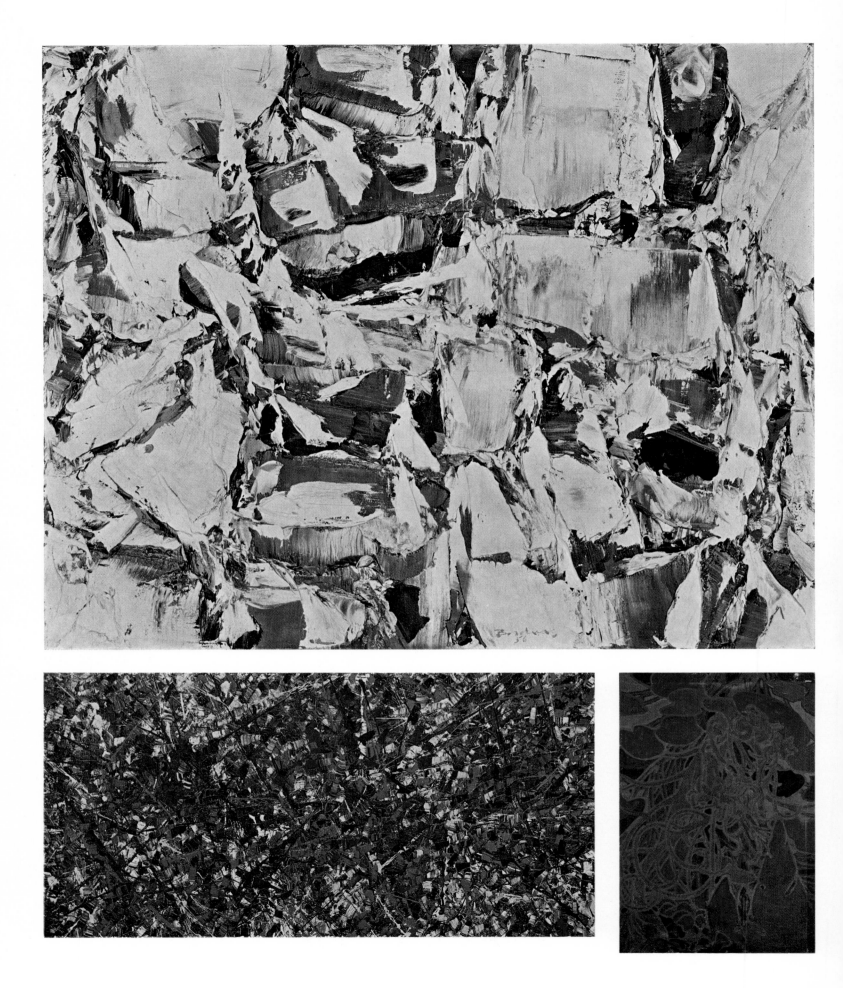

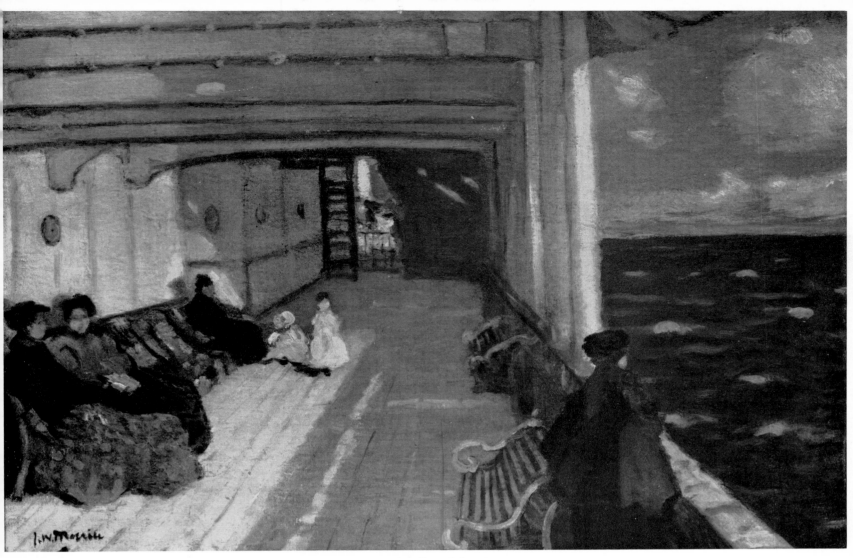

James Wilson Morrice *On shipboard* oil on canvas, 15 × 23 in. Coll: The National Gallery of Canada

David Milne *Window c.* 1930, oil on canvas, 22 × 28¼ in. Coll: The National Gallery of Canada

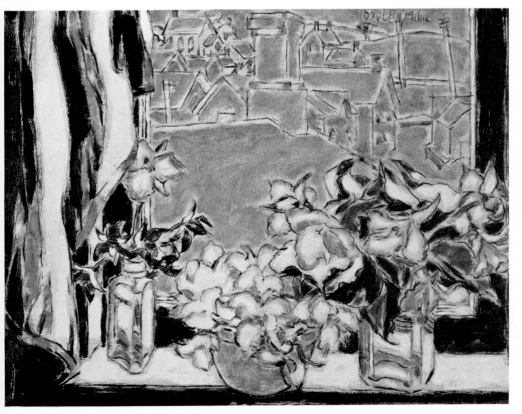

John Lyman *Landscape, Bermuda* 1913, oil on canvas, 21¾ × 18 in
Coll: The National Gallery of Canada

Paul-Emile Borduas
1
Sous le vent de l'île c. 1948,
oil on canvas, 45 × 58 in
Coll: The National Gallery of
Canada

2
3 + 4 + 1 1956, oil on canvas,
78 × 98 in
Coll: The National Gallery of
Canada

3
Alfred Pellan *Floraison c.* 1945,
oil on canvas, 71 × 57½ in
Coll: The National Gallery of
Canada

4
Jean-Paul Lemieux *La visite* 1967,
oil on canvas, 67 × 42 in
Coll: The National Gallery of
Canada

5
Goodridge Roberts *Landscape near
Lake Orford* 1945, water-colour,
21¼ × 29½ in
Coll: The National Gallery of
Canada

6
Alex Colville *Dog, boy and the
St John river* 1959, oil on canvas,
17½ × 24 in
Coll: London, Ontario, Public
Library and Art Museum

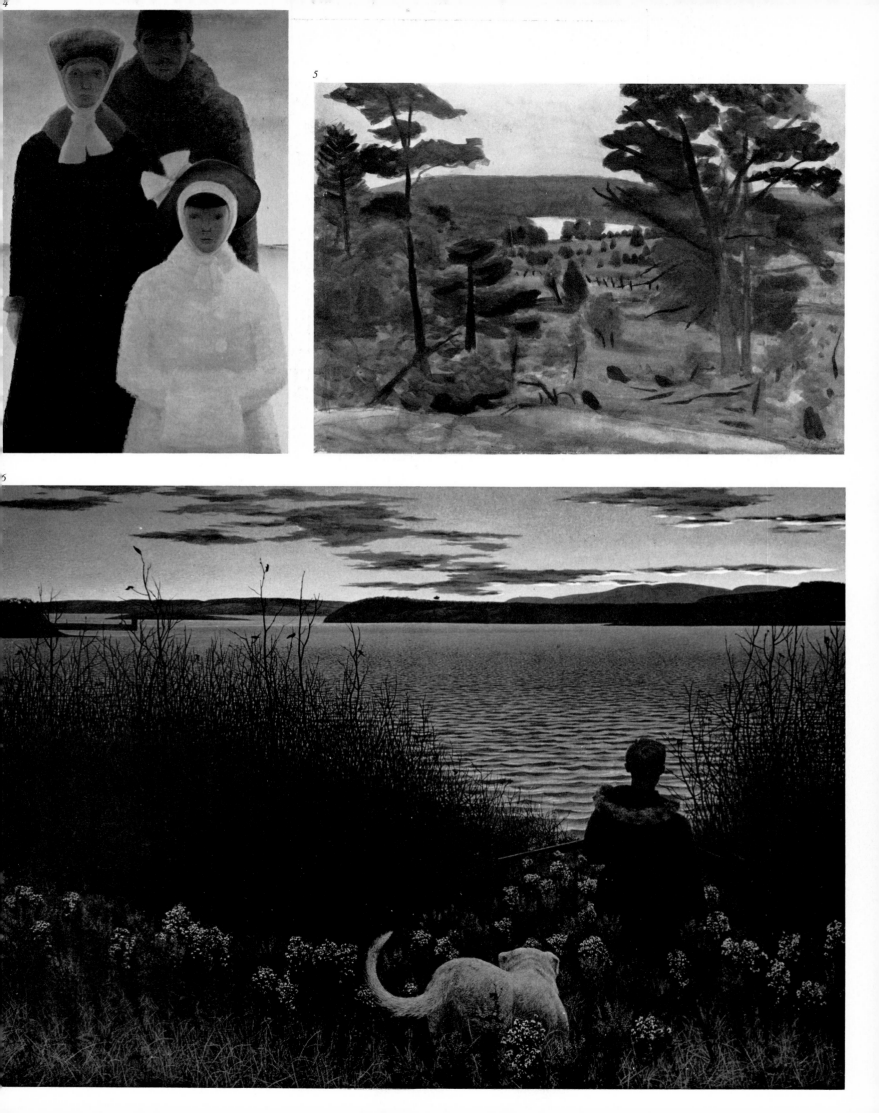

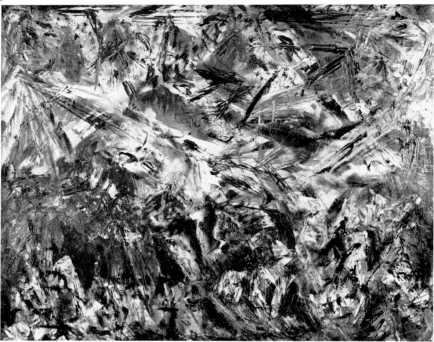

Marcel Barbeau

1
Le tumulte à la mâchoire crispée 1946, oil on canvas
30 × 35 in
Coll: Musée d'art contemporain

2
Bas de fleuve 1964, liquitex on canvas, 80 × 60 in
Coll: The National Gallery of Canada

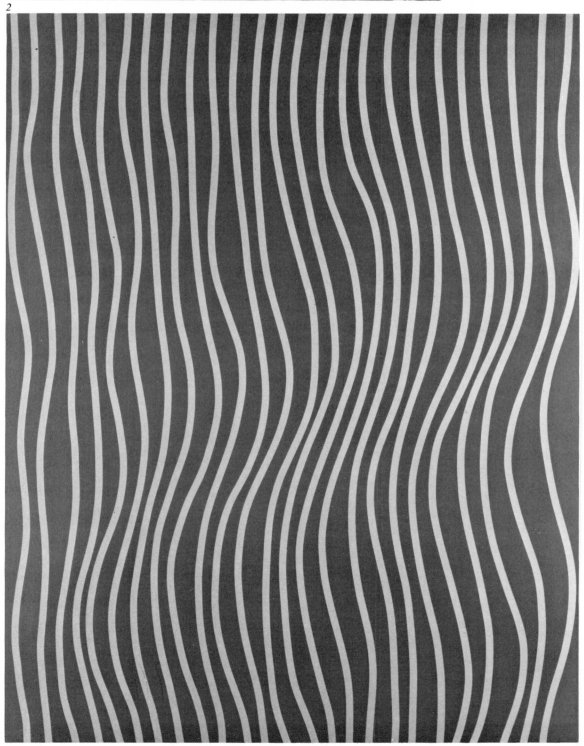

Les Plasticiens

Pierre Theberge

In February of 1955 four young Montreal painters exhibiting together issued a manifesto which they simply signed: *Les Plasticiens*. In it, Louis Belzile, Fernand Toupin, Jean-Paul Jérome, and Jauran (pseudonym of the art-critic Rodolphe de Repentigny) stated their general aims: 'The significance of the work of the plasticiens lies with the purifying of the plastic elements and of their order; their destiny lies typically in the revelation of perfect forms in a perfect order.' The adoption of such purist formal preoccupations implied for the Plasticiens a denial of any conscious symbolic significance to their paintings: 'The plasticiens are totally indifferent, at least consciously so, to any possible meanings to their paintings.' The manifesto also included aphorisms on the truth and integrity of art. Although they did not specifically say so, the Plasticiens sought to express themselves in an abstract-geometric vocabulary and saw Mondrian's neo-plasticism as its main source.

To understand what such a programme meant in Montreal in 1955 one has to remember that automatist painting had been the prevalent style of a group of artists around Paul-Emile Borduas (1905–60) roughly between 1945 and 1954. Borduas, influenced by the surrealist writings of André Breton, had experimented with what he called 'surrealist abstraction' in 1942 and through his teaching at l'Ecole du Meuble in Montreal had influenced a number of young artists among which were Jean-Paul Riopelle, Marcel Barbeau, and Fernand Leduc, into experiments in automatic abstractions.

The Automatistes group held its first exhibition in 1946. In 1948, Borduas published *Refus global* (total refusal), an artistic and political manifesto which called for total freedom of expression in art and for an end to the stifling social and political atmosphere of Quebec. *Refus global* was signed by fifteen other artists. It had wide repercussion and resulted in Borduas' eviction from his teaching post.

Automatism had of course been defined, much before the publishing of the manifesto, in the paintings of Borduas, Riopelle, Leduc, Barbeau and others as a form of gestural painting free from formal considerations while being executed and to which were associated various symbolic meanings (Marcel Barbeau: *Le tumulte à la mâchoire crispée*, 1946). Automatism was not confined to painting only but also extended to poetry and theatre. By 1954–5 the automatist movement which had been tremendously important as a liberating force had practically run out of breath and some of the younger artists were looking for other solutions. Borduas had left for New York in 1953, Riopelle for Paris in 1946 and Fernand Leduc lived in Paris between 1947 and 1953. The Plasticiens' manifesto thus appears as a desire to fill a void and to propose a new formula, geometric abstraction.

What is surprising today is that the first Plasticiens did not persist very long in geometric abstraction and by 1960, they had adopted an 'informal' style. De Repentigny who had been the ideological force of the group, died in 1959, and Fernand Toupin, who had perhaps produced the group's most interesting work by adapting Mondrian's grid to odd-shaped canvases in 1956, later characterized his plasticien period as a 'transitory step'.

Fernand Leduc joined the Plasticiens in 1956 and he quickly came to exert a strong influence on it, being more mature and having had a much longer career. Guido Molinari and Claude Tousignant never joined the group although their aims at that time were somewhat related to the others'. Both, with others who appeared slightly later, Denis Juneau and Jean Goguen, formed a loose second plasticien group, without a defined programme.

Fernand Leduc remains the only one of the first group to have persisted to this day. After his hard-edge paintings were exhibited in 1956, he was to explain in the following terms his transition from automatism to abstract geometry: 'I was disillusioned. There was too much literature in the painting. I'm attracted by order rather than the fluid appearance of form. It's more important to discover order. This is what I'm trying to do.'

In Paris Leduc's painting had undergone considerable change from his early automatist style with his coming into contact with a more formal European art. His preoccupation with internal structural relationships in the interplay of forms, prevalent in his first plasticien period (*Nœud papillon*, 1956), has more recently been followed by freer hard-edge painting using quasi organic forms, (*Chromatisme binaire-vert* 1964). Leduc returned to Paris in 1959 where he still works. He is now a remote and, unjustly so, almost forgotten figure, and his retrospective at the Musée du Quebec and the Musée d'art contemporain in Montreal in 1966 unfortunately failed to arouse much interest in artistic and critical circles.

Guido Molinari and Claude Tousignant revealed themselves to be more independent and more original than the Plasticiens of 1955 when they exhibited in 1956. Molinari showed a series of black and white hard-edge paintings

which went beyond notions of compositional order, clarity and equilibrium, (*Uninoir* 1956). Tousignant was even more radical in exhibiting hard-edge canvases consisting of two sharply defined areas of colour done with shiny industrial paints, forcefully asserting the two-dimensional character of the surface (*Schizophrenie* 1956).

These paintings met with little success and much incomprehension, even on the part of the first Plasticiens, as they seemed totally abstract and much less reliant upon a Mondrian-like image, although a well assimilated influence of Mondrian was to be present in Tousignant's and Molinari's paintings of the late fifties and early sixties (*La ligne jaune*, 1960 by Tousignant; Molinari, *Equilibre* 1960).

In 1959 both tendencies of placticism were represented in an exhibition of abstract art which included Leduc, Belzile and Toupin of the first wave, and Tousignant, Molinari, Goguen (*Chromatique no 6* 1966) and Juneau of the second. The exhibition thus came about at a point where the first group was about to disappear from the forefront and the second one to assert itself more strongly and to go beyond geometric abstraction into colour painting. In the sixties, Barbeau, Gaucher and Hurtubise were also to go into colour painting.

Marcel Barbeau's career has been extremely agitated both physically with stays in Paris, New York and Montreal, and stylistically with abrupt changes in rapid succession. Having been with the automatistes from the earliest, his interest in a more structured abstraction came rather late with a series of 'minimal' two colour canvases done in Paris in 1962. From 1964 to 1967 he did extremely vibrant optical canvases (*Bas de fleuve* 1964), followed by more 'geometric' abstractions. His latest works consisted of a series of similarly shaped monochrome canvases. Yves Gaucher started rather late as a painter in 1964 with optical canvases after a very successful career as a printmaker. Jacques Hurtubise's career has been equally prolific since he adopted colour painting in 1965.

Guido Molinari and Claude Tousignant appear to me as the more original and inventive of the painters who started exhibiting in the middle fifties. Their early careers follow parallel lines of development from an interest in gestural painting into hard-edge with their paths sharply diverging after around 1960–2. Tousignant's art is now strictly optical with colour vibrations in concentric circles (*Gong 88* 1966).

After exhibiting his black and white paintings in 1956,

Guido Molinari stopped painting for a while and opened a gallery in Montreal although he still experimented in gouaches, watercolours and inks. He came back to painting in 1958 with hard-edge canvases using both horizontal and vertical axis composition (*Equilibre* 1960). In 1961 he experimented with a strictly vertical composition, with *Hommage à Jauran*, but it was not until 1963–4, (*Espace rouge-vert* 1964) that he started using parallel vertical bands of colour exclusively, thus getting rid of compositional preoccupations with finding an 'interesting image' in order to concentrate on the creating of a visual space in an open structure. As he has himself said: 'The evolution of my work is based on the complete serialization of the elements. I have chosen to work with elements that are strictly analogous in their quantity of form-colour and which acquire a completely different quality, through the process of their different positions. Once the naturalistic factor of quantity is eliminated it is uniquely through the perception of the various positional functions of the colour-planes that is established a space-time continuum submitted to a constant change.'

Molinari's use of simultaneous contrasts of colour in his serial elements introduces a complex series of ever changing visual relationships which lead to 'the continuous perceptive restructuration of the painting'.

Molinari has also done some sculpture as an extension of the discovery in his paintings that 'space was something created by the spectator . . . for me space is neither interior nor exterior, but in the fourth dimension of perception. Space to me is a continuum in the mind and exists only in the mind.'

Molinari and Tousignant went beyond the canons of neo-plasticism and their current production links them with American preoccupations rather than European ones. Their generation is the first one not to attempt to link itself to the European mainstream. Along with Gaucher, Hurtubise, Barbeau and others, they share an awareness of the North American character of their milieu. Montreal's proximity to New York allows them to exhibit there and to have a first hand knowledge of New York painting. Yet this proximity has not led to imitation, partly because the 'Montreal school' has been active and aware of itself since the forties; their art has not appeared overnight. Also one has to take into account the French-speaking character of their milieu which allows a difference in outlook and temperament, which may be difficult to define or explain but which is part of their reality.

Yves Gaucher

David Silcox

I think of Yves Gaucher primarily as a print-maker. This is because I happen to like and to collect prints and because Gaucher was at first known only as a printmaker. In fact his reputation in Europe and America until 1965 rested entirely on his prints and on a total production up to that point of not much above a dozen works. Although now Gaucher's output as a painter far exceeds his graphic work and although it is by his paintings that he will be better known in the next few years, it is his prints which convey his aesthetic principles more succinctly. Turning points in the evolution of Gaucher's thought and style are almost always heralded by a print.

One of Gaucher's beliefs about life is that a person never really changes, but that one can, through exploration of thought and expression, become more fully and more profoundly oneself. His own work seems to verify this, for from the earliest work to the latest certain principles and characteristics are constant. The work of today is a deeper imprint of yesterday's; though for Gaucher, just 35, yesterday is not long ago. Through 1961 and 1962 Gaucher produced a number of copper etchings in very deep relief. These look a little like arrangements of rough but rounded stones in a Japanese garden, and they occupy the paper without reference to the background which is white or the edge of the paper (there is no plate mark). The cluster pattern, which is very tight in the first works, gradually opens, and texture is given less prominence while greater tension is created between the various elements. In two final prints in this romantic vein only two or three stone-like forms are set against a background composed of overlays of different coloured and textured papers which are cut to produce rectangles and borders not unlike the patterns we associate with Mondrian, and are laminated in the printing process. These were the last of the arbitrary shapes, and from that point forward Gaucher has used only straight lines and rectangles. The shapes were distracting from his chief purpose which was to emphasize the activities between the different elements rather than their appearance.

What pushed Gaucher a crucial step further in his development was a moving concert of work by Anton Webern, which he already knew from records but had not fully grasped. 'The music seemed to send little cells of sound out into space, where they expanded and took on a whole new quality and dimension of their own.' In response to this experience, Gaucher produced three prints called *En hommage à Webern*. These and the set of prints called *Transitions*, 1968, are to my mind Gaucher's most important works up to the recent grey paintings.

The Webern prints are complex works as prints. They are printed on white laminated paper between a male and a female plate, thus producing relief in positive and negative, and they are in five colours: black and four tones of grey. They are 22 × 30 in. The composition is made of a few ¾ in squares and a few short thin lines from 1 in to 2 in long set either vertically or horizontally. A few longer lines in colourless relief appear, sometimes twice in the same plane. There is no symmetry, but rather a 'scatter' effect that reminds one a little of some of Earle Brown's music scores. The complexities of the patterns, the rhythms, the interlocking areas and the spatial tensions and contradictions do not reveal themselves easily. Mostly they emerge as one looks and then disappear as another aspect takes one's attention. After three more works in the same manner and format but in colour, Gaucher moved to painting. The works of this period were square paintings hung on the diagonal. The squares (in colour) and lines of the Webern series, now worked out in modular intervals and in perfect symmetry, were used to activate a field of solid, pulsating colour. The little squares bounced across the canvases creating echoes and after-images. The interaction of the lines and the field created what Gaucher called chromatic antagonisms or energetic events. Certain colours and lines would have certain speeds or quantities of movement. Against these would be balanced colour intensities or confining patterns. As the viewer watched the painting would shift to one side of the equation and then to the other. These works were exhibited in Buffalo's 'Art Today' exhibition and in the New York exhibition 'Vibrations Eleven'.

In 1966, Gaucher returned to the rectangle and began to use only thin horizontal lines as compositional elements. He called these *Signals* and he again arranged them in perfect symmetry with the intervals calculated on a modular system. The background was a one-colour field, still in very strong colour. To accent the rhythms of the signals and to create a conflict or dynamism between the rhythms and the occupied space, Gaucher painted borders on the two sides (to create vertical expansion and horizontal compression) or on the top and bottom (which does the opposite).

In some instances a border colour would give the appearance of being an entirely different colour when isolated in the middle of the field, a pair of lines would

produce a different colour than a single line and different again depending on its position in the field. Again, Gaucher would sometimes marry the actual colour with the seeming colour to create a double illusion. The same alternation between dominant and recessive rhythms and patterns persisted, however. Gaucher referred to it as the 'visual expression of emotional states at once variable and invariable, fixed and evasive, that remain and flow at the same time without remaining or flowing'.

Late in 1966 another major series of prints began to take shape in his mind and after working through a welter of elementary drawings he got to work with a commercial printer to produce late in the following year eight of the most challenging and subtle works I have seen in a long while. These were published as a portfolio called *Transitions* in 1968.

Transitions is again composed only of pencil-thin horizontal lines in seven soft, carefully graduated tones of grey. It begins with eighteen lines of three different lengths and five intensities arranged in perfect symmetry around both the vertical and horizontal axes, with left mirroring right and the top the bottom. It recalls the *Signals* of 1966. The succeeding three prints play on reversals, inversions and varying intervals. With the fifth work asymmetry is introduced though it is almost unperceived, and the number of lines is seen to be gradually decreasing. The sixth and seventh prints are increasingly askew, though echoes of balance and symmetry remain, and the final work is totally without axis or centre point. All that remains is a sense of structure and a balance of forces rather than of pattern. We have arrived at the starting point of the recent series of grey paintings.

While Gaucher began the grey paintings in late 1967, he had really been preparing for them for a long time. The Webern series had suggested a direction, but the artist felt a necessity to work through symmetrical structures first. Further, some of the works of 1965 and most of those of 1966 used grey as the elements or signals in the colour field, so that the behaviour of grey against other colours had now been quite thoroughly studied. It remained to use grey as a field and the result is a revelation of considerable magnitude.

The grey paintings at the time of writing number nearly fifty. They vary in size from quite small (30 × 30 in) to 9 × 15 ft. I prefer to discount the smaller ones and take the majority which range upwards from 7 × 7 ft. They are all in subtly different accents of grey, from rose-grey, blue-grey and purple-grey, to green-grey, yellow-grey and chalk-grey. The hue is often not recognizable except by comparison. Each painting has from five to nine short (6 to 24 in) thin lines, in unmixed grey which are placed in no discernible pattern. Indeed some, though undoubtedly perceived, are not immediately seen, but leap out only as the eye passes over that particular part of the canvas. The lines sometimes establish and then seem to destroy the rhythms and patterns that one perceives.

It is slightly irrelevant but nonetheless interesting to note the reactions people have to these works. They report what isn't there and miss what is. They exaggerate the size of a small line up to five and six times its actual size. They believe they have detected colours and patterns which in fact are not there. Though the arrangements vary sharply from one work to the next, it is almost impossible to remember which is which and people even confuse paintings of different sizes with each other. In fact, these works put the viewer on trial. These works have ceased to be objects containing something identifiable or describable and have become instead a kind of magic wall from which the viewer may extract only what he puts in. The artist would agree, since for him the colour grey 'contains all colours and all emotional states'.

As in earlier works Gaucher had got rid of texture because it was no longer needed, and then symmetry and then colour and then verticality, so in these works he seems to be exorcizing the horizontal, or indeed the need for any kind of orientation. The lines no longer create conflict or illusion, but rather seem to be there only to remind you that they don't really exist. The vast scale of these works makes scale almost unnecessary. The texture is really a non-texture, the colour a non-colour.

Though each painting is now known by its formula, Gaucher had begun to call each of them *Alap*, after the initial, tentative section of an Indian raga before the heavy rhythm begins. The paintings are like that, full of suspense and anticipation and eagerness, and awaiting only a viewer to come and find what resolution he can.

February 1969

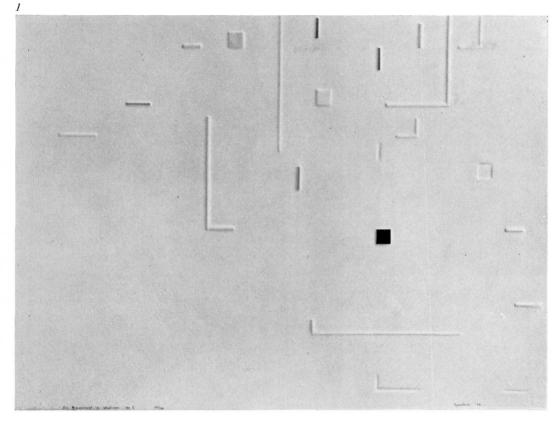

Yves Gaucher

1
En Hommage à Webern No 3 1963
impression in relief on laminated paper
22 × 30 in

2
Grey silences for green 1966
oil on canvas 50 × 100 in
Coll: The Canada Council

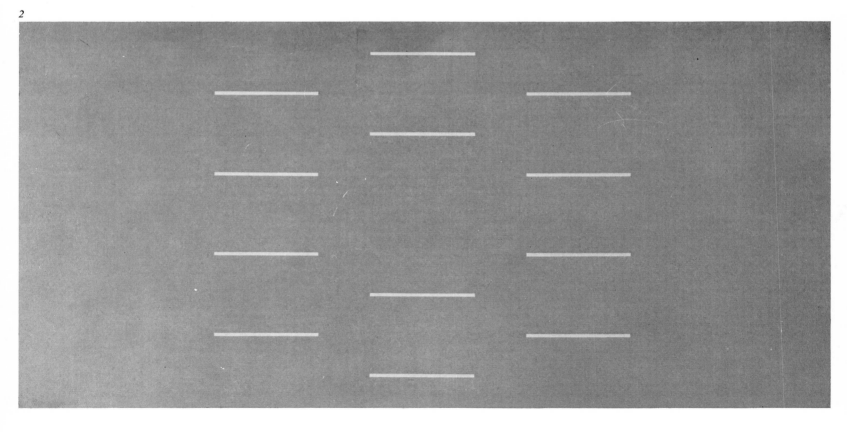

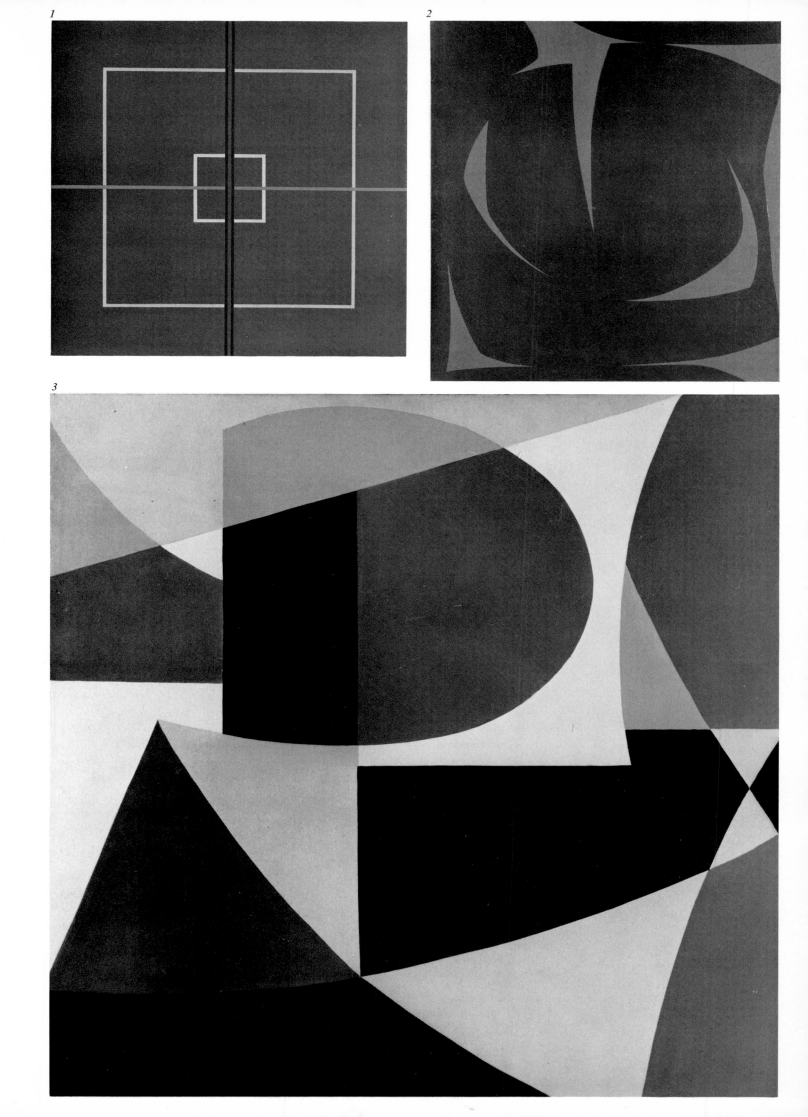

1
Jean Goguen *Chromatique No 6* 1966, acrylic on canvas, 40 × 40 in
Coll: The National Gallery of Canada

Fernand Leduc

2
Chromatisme binaire-vert 1964, acrylic on cloth, 71 × 65½ in
Coll: Musée d'art contemporain

3
Nœud papillon 1956, oil on canvas, 24 × 24 in
Coll: The National Gallery of Canada

Guido Molinari

4
Uninoir 1956, duco on canvas, 45 × 51 in
Coll: the artist

5
Equilibre 1960, duco on canvas, 39 × 43½ in
Coll: the artist

6
Hommage à Jauran 1961, duco on canvas
Coll: The Vancouver Art Gallery; photo: Williams Bros
Photographers Ltd, Vancouver

7
Espace rouge-vert 1964, duco on canvas, 81 × 108 in

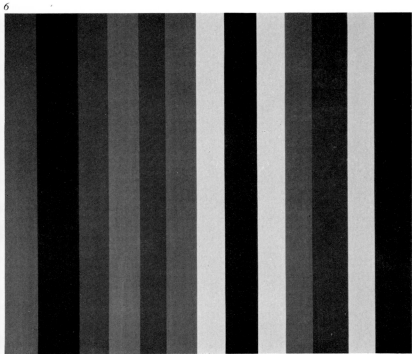

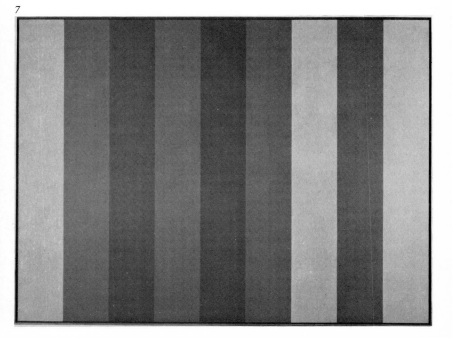

Claude Tousignant

1
Gong 88 1966,
acrylic on canvas,
88 in in diameter
Coll: The National
Gallery of Canada

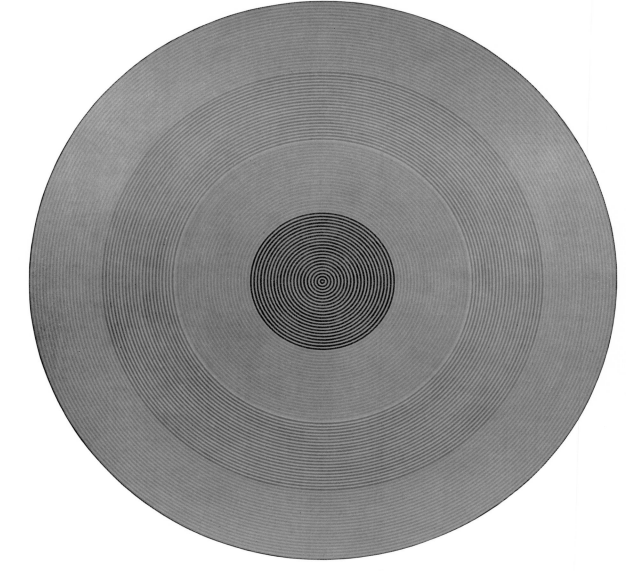

2
Schizophrénie 1956,
enamel on canvas,
59 × 50½ in
Coll: the artist

3
La ligne jaune 1960,
oil on canvas,
57 × 51¾ in
Coll: the artist

2

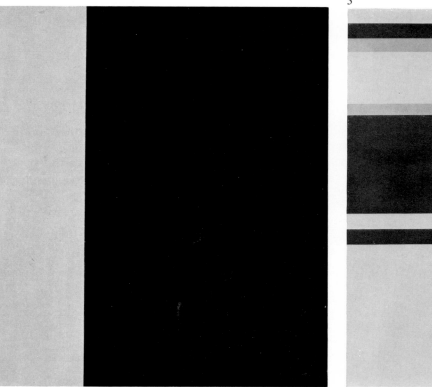

3

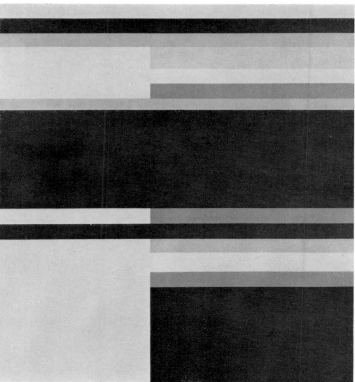

Notes on the Toronto Painting Scene: 1959-1969

Dennis Reid

The Nature of the Toronto Scene

Toronto is the financial centre of Canada. The intense commercial activity arising from this fact perhaps goes the furthest towards explaining the large number of commercial galleries found in that city: probably more than in the whole of the rest of Canada combined. Of these, only about eight warrant serious attention. But the fact remains that Toronto is the best market for art in Canada. All artists of any great importance in Canada exhibit regularly in Toronto, and a considerable amount of contemporary American, British and European art can be seen there as well.

The scene, though understandably active, is fragmented. There is not, as in Montreal, a traditional role for the artist within a strong and active intellectual community. The struggle has been one for professionalism— to be able to make a living from painting while continuing to paint with integrity—in spite of the many opportunities to exhibit. Consequently, painters have tended to become ingrown, spending most of their time within small closed groups of artists, sharing the same problems of relating their way of life as individuals to a social presence. Such 'incestuous' situations have seldom been alleviated by contact with poets, writers, dancers, etc., and there has been little support from critics, who are in most instances journalists who approach the scene with a nose for 'news' or 'personalities'. The good citizenry of Toronto certainly doesn't need art, and there is yet to be a sustained sub-community large enough to really support moving ideas. The recent history of painting in Toronto has had little to do with manifestos or movements. The course of the art generally has been plotted by the rise of individual painters, independent of a relevant supporting cultural matrix.

The Background: The Group of Seven to Painters Eleven

Before the mid-fifties there was not even the benefit of this loose and fragmented scene. The Group of Seven struggled against the established situation immediately before and after the First World War. But they succeeded in gaining acceptance to such a degree that they and their academic perpetuators in the Canadian Group of Painters carried what had become the established 'modernist Canadian landscape' view of painting well into the forties. The depression, prairies dust-bowl and Second World War (without the benefit of an equivalent to the WPA) forestalled any positive resolution of the dilemma of art in English-speaking Canada. A sort of bastard school-of-Paris style entered via magazines, stimulated by the taste of collectors and art officials, and Toronto in the early fifties was—often described—a backwater.

Jack Bush, Jock Macdonald, William Ronald, Kazuo Nakamura, Tom Hodgson, Oscar Cahen, Alexandra Luke, Ray Mead, Harold Town, Walter Yarwood, and Hortense Gordon, banded together as Painters Eleven, generated enough enthusiasm in the city to be able to assert their view of abstract expressionist painting. They showed as a group from February of 1954 until the fall of 1958. But the real turning-point came in April of 1956, when Painters Eleven was invited to exhibit at the annual American Abstract Painters Exhibition in New York. Critical attention was considerable in New York, and compounded in Toronto. Abstract painting was established in Toronto and with a New York bias.

Towards the Establishment of a Climate: 1955–1960

Coincidental with the success of Painters Eleven, a number of new, adventuresome galleries appeared. Painters Eleven was exhibiting at the Park Gallery. The Isaacs Gallery opened as the Greenwich Gallery in 1955. The Gallery of Contemporary Art joined it, along with some coffee houses and boutiques, to form Toronto's first bohemian enclave, the Gerrard Street Village. The Bohemian Embassy opened, presenting jazz, poetry readings and *avant-garde* theatre. It is within this milieu that a whole new generation of painters began to appear in the galleries: Graham Coughtry, Gerald Gladstone, Mike Snow and Tony Urquhart at the Greenwich Gallery; Dennis Burton and Robert Hedrick at the Gallery of Contemporary Art. William Ronald was then living in New York and doing his best work to date. Harold Town was painting spontaneous yet tough paintings which held their scale and which appear in retrospect to have been some of his best work as well. Jack Bush and Jock Macdonald were advancing steadily. Of the other members of Painters Eleven, perhaps only Tom Hodgson was still increasing his potential. By 1960 there were at least four galleries in Toronto exhibiting contemporary art of calibre, and by 1965 the succeeding generation to Painters Eleven was easily identifiable.

Post Painters Eleven: 1959–1967

Painters Eleven presented the possibility of making, exhibiting and selling paintings which went beyond the level of acceptance of the Society exhibitions and of

general public taste. The one characteristic which unites the better painters of the first half of this decade is a concerted attempt to force further the boundaries of propriety: as much in terms of the life-style of the painters and content of their work as of its style. The studio became the centre of the social life of the artists, and a refuge from which periodic forays were made against the philistines.

Graham Coughtry, Robert Markle and Gordon Rayner are, as a group, perhaps the most notable figures in this respect. Coughtry, of the three, has the most intense vision in his Two Figure series, in which he engages in the creation of creation through the emotion-charged expressionistic conformation of two figures linked in various sexual and psychic attitudes. His most recent work seen in Toronto continues his theme of two figures, but on irregularly shaped flat canvases, often bending off the wall as hinged wings, in which the emotional subtleties are suggested through intense colour staining rather than expressionistic impasto [p. 37].

Markle's ink and wash drawings involve the same emotional charge inherent in a sexual context, but he is more involved in examining the sensual possibilities of the displayed body. Gordon Rayner proceeds with a certain emotional detachment to expand the potential of the artist in his construction, films and paintings. A piece such as *Homage to the French Revolution*, with its complex tensions between the vulgarity of its means and the elegance of its effect is a good example of the poetry he often achieves [p. 37].

Robert Hedrick and Dennis Burton are painters of this generation whose concerns have included that of forcing a new freedom for the artist: Hedrick in terms of stylistic variety and Burton the same, but with an added imaginative pursuit of erotic subject matter. Gershon Iskowitz and John Meredith should also be singled out for the merit of their pursuit of a personal vision.

The Problem of Staying in Toronto

Graham Coughtry owns a home in Ibiza, off the coast of Spain, and spends as much time there as he can. He represents in this fact an example of one solution to the problem of the Toronto scene: removing oneself from its immediate frustrations. The question of completing that which is lacking in Toronto is generally, however, thrown into sharp relief by the possibility of New York. Since the time of Painters Eleven, most artists in Toronto have had to face at least the question of emigration.

Of the members of Painters Eleven, the three who have continued to remain active and valid have each manifested a different approach to this problem. Of these, only Jack Bush has continued to produce work which has surpassed his initial promise. Through his contacts in New York from the time of Painters Eleven, those of his dealer, David Mirvish, who handles American art of such demand that his gallery is well known and visited by serious collectors from all over the world, and through the inherent quality of his large stained canvases [p. 42] which, at their best, are the most confident and accomplished paintings presently being done in Toronto, Bush has been able to achieve and sustain a truly international reputation while continuing to live and work in Toronto.

William Ronald lived in New York for about ten years (and was responsible for Painters Eleven showing there in 1956). His best work was executed in New York between about 1956 and 1963, but by then he had run into difficulties in making the transition out of abstract expressionism. He eventually stopped painting and returned to Toronto in 1965. He has recently begun painting again, and has not as yet achieved his full stride.

Harold Town has always insisted upon staying in Toronto. This stance, coupled with the work he was producing between about 1956 and 1963, led to a great public acclaim in Toronto and a certain international reputation. He is, in the public eye, the very image of the Painter. In recent years he has had more presence in the art community through his personality than through his painting, and his international reputation seems of a limited sort.

Two other painters who found that they needed to leave Toronto, or at least that they had to go to New York, are Mike Snow and his wife Joyce Wieland. The move has in this case proven enriching, and they stand today as two of the best artists that Toronto has produced.

Snow's work is amazing in its consistency. His expressionistic paintings quickly developed into very cool, yet movingly beautiful examinations of the paradoxical implications of the rectangular painted picture, explored with an absolute minimum of means. These works, in retrospect, were perhaps the most original paintings being done in Toronto at the time [p 38.]. He moved from that directly into his Walking Woman series, in which he contrived a 'found' image of perhaps *the* primal artistic image, woman, and over a number of years, put her through every artistic ramification possible, including film. Again we are constantly caught up by the paradoxes

involved in the ways we see: in the art context, in an every-day context, with and without the benefit of various stylistic stimuli, and in various combinations of these different attitudes.

Snow's most recent work continues in an even stronger vein. His movie *Wavelength* has received international acclaim, and will prove to be one of the most important films of the sixties. Its single-mindedness in opening up one idea, peeling it back and making of it one continuous and never-ending experience, is carried over into his constructed objects. In a work like *Blind*, as in *Wavelength*, the viewer is confronted with the possibility of intense pleasure [p. 38]. Though the piece has lateral bounds in real space—a 'frame' of some sort—it is infinite in its depicted penetratable space and in its potential as an experience.

Joyce Wieland's work suffers not in the least beside Snow's. But whereas with Snow one never confronts him within himself, but at a point where you both meet in some phenomenal construction out of his imagination, Wieland takes you into her. This is toughened by an obvious awareness on her part of this role, and the resulting implications are profound. Her 'womanly' concerns as exemplified in her films, paintings and assemblages seem easy to indulge at first, but then they shift to reveal an increasingly faceted microcosm [p. 37].

Though Snow and Wieland live in New York and participate actively in that scene, they still continue to exhibit mainly in Toronto, and through frequent visits, maintain the essential link with their home town.

Les Levine, though he shows regularly in Toronto, is most definitely and calculatingly becoming a New York artist with less direct relevance to the situation in Toronto. Levine arrived in Toronto from Dublin via London in 1957, and eventually became an over-night success with his first show at the David Mirvish Gallery in 1964. The exceptionally original works (mainly canvas stretched over chairs, sprayed silver) were displayed in a completely silver-coloured gallery, and represented the first attempt in Toronto at an environmental effect [p. 39]. Levine moved to New York in 1964, but has continued to exhibit in Toronto. His environmental project *Slipcover* was first exhibited at the Art Gallery of Ontario in the early fall of 1966, before its New York exhibition [p. 39].

The latest generation: 1967
The appearance of a new generation, capitalizing upon

the climate of a conditional acceptance of advanced modes established by their precursors, and given the added cultural liberalness of the Centennial celebrations, has led to the surprisingly fast rise of a number of figures. Two of the earliest to appear were Gerald McAdam and Tom Seniw, both of whom exhibit eccentric abstractions of some power. John MacGregor has completed two memorable exhibitions of very personal and unusual graphics, paintings and constructions, exploring the possibilities of an absurdly thorough application of Freudian sexual symbolism to practically everything [p. 37].

Out of a flurry of shaped canvas practitioners who appeared late in 1966, Jerry Santbergen and David Bolduc have continued to exhibit pieces of more than average interest. Santbergen has left the shaped canvas to paint a large serial group of flat paintings which derives from his study with Frank Stella at Emma Lake in the summer of 1967 [p. 38]. Bolduc has continued to wrestle with the problem of contriving three-dimensional shapes on a wall, running a thin line between the loss of formal coherency on one side and the slip into stylishness on the other. His latest works are a series of watercolours in which the forms are dependent completely on colour, and some wall or floor pieces constructed of unpainted wood [p. 39].

The new faces include a number of colour painters, most notably Milly Ristvedt and Eleanor Mackey. One other person who should be mentioned is Karl Beveridge, whose floor pieces achieve an assured manipulation of space through a minimum of linear articulation.

Some movement away from the isolationist tendency of most Toronto artists is being attempted by a group known as Intersystems. Made up of a sculptor, a poet, musician and architect, they have been involved in a number of events and environments. The most successful has been *Duplex* staged at the Art Gallery of Ontario in March of 1968 [p. 39]. Working with a barrage of sensual stimulants and communicating devices they bathe the audience in light and sound. Their projects are most successful when most theatrical, and they now have a stage show which they have performed on and off the stage in various communities in Canada and the States.

Of the other people working in mixed media, Zbigniew Blazeje is perhaps the most accomplished, with an impressive record of installations, most notably at Expo 67 and the Art Gallery of Ontario.

Ottawa, January 1969

The Art Boom That Was a Trifle Flat-Chested—Not a Complete Bust

Harold Town

To find out where Canadian art really is you have to come to Toronto. But Torontonians are constantly being told the art isn't made here. It's always from somewhere else.

Currently commentators insist that the art that Really Is swings quietly in the staid old millionaire city of London, Ontario, not more than 100 miles from our famed new City Hall. Naturally there are other art centres —Montreal, Vancouver, Regina, etc., but no one buys pictures there. All the real action is in Toronto, which has more galleries than any city in Canada.

I was initiated into the Art Union and paid my dues in Toronto during the forties. At that time the art scene was nil. Except for a hangover lingering from the Group of Seven party, which was held all over the country but Toronto was blamed for it, there really was nothing much.

At the Ontario College of Art teachers actually railed against Modigliani. One fustian cut his creative salami at Rembrandt and needed a cold compress the day I suggested the great Dutchman was weak in composition.

Exhibitions were controlled by societies which held interminable meetings and annual defecational displays where members never failed to appear and newcomers made rare appearances disguised as oldcomers.

Under the directorship of an architect the Toronto Art Gallery acted as if Canadian art had stopped dead with the Group of Seven. One could hardly blame it. All the art societies held annual exhibitions at the TAG, which were completely interchangeable because the same artists belonged to all the same societies. The exhibitions were a continuing cyclorama of bored painting.

Around 1948 the Women's Committee of the Toronto Art Gallery came up with the then incredible idea that paintings could be sold. They unquestionably lit the first match in the second Dark Age of Canadian art, an example emulated by other Women's Committees all over the country.

There were only four private galleries of any consequence. One, the Picture Loan Society, was operated by the late Douglas Duncan who took a genuine interest in younger artists. Along with many other Canadians I had my first one-man show at the Picture Loan Society. Unfortunately Mr Duncan, the one qualified saint of Canadian art, was an eccentric businessman and the gallery space prohibited exhibiting pictures of any size. The other galleries—Laing, Roberts and Eaton's College Street— played it safe with browned ground round cavaliers, flower

Harold Town *Frank Zappa* June 1969, zinc lithograph, 14 × 17 in

The collector 1963
Coll: Cara Operations Ltd

36

1
Graham Coughtry *Twist* 1966, acrylic on canvas, 85 × 96 × 48 in
Coll: The Isaacs Gallery, Toronto; photo: Ayriss-Reeves, Toronto

2
Gordon Rayner *Homage to the French Revolution* 1963, painted
wood construction, 70½ × 45 in
Coll: The Art Gallery of Ontario

3
John MacGregor *Love Chart* 1967, pencil acrylic tempera, 35 × 23 in
Coll: The Isaacs Gallery, Toronto; photo: Ayriss, Toronto

4
Joyce Wieland *Young Woman's blues* 1964, assemblage 20½ × 12¼ × 8½ in
Coll: The Isaacs Gallery, Toronto, photo: Ayriss, Toronto

1

2

3

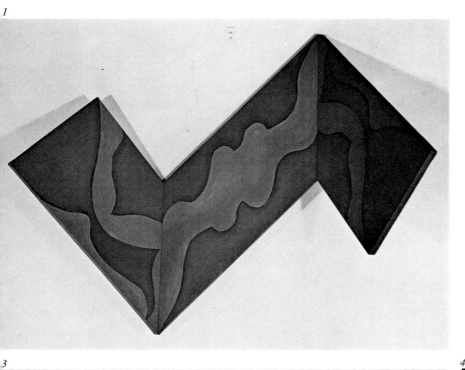

4

1
Michael Snow *Blind* 1967, steel, 8 × 8 in
Coll: The Isaacs Gallery, Toronto

2
Michael Snow *Lac Clair* 1960, oil on canvas with brown paper tape,
70 × 70 in
Coll: The National Gallery of Canada; photo: Ayriss-Reeves,
Toronto

3
Jerry Santbergen *No 2* 1968, fluorescent paint on canvas, 8 ft
Coll: The Carmen Lamanna Gallery, Toronto

4
Jack Bush *Blue M* 1966, acrylic on canvas, 89 × 81 in
Coll: Mr David Mirvish

5
David Bolduc *Marten I* 1968, wood, 78 × 136 in
Coll: The Carmen Lamanna Gallery, Toronto; photo: Ron Vickers
Ltd, Toronto

6
Les Levine *Rocker column* 1963, wood and canvas, 74 × 46 × 41 in
Coll: The Isaacs Gallery, Toronto

7
Les Levine *Slipcover* 1966, a place, displayed at the Art Gallery
of Ontario, 23 September–23 October 1966, mylar

8
Intersystems *Duplex* performance at the Art Gallery of Ontario,
6 and 8 March 1968

2

1

3

4

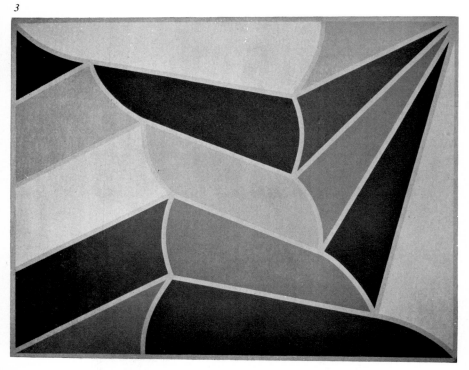

Harold Town

1
Enigma 1968, brush pen,
black and white ink on brown arche,
$25\frac{1}{2} \times 19\frac{1}{4}$ in

2
Woman undressing
1963, charcoal brush and ink,
27×19 in

3
Premonition of Sam
1962, charcoal, 30×22 in

4
Self portrait 1962
Coll: Mr and Mrs Jack Gordon

5
O'keefe lady 1963
Coll: Cara Operations Ltd,

6
Smoke Pica's place 1966

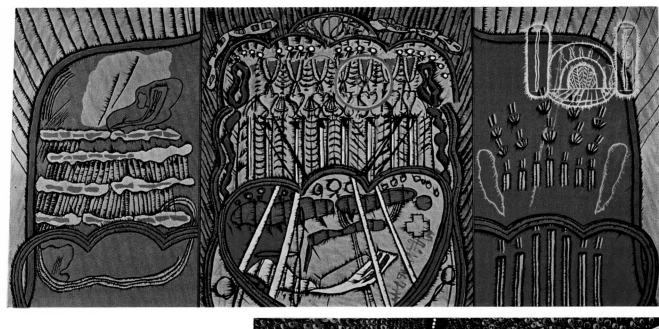

John Meredith *Untitled painting* (*triptych*)
1966, oil on canvas, 70 × 145 in
Coll: Art Gallery of Ontario,
photo: Eberhard Otto

Harold Town *Great divide*, 1965, oil and
lucite on canvas, 90 × 60 in
Coll: Art Gallery of Ontario

Jack Bush *Light grey* 1968, acrylic on canvas, 89 × 68 in
Coll: The Waddington Galleries London, England

Off-centre 1969, acrylic on canvas, 85 × 67 in
Coll: The Waddington Galleries London, England

pictures, smatterings of Canadians, gilt-edged internationals, the Impressionists and such, served in a stew made from Highland cattle in a gravy fog. One had to admire their survival.

The young artist, rejected by the societies and private galleries, had to use theatre lobbies, union halls and store windows as his medium for display. He was told that this was great publicity, sold nothing, carted the pictures back and forth at his own expense and accepted damage as proof that someone had been near the picture.

The creative life of Toronto accurately mirrored the spirit of the city. Gigantic cops in London bobby hats (remember, this is Toronto, Ontario), calmly directed the tepid gaieties of a white, Anglo-Saxon, repressed, Calvinistic citizenry. We were allowed to drink in Belsen-like urinals called beer parlours with separate entrances for women and nightly entertainment provided by bouncers throwing sodden drunks into the street. People watched the Orange Parade without laughing. A tawdry carnival called the Canadian National Exhibition was the event of the year, closely followed by the Royal Winter Fair, mandatory experience for school kids who had to look at the prize cauliflowers and really hoped to see the prize bull get an erection. The year finished with a frozen-toed spectacle, the Santa Claus parade and the Queen's message on Christmas Day was boffo showbiz. Now and then an International Shriners Convention would interrupt our honky-tonk delights and we could witness for a moment a piano burning in the street and women leaping around as firecrackers exploded under their skirts.

If this appears to exaggerate I refer you to Wyndham Lewis's 'Myself Surprised', a savage work based on the author's stay in Toronto during the early forties, when, incidentally, Lewis made a permanent impression on the thinking of the then unknown Marshal McLuhan. Despite years of justified abuse Hogtown, as Toronto was called, remains a fixed attraction to such internationally recognized figures as novelist Morley Callaghan, critic-essayist Northrop Frye, McLuhan and pianist Glenn Gould. Presently the Toronto *Daily Star*, unquestionably one of the world's great newspapers, is reprinting a series of columns written by Ernest Hemingway when he was a young *Star* reporter. It's plain, the city got to him.

For eleven painters the situation was intolerable. Without manifesto or militancy they banded together to form a mechanism for exhibiting their work. Catching Roberts Gallery with its seascapes down, Painters Eleven held an exhibition in 1954 which stated firmly that the art of the twentieth century was here to stay. The Establishment *harummphed*, swatted at a random moth and promptly went back to sleep in its leather chair. Genuine support was given by the late Pearl McCarthy, art critic of the *Globe and Mail* and the CBC's George Robertson. The group continued exhibiting across Canada and in New York for another five years.

During this period Alan Jarvis was appointed director of the National Gallery of Canada. With his writing, speeches and television appearances Jarvis gave Canadian art in general a new focus and thrust. Art was being talked about. There was steam showing at the top of the pot.

In 1956 the authentic precursor of the local contemporary gallery style opened in Toronto's version of Greenwich Village. The first exhibition, a stunning show of pre-Columbian art, held under a ceiling of black egg crates offered free Canadian champagne, a superb catalogue and high hopes. Thereafter director Barry Kernerman got his Gallery of Contemporary Art hopelessly in debt with fine exhibitions by young Canadians alternating with shows of John Marin, Hokusai, Le Brun and exhibits of African artifacts. Before Kernerman folded his egg crates in 1959 the champagne had turned to cooking sherry but art was booming. Around the corner, with the money earned from his frame shop, Avrom Isaacs collected a close, young and yeasty stable in the new Greenwich Gallery. Both galleries were fortunate to find in the brilliant young journalist-critic Robert Fulford, a sympathy and concern that made their efforts viable to the indifferent manipulators of the city's cultural life.

For a few years galleries snapped, cracked up and popped out all over town. The Jordan and Moos galleries started in Yorkville, the city's hippie village. Older galleries presented new artists. Dorothy Cameron opened a gallery on the edge of a parking lot and her ebullient presence symbolized the excitement of the time. She went to everybody's openings roaring appreciation, promoted other artists, she laughed and cried simultaneously, prodded collectors, organized group shows, founded foundries and convinced the public that art was fun. But then the Morris Gallery, which pioneered the New York School in Toronto (especially Pop) and the Cameron Gallery closed and the crepe hangers got busy and prematurely buried the art scene. Fortunately Morris opened again and the Cameron graveyard was re-

1

activated by the Carmen Lamanna Gallery with a series of tough shows, supported in the great Toronto tradition by a framing shop. Discount merchandizer and dancing master Ed Mirvish turned over one of his city streets to small galleries and minimum rent studios for artists. Now galleries are established in various parts of the city, breaking the New York 57th Street pattern of a concentrated art area. The successful Mazelow Gallery is easily 6 miles from Gallery Row.

It is doubtful the champagne effervescence and picnic atmosphere of the first art boom will ever return. Metropolitan Toronto is the fastest growing urban centre on the North American continent and as a city is finally larger than the sum total of its parts. This is where the money is. In spite of a hick mayor who asked the directors of Expo 67 to give him back his donated garbage cans and a city council whose picayune bickerings would make a rafter of turkeys sound like the Vienna Boys Choir, *this is where the action is.*

2

BURN BABY

September saw the opening of the Ontario Science Museum, a definitive model of its kind. The Royal Ontario Museum with its great Chinese collection is, under the swinging direction of Peter Swann, turning into an institution as essential to this city as its sewers. Next door to the Museum the new McLaughlin Planetarium is wowing the kids and the Ontario Art Gallery is threatening to expand. We have one of the best Rock or Pop music environments in North America. A new discotheque opens every week and boutiques pop up like the morning toast and just as often get burnt. There is a new master plan for the redevelopment of the entire waterfront area. In short, the growth of this city has so alarmed our national government that it has seen fit to direct special economic restrictions against further building. Most significantly the major portion of immigration to Canada arrives and stays in Toronto. Artists who were giants in Europe, Australia and the United States are repeatedly telling us what is wrong with the local plumbing and complaining that fame has escaped them in the three hours they've been here. Toronto is analogous to New York in that, despite a deluge of denigration, resident art workers feel they have to make it here.

Canadians have a deeply rooted desire to call in an outside opinion before they make their own qualitative judgements. The Establishment in Toronto seems to have swallowed whole the Clement Greenberg Post Painterly Colour Field argle bargle. And for some strange reason the writing of Harold Rosenberg (possibly the most effective living art critic in the world) and his criticism of the Greenberg machine go unnoticed. Hopefully we will outgrow this regrettable tendency. But in the meantime a staggering amount of fashion is being heralded as art. Fashion always will be the coffin for dying enthusiasms. It gives neither final verification nor support to any art. In the last few decades enough work has been done in Toronto to let Time, the ultimate judge, render the ultimate judgement.

1
Ginsberg June 1969,
zinc lithograph, 14 × 17 in

2
Burn Baby
February 1969, brush, stencil ink
on light blue paper, 25 × 19½ in
Unless otherwise stated all photographs in this article are Coll: Mazelow Gallery, photographers John Reeves, Roy Robel, Toronto.
© 1970 Harold Town

Memories of Saskatchewan

Andrew Hudson

'*Artists produce for each other the world that is fit to live in.*' Birkin in *Women in Love* by D H Lawrence

Saskatchewan will always be for me the place where my life began. I went there in 1961 to study art with Eli Bornstein and music with Murray Adaskin at the University in Saskatoon. Soon, maybe as a reaction to the geographical isolation, the long winter and the wide-open landscape (which I came to love), I started to develop in all sorts of directions—painting, writing art reviews, conducting art classes and poetry recitals. Two things that helped sustain me were the good climate for painting in Saskatoon and the stimulation of the Emma Lake Artists' Workshops organized by artists at the Art School in Regina.

The artistic climate in Saskatoon had been built up by two or three generations of painters, some of whom, as teachers, had fostered the early talents of others. (Otto Rogers and Henry Bonli were two among many students of promise that Nonie Mulcaster came upon in her class at Teachers' College and packed off to art school.) Also contributing very importantly to this climate were the efforts of Lea Collins, director of the Saskatoon Art Center (originally an artists' club) who insisted—despite criticism from museum colleagues in other parts of the country—on supporting all the local artists, no matter what their style, by giving them regular one-man shows. This gave the artists incentive and at the same time brought into being a local art audience keenly interested in their work. (Extensive newspaper coverage in the earlier years also helped to build this audience. But, alas! this sympathetic press ceased when the artists began to produce abstract art.)

The Emma Lake art camp was started in the 1930s by an Englishman, Gus Kenderdine, one of the first artists to settle in the province, and subsequently the first teacher of art at the University. This camp, way up in the north of the province, became the site of a regular six-week summer school art course. When the staff of the University's small Art School in Regina took over responsibility for it in the 1950s, they came up with the idea of keeping the camp open an extra two weeks for a workshop for serious artists and senior students. They had the further, brilliant idea of inviting artists from New York to conduct this workshop—which solved for many Saskatchewan painters the problem of not being able to get to New York to find out what was happening there. New York artists who have conducted workshops over the past twelve years include Will Barnet, John Ferren, Hermann Cherry, Barnett Newman, Kenneth Noland, Jules Olitski, Frank Stella

and Donald Judd. Art critics Clement Greenberg and Lawrence Alloway and composers Stefan Wolpe and John Cage have also led workshops; in 1966 Harold Cohen was invited from England.

Through the workshops, Saskatchewan became aware of developments in American painting and artistically orientated towards them in a way that Toronto and Montreal were not. (Jack Bush in Toronto was an exception.) This led eventually to some disputes among the Saskatchewan artists, for and against 'American-style' painting and American influences. It remains true, though, that without the Americans, Saskatchewan painting would not have grown in the way that it did.

Barnett Newman's workshop in 1959 made the first major impact. Within a year, five Regina painters, fired by Newman's seriousness of approach, had moved into more ambitious abstract styles. Within another two, the expert public relations of Ronald Bloore, director of the Norman Mackenzie Art Gallery, and a group show circulated by the National Gallery in Ottawa had made them known across the country as the 'Regina Five'. Bloore, Arthur McKay, Ted Godwin and Douglas Morton had participated in Newman's workshop; the fifth member of the group, Kenneth Lochhead, who'd been away for a year in Italy, quickly picked up the new spirit in the air on his return.

Lochhead's art changed again three years later—and for the better, I think—as a result of Clement Greenberg's workshop in 1962, which also had a major effect on several painters from Saskatoon. For me, this workshop was a godsend. Greenberg encouraged me to continue writing criticism, and I learned an enormous lesson (though I did not understand many of the things he said until quite a bit later) from watching him conduct studio criticisms, where he treated every artist's work, no matter what their style, with equal seriousness.

Greenberg had undertaken to write a full-length survey of western Canadian art for *Canadian Art*, the national magazine, on his trip out west. When this came out in the spring of 1963, it caused a furore. Greenberg made very plain how impressed he had been by the spirit of the 'Regina Five' and by the paintings of McKay; put forward a plea for Canadian landscape painting and commented on its development in Saskatoon; didn't hesitate to criticize abstract paintings produced outside of Regina for their 'Tenth Street mannerisms' and preoccupation with *cuisine*. In later years, when I got to see the art of

45

Calgary, Edmonton and Winnipeg, I thought he had dealt fairly and squarely with each artist's work, as at the workshop, and that many of his insights had been acute.

Someone else who came to the praries from outside and helped get Saskatchewan art known and talked about was Will Townsend. The exhibition that he chose for the National Gallery of Canada in 1965 included more paintings from Saskatchewan than any previous Biennial. However, by that time the Regina painters had begun to disperse and the impetus that had propelled their urge towards ambitious abstract art was slowing down.

Lochhead, who'd been director of the Regina Art School for fourteen years and was the real brains behind the workshop programme, left for Winnipeg in 1964; Bloore returned to Toronto the following year. Last year, two promising younger painters of Regina, Bruce Parsons and Kenneth Peters, moved to Toronto and Montreal.

Saskatoon has kept its community of artists, but suffered a loss when Lea Collins was relieved of her post at the Art Centre, though she is still helping local artists in other ways as Visual Arts Consultant to the government Arts Board in Regina.

The workshops at Emma Lake seem, by all accounts, to be declining in their appeal; perhaps, now that most of the artists have formed their styles, there is less need for them. Or perhaps they are undergoing the natural death that overtakes any programme.

I consider myself lucky to have been there when I was: various moments at the three workshops I attended (Greenberg's, Noland's, Olitski's) are among the things I remember most vividly from Saskatchewan. Whenever I happen to hear a certain tune from a record of Thelonious Monk, it triggers off memories of Noland's workshop in 1963—of sunlight, smell of trees, walking into the studio, everyone working. How the work would change in the second week, as a result of all the talk and exchange of ideas—and how exhilarating that shared involvement and experimentation was!

Seven Abstract Painters

Henry Bonli *Orange field* 1962, enamel on board, 48 × 42 in

I call this painting 'one of my critical Waterloos'. Just two straggly-edged rectangles of bright orange on a bare board, it was the first thing I saw in the studio when I arrived for the second week of Clement Greenberg's Emma Lake workshop in 1962. I thought it looked very childish, and couldn't understand how Greenberg could take Bonli's new abstract direction seriously. A few months later, at a November group show Lea Collins put together at the Saskatoon Art Centre, I suddenly realized that *Orange field* was the outstanding work, and full of feeling about the prairie.

Kenneth Lochhead *Dark green centre* 1963, acrylic on canvas, 83 × 81 in

Dark green centre, done shortly after Greenberg's workshop, was one of the three Lochheads included in Greenberg's exhibition 'Post Painterly Abstraction' in 1964 (McKay and Bush were also included from Canada). For me, Lochhead's most personal and expressive flat abstracts are the ones that came just after this—a series of large paintings accompanied by many delightful watercolours—where the 'petals' and 'stem' of the vaguely 'floral' motif begin to move about like arms, fingers and legs running and gesticulating.

Ronald Bloore *Untitled c.* 1958, enamel on board, 24 × 36 in. Collection Lea Collins, Regina.

This small painting, one of the very few still extant in Bloore's earlier palette-knife style, introduces us to the two gallery directors who did so much to form the climate of art in Saskatchewan in the 1960s.

Sometimes I look back and consider the very different approaches which Bloore and Collins took in running their galleries in Regina and Saskatoon: he much concerned with 'standards' and exclusive towards local art (only the 'Five' from Regina, a primitive artist Jan Wyers, and Ernest Lindner of Saskatoon were shown by him at the Norman Mackenzie Gallery); she insisting on having as many local shows as travelling exhibits, wanting to give encouragement to every local artist who had anything to say. Arguments can be made for both approaches, but today I'm inclined to favour the 'inclusive' one, as helping to get local art created, looked at, and discussed.

The series of one-man shows of local artists staged by Lea Collins at the Saskatoon Art Centre was augmented in the early 1960s by a series of one-man shows given by James Ait Studio, the artists' supplies store, and by various group shows held at a shortlived artists' gallery, 'Gallery Nine', and by the University Art Department (which today has frequent one-man shows at its new gallery in Marquis Hall.) All of these exhibitions helped sustain local interest in Saskatoon art and were a boon to me as a beginning art critic.

Arthur McKay *The enclosure* 1963, enamel on composition board, 48 × 48 in. Collection the artist.

McKay is the only one of the 'Regina Five' whose stature I feel quite certain about. Like Bloore, he was greatly inspired by the Newman workshop of 1959. His current mandala-images emerged, as it were, out of the textural effects of Pollock- and Still-like paintings done in the two years after that workshop. The images are formed by several layers of enamel varnish falling into the furrows of a roughly painted ground. But, as McKay once emphasized in a conversation with me, it is their placing on the format that is of crucial importance. An inch more or an inch less in the margin around them and the paintings might become pretty or banal.

46

Henry Bonli *Orange field* 1962
enamel on masonite, 48 × 42 in

Kenneth Lochhead *Dark green centre*
1963, acrylic, 83 × 81 in

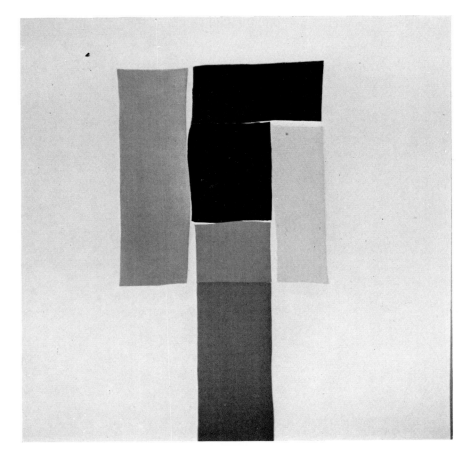

Ronald Bloore
Untitled c. 1958,
enamel on board,
24 × 36 in
Coll: Lea Collins,
photo: Brigdens
of Saskatchewan

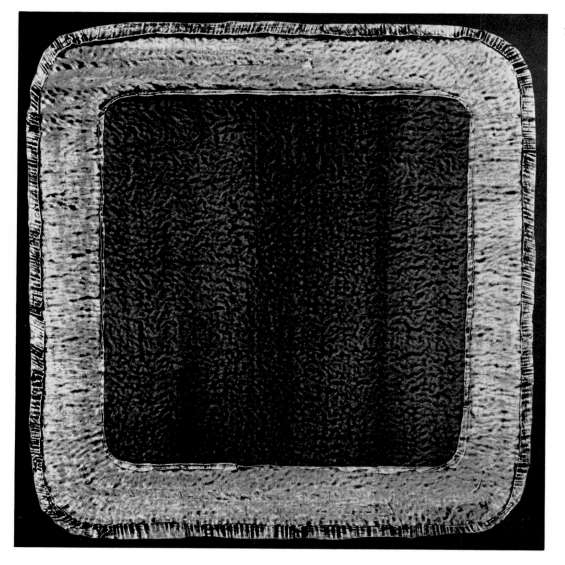

A F McKay
The enclosure 1963,
enamel on compo-
sition board,
48 × 48 in
Coll: the artist,
photo: A J
Govinchuck,
Regina

Kenneth Peters *Untitled* 1968, acrylic on canvas, $78\frac{3}{8} \times 110\frac{7}{16}$ in
Coll: Norman Mackenzie Art Gallery, photo: Brigdens of Saskatchewan

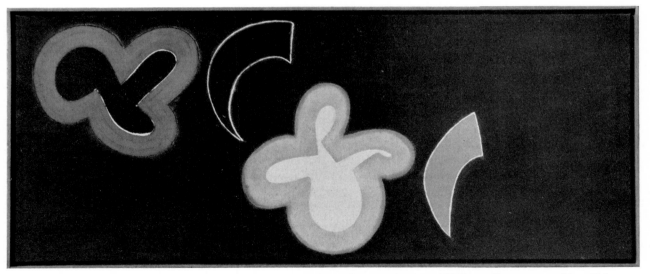

Bruce Parsons *Aroma red* 1965, acrylic on canvas, 32×78 in
Coll: Saskatchewan Arts Board

Dorothy Knowles *The Biggar Hills* 1966

Mollie Lawrence *Up to the top* 1962, oil on cardboard, 28¼ × 22 in
Coll: Mrs Elizabeth R Cruickshank
Photo: Brigdens of Saskatchewan

above
Otto Donald Rogers *Landscape vibration No 6* 1966, acrylic on canvas,
5 × 5 ft

right
Ernest Lindner *Cornucopia* 1964, egg tempera, 30 × 24 in
Photo: Nik Semenoff, Saskatoon

Kenneth Peters *Untitled* 1968, acrylic on canvas, 78¾ × 110 7/16 in. Norman Mackenzie Art Gallery, Regina.

The most recent big 'news' from Regina, I discovered on a lecture tour across Canada in the fall of 1968, was the paintings Kenneth Peters had produced during the previous year, before he left for Montreal. Terry Fenton, assistant to the director at the NMAG, and Douglas Morton, now director of the Art School, helped me see several of these works, large and small. Quite a few of them, like the one reproduced, impressed me as being very fine, with a wonderful daring in the use of image, space, and colour.

Bruce Parsons *Aroma red* 1965, acrylic on canvas, 32 × 78 in. Saskatchewan Arts Board, Regina.

It was Jules Olitski who pointed out at his workshop in 1964 the comparative freshness of some seemingly inconsequential flower designs that Parsons was doing on paper, as opposed to his large canvases of poured and overpainted images. During the next year Parsons produced several paintings with a 'flower' theme. The large one reproduced above and one like it in the collection of the Regina Public Library seem to me among the best moments so far in Parsons' development.

During his six years in Regina (1962–8) Parsons built up an active cultural programme at the new Public Library where he was employed as director of the Art Gallery. He began a series of one-man exhibitions of artists from Regina and Saskatoon, which off-set and complemented the 'exclusive' programme of the University Gallery. (Tribute for this improvement in the Regina art climate should also go to Chief Librarian Marjorie Dunlop, whose dream-child the Library Art Gallery was.)

Mollie Lawrence *Up to the top* 1962, oil on cardboard, 28¼ × 22 in. Collection Mrs Elizabeth R Cruickshank, Regina.

It's often the case that in a flourishing art centre, an artist whose work doesn't quite 'fit in' is slow to have his worth recognized and gets left out of the 'official lists'. (I think of Ludwig Sander in New York and Blaine Larson in Washington.) In Regina, this has been the unfortunate lot of Mollie Lawrence. That she works for the most part on paper or cardboard and in a small format, where museum directors, etc., are looking for 'large statements', may possibly be a reason why her highly idiosyncratic and often extraordinarily 'open' art hasn't yet been taken up in the way that it deserves.

The Saskatoon Landscape School

Reta Cowley, Wynona Mulcaster, Otto Rogers, Ernest Lindner, Dorothy Knowles

Something else waiting to be generally 'discovered' in Canada is the group of landscape painters living in Saskatoon. For myself, I would say that in all my travelling I haven't come upon such a concentration of good landscape painting anywhere else in North America. This Saskatoon 'school'—if it is one—is healthily nonhomogenous: the landscape styles there range from the airy, meticulous watercolours, usually focused on a group of buildings or a clump of flowers, of Reta Cowley to the large, bold renderings of prairie space by Wynona Mulcaster. (And we can perhaps stretch this landscape category to include Otto Rogers's 'synthesis' of Klee's lollipop trees with Rothko's atmospheric colour rectangles.)

Greenberg's 1962 workshop was important for two Saskatoon landscape painters. Ernest Lindner began a new series of close-up renditions of mushrooms and tree-trunks in which he discarded the filled-in background (a parallel development to the 'stripping-down' that was going on in the abstract painting of Lochhead, Bonli and Perehudoff). Prompted by Greenberg's admonishments, Dorothy Knowles moved away from an uneasy 'semi-abstraction' towards a more faithful depiction of the landscape, in which direction she has since developed a strong and independent style.

Notes on Structurist Vision *Eli Bornstein*

We are separated: physically, as continents, by great seas;

 linguistically by bias of communication and
 semantic seas of sense and value;

 psychologically by neurotic distortion and
 conditioned sensory response.

Abbreviated electric messages span great distances to bridge our separation.

My telegraphic notes seek a similar connection.

Structurist vision is consequence of human vision and awareness expanded
 by man throughout history.

Human vision began with eolithic man and begins anew with each newborn infant.

Innocence and freedom of vision are undivided between art and nature and
 precede social/semantic conditioning.

A child may stand before structurist relief or flower and respond simply
 and directly to visual reality of both without distinction.

Children are quickly "educated" away from openness of vision.

Adults lose total vision to gain separated, fragmented perceptions.
 Unless these are fully integrated we cannot recover
 wholeness again.

Photography spawned a latent image whose force revolutionized world vision
 and changed our view of art forever.

Monet and his contemporaries began the successive shattering of traditional
 Renaissance focus dissolving value-modelled image through
 Color into Light.

Cézanne transformed Color/Light focus into structured planes revealing
 fundamental reality of painting and vision of art as
 harmony parallel to nature.

Cubists, van Doesburg, Mondrian, Malevich and others altered our vision
 further toward Abstract, Non-objective, Pure, Constructive
 art of relations.

Illusionary, mimetic images disappeared and we were brought up to the very
 surface and substance of the picture plane. Subsequently . . .

Actual Light/Color/Space/Structure—the parallel elemental qualities in
 nature—burst forth to displace their static frontal
 representations with dynamic multi-dimensional realities.

A new vision emerges beginning with creative exploration and integration of
 these visual/tactile elements and evoking metaphorically
 a plastic equivalent to music.

Simultaneously with origins of structurist vision Futurist/Dadaist/Surrealist
negations and disintegrations of art appeared. Destruction
and nihilism became "new" vision.

This view dominates our cultural life. Dadaist/Surrealist vision in many
guises pervades most art for the last half century.

Unstructured vision characterizes current ethics of change and quests for
total involvement.
Un-structured is similar in essence to un-reason, un-
conscious, un-order of Dada/Surreal views.

Persistence of irrational views suggests failure of rational vision and discourse
which often seems over-simple, narrow or sterile.
Seductions of sur-reality are its facile leaps over
and pseudo-containments of the unknown.

We witness great variety of visions and anti-visions of art and non-art in
collision.

All visions are in serious jeopardy amidst accelerating deteriorations of
value, meaning and language concerning art.

In our rapidly changing society what is the relevance of art?

Art appears in profusion to serve theories, critics, collectors, publications,
schools, museums;
to serve fashion, decoration, entertainment,
merchandising, voyeurism, solipsism.

How can we generate and recognize art as
celebration of life,

reverence for man,

expression of identity parallelling
nature's self-expression,

advancement of man's creative potential
and sensory knowledge.

progressive transformation of environment,

nourishment for regeneration through beauty
within ecologies of man/nature?

and as
revelation of new creative life and vision?

Structurist vision finds its primary source in nature—the wild, unspoiled wonder of nature and its processes.

We stray from this infinite source in vain and at great peril to survival. Separations of man from nature and from his own history are semantic delusions.

Man's media, science, and technology are highly developed extensions of natural man through discovery of nature's laws.

Structurist vision is concerned with the forming processes in art/nature. It suggests organic approaches to art based on the principle of inherency.

Structurist vision as presently manifested in the structurist relief is a germinal beginning, like a growing tip unfolding toward more space and light.

It seeks to extend visions of countless artists of past/present and to find continued integration of man's emerging knowledge of creation. It rejects rigid dogmas and closed "isms", recognizing need for variety and plurality of developments.

With unequalled constructive resources now available to man, this vision sustains a positive faith in the potential future of man and art.

Saskatoon, April, 1969.

Eli Bornstein *Structurist Relief Number 3* 1966–7, painted aluminium and plexiglass, 34 × 24 in

Donald McNamee *Relief # 2* 1967, painted birchwood, 32¾ × 27 in
Coll: the artist; photo; Dommasch

Ronald Kostyniuk *Relief 1968* (*white, yellow, red*) oil on wood, 27 × 27 in

Elizabeth Willmott *Structurist Relief # 4* 1968, wood painted with acrylics, 25 × 25 in

Donald Geary *Structurist relief No 1* front view, 1969, wood, 32 × 32 in

Brian Fisher *Passage* oil on canvas, 86 × 68 in
Coll: Mr and Mrs J R Longstaffe; photo: Williams Bros Photographers Ltd, Vancouver

Jack Shadbolt,
mural in terminal
building at
Edmonton Inter-
national Airport to
commemorate bush
pilots, 1963.
Courtesy: Depart-
ment of Transport
Edmonton
International
Airport and the
National Film
Board of Canada

Gordon Smith
Folded blue 1968
acrylic on canvas,
35 × 70 in
Coll: Galerie
Godard Lefort,
photo: Tommy
Thompson &
Company Ltd,
Montreal

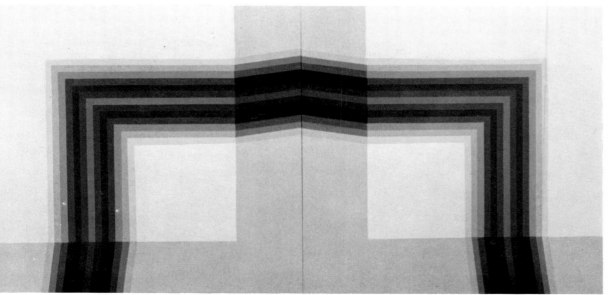

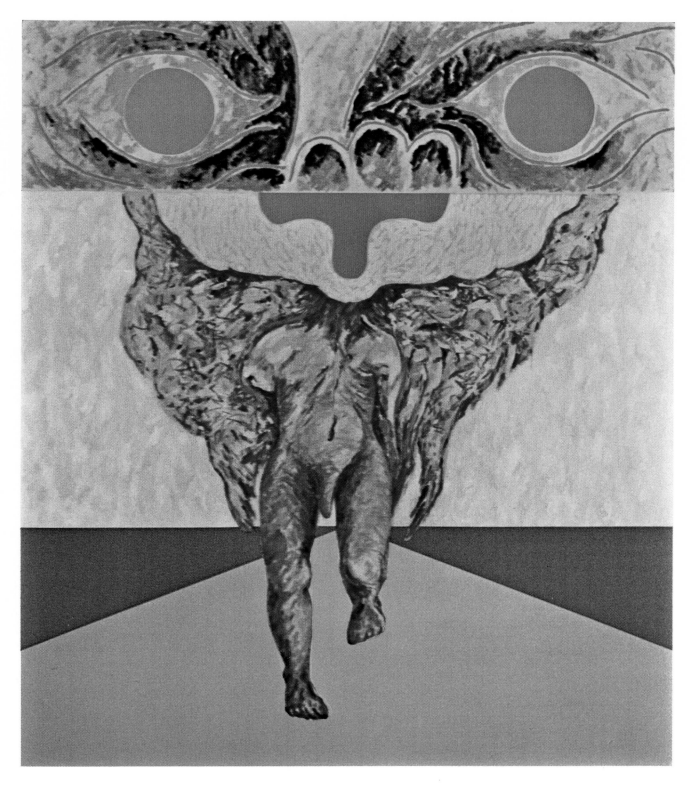

Claude Breeze *Man Painting 16* 1966, acrylic on canvas, 78 × 66 in.
Coll: The Isaacs Gallery; photo: Ayriss, Toronto

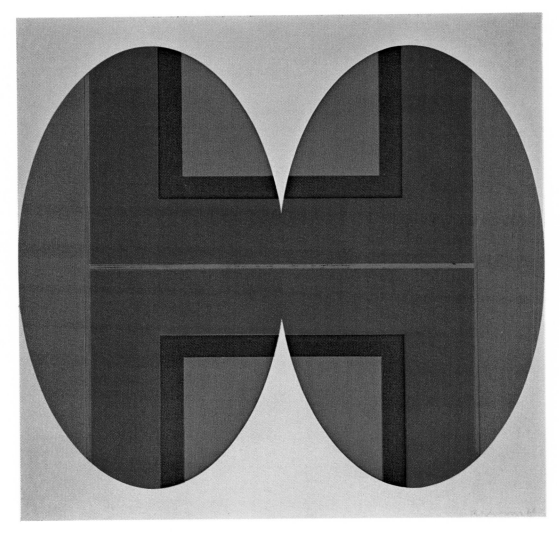

Roy Kiyooka *The bridge* 1965, acrylic
on canvas, 60 × 60 in.

Kenneth Lochhead, *Pink base dimension*
1967, acrylic on canvas, 81 × 136 in.
Coll: The Canada Council

The Vancouver Scene

Doris Shadbolt

Vancouver 1969—the only Canadian metropolitan centre west of the Rocky Mountain barrier, third largest city of the country and port on the Pacific, accounting, with its environs, for almost two-thirds of the entire population of the province of British Columbia. Growing urbanization and industrialization with all the attendant problems of congestion, pollution, frustration. With only eighty-three years of accumulated history it has a big-town quality, an awkwardness of a city grown too fast. No traditional wealth, institutions, learning, no traditional interest in or support for the arts—in fact no traditions except the mountains, the sea, the lush growth, the easy climate. Between the last-sprouted high-risers still a slice of mountain, a glimpse of sea; and only one-half hour's drive from city centre over the bridge and up the mountain to the brink of a vast and virtually untouched wilderness.

The absence of tradition, a relative absence of *establishment* and institutionalism make for a creative openness, a freedom, an ease which is powerfully and pervasively paraphrased by nature—the unclimactic merging of seasons, the ocean opening to the orient, the opalescence and softness of atmosphere. To these conditions dictated by history and geography add now, through the communications leap the immediate accessibility of the rest of the world in the form of information and increasingly of experience, to get some notion of the amalgam of stimuli and deterrents, obstacles and incentives which have for the past fifteen years provided a climate in which art could grow; and for the past five or so in which it could blossom rather spectacularly.

The blossoming of the late sixties is striking in the genuine vigour of its achievement and in the conspicuous reputation and success it has brought to the small group of artists at its core and to the art scene in Vancouver in general. But it did not happen miraculously out of a total artistic hiatus and any implication that it has been a mushroom activity is both to falsify the past and to suggest too little hope for its future.

In 1937 Emily Carr, who remains the single giant of west coast painting could correctly refer to the cultural vacuum of the area; and while the working situation for the artist had certainly ameliorated by the time of her death in 1945, the generation who were developing or peaking in the fifties had as their chief artistic inheritance her example: that is an individual who in the grand romantic manner had triumphed over an impossible situation and an art whose strength related to its regionalism even

though it was powerful enough to transcend the limitations of that regionalism. In 1955 when the curator of Canadian Art of the National Gallery claimed that the artistic leadership of the country had been assumed by Vancouver, the reference was to the activity of a group of artists (and architects) working within the concept of possibility and ambition largely determined by her precedent. They worked as individuals but shared the assumption that their art should spring from their unique coastal experience, however informed by awareness of movements in the art world at large. They were mostly connected with the Vancouver School of Art as instructors and/or students and all played to some degree the necessary role of organizer-promoter-educator in creating a community awareness in which essential institutions and at least minimal support for art would develop. Jack Shadbolt's contribution to the scene as a combination of dynamic teacher and energetic artist was probably at its height in the mid and late fifties. An omniverous observer, rapid assimilator, explosive worker, a juggler capable of keeping several ideas going at the same time often over a period of years, he produced a changeful and prolific art whose continuity is in its particular energy. His imagery, however abstract, is usually found to rest on a highly subjective response to nature in intimate or grandiose moods which he invests with a psychological edge sometimes bordering on the surreal. Bert Binning translated the coast world of boats-sea-sky into flattened simplified patterns sometimes of architectural calm, sometimes of Miróesque playfulness. Gordon Smith's *Structure with red sun* which won the main award in the National Gallery's first Biennial of Canadian Painting in 1955 represents a kind of lyrical abstraction based on nature experiences which was felt to be characteristic of much west coast painting at that time. He has since been more active in print-making and architectural decoration. Don Jarvis was producing strong canvases using nature imagery, expressionist brushwork and romantic atmospheric colour. These artists are all still working today but in the last half of the fifties, along with others, they constituted a new peak of achievement, activity and awareness; they were recognized in national terms and took part in Canadian exhibitions abroad. But in the retrospect of ten or so years their activity of that time may be seen as regional, generally of easel-painting scale and limited in ambition by the condition of relative isolation.

Given a living art situation, the developments of the

next ten years, though striking in their acceleration, are seen to relate to the general changes taking place everywhere. The Fine Arts Department (under B C Binning) was developing on the campus of the University of British Columbia with a campus gallery; the number of commercial galleries multiplied, including a few concerned with good contemporary art, living a precarious existence but providing the serious artist with a show-case if not with a market; the Canada Council began its effective programme of help to individual artists and to institutions.

New artists arrived on the scene: Toni Onley in 1959 whose quiet personal canvases, collages and prints in muted greys, blues and greens, are of a consistently high quality. Though differing in origin they have given continuity and amplification to the lyrical nature abstraction tradition. Roy Kiyooka, painter, poet, arrived in the same year from Regina, at that time the location of a small vital group of painters whose talents and aspirations had been fired by contact with visiting Americans Will Barnet, John Ferren, Barnett Newman and others. A teacher by necessity, a 'guru' by nature, his presence in Vancouver for the next five years was a powerful stimulus. His role was to represent, in his art but even more in his person, an intellectualism, a sensibility and an ambition that related uncompromisingly to current international awareness rather than to local conditions. His paintings of the early sixties, large scale and big-impact works using simplified areas of flat colour, related to current New York art and brought bigger issues into local focus. Since 1963 Jack Wise has been an unobtrusive focal figure for younger artists who like him are attracted to eastern mysticism. His contemplative manuscript scale paintings and drawings with their intricate flame-like calligraphy and recurrent mandalas are reminiscent of Tibetan and other asiatic religious painting. He is now only one of several American artists or art students who find the Canadian political and spiritual climate more sympathetic, as well as the openness and more relaxed pace of west coast living conducive to the practice of their art.

The burst of activity of the past three or four years has been recognized and well reported in a number of recent articles in international magazines—so much so that there would be no reason for these comments here were it not that their omission would leave a conspicuous gap in an issue intended to provide an up-to-date cross-section of the country's art in one package. These articles centre around six to eight artists, most of them under thirty, all of whom have for several years had critical recognition, at least on a national level, invitations to and often awards in prestigious exhibitions in this country and abroad, received sufficient monetary support through sales and/or foundations to assume the unequivocal stance of artist (though some of them supplement their incomes with part-time jobs as necessary). They have no shared aesthetic or point of view, having in common only their seriousness and their determination to develop as individuals. Most of them have had some kind of art school encounter though none of them are straight art school products in the old sense. Through their own travel, through the current art-literature, or increasingly through the better shows and international figures who are coming to Vancouver, they know where 'art is at'. Naturally their work is within the framework of the international styles current everywhere; on the whole they have been informed more—or more directly—by Los Angeles and London than New York.

Iain Baxter, a catalytic presence in Vancouver since 1964 is the strongest and most consistent proponent of *art as idea.* The relatively unchartered and unclaimed wilderness of this area—geographically and artistically, has obviously been of tremendous stimulus to his evolution and he in turn has been a potent force in the community for his boldness and dazzling inventiveness. There is more about him elsewhere in this issue.

Michael Morris is an urbane and travelled artist of sophisticated intelligence, with a capacity for tune-in to the core of action and issues. At the age of twenty-six he has produced a body of work impressive in its prodigality and its high level of accomplishment, managing persistently to declare an identity while witnessing the successive and sometimes simultaneous influences of English and California sensibilities. His use of the tonally-dissected stripe, which in execution always retains a certain nervous hand-executed quality; the creation of ambiguous space and volume through the employment of isometric projection; an abstract imagery which often seems to be representing metaphysical structures; a tension that is as much psychological as perceptual—these have been frequent features of his painting. He has ventured into film and various inter-media, he has been very active in graphics, and there are signs that a period of intensely productive outward orientation is giving way to one of inner-turning.

Claude Breeze is an important maverick in the Canadian scene, remaining steadfastly a painter in the traditional sense and moreover a painter of 'hot' imagery. His passionate concern is the human condition and his attitude involved. He paints violence—of sex, drugs, love, hate, war, politics, racism. The images are drawn from television, the press, or his own imagination and painted in high-keyed colour; his brushwork and his imagery have long since absorbed their lesson from Bacon and his time-space structure its information from Persian and Indian miniatures. The summer of 1968 spent on an island produced a series of works dealing with abstract sexual imagery and marked by a new detachment and quiescence.

Bodo Pfeifer and Reg Holmes are curiously among the few concerned with purely abstract problems. The work of German-born Pfeifer is marked by an ambitious professionalism of a high order. His particular concerns with colour and depicted geometric shape have found progressively simpler statements in the past few years. In the canvases of his last show (March 1969) the rectangle was divided by a single diagonal band into three zones of acid day-glo colour activated by careful manipulation of quantity and quality of hue into unique states of precarious tension. Reg Holmes (presently in New York) deals with illusion, contradiction and flatness in cut-out canvases which stimulate folded ribbons of brilliant colour.

Brian Fisher, an artist who pursues an idea through a long and steady evolution, works with fine painted lines of mechanical precision to create centralic configurations of an imagistic nature; they have the quality of being both referential and abstract, like beautiful diagrams for secret celestial devices. Gary Lee-Nova's work in various media includes the production of several notable films, and sculpture. The symbols and devices of his hexagonal and triangular canvases, and his graphics, frequently evoke the astronomical observations and mathematical concepts of the universe of Tantric metaphysics. His clouds, stars, rainbows, mountains, relate at least as much to eastern mysticism as to specifically coastal experience. The west coast ambience may of course be considered to include a strain of oriental consciousness; it will be remembered that this was also the territory of Mark Tobey and Morris Graves.

Gathie Falk and Glenn Lewis, both from a background of traditional ceramics, have moved into the general area of *funk* sensibility developed by California artists of the Bay region several years ago. Lewis' collapsed white porcelain pieces, strongly sexual in overtone, set in elegant plastic and/or mirrored boxes combine parody and visual pun in works of considerable elegance. Falk's pieces, with their ceramic earthiness, flock-surfaced props and occasionally bilious colours, have a strong haptic and visceral quality. Both are also, like many others of their generation, working in media and forms which cut across and question conventional categories and notions of art. Audrey Doray, whose works combine light, sound and motion, must also be mentioned in any list which speaks for the vigorous activity and achievement among the younger generation.

Several of the above, in shifting direction, are aligning themselves in sensibility and interests with a still more recent emergence of young artists who promise to give creative continuity to the scene. Dallas Selman, Glenn Toppings, Dennis Vance, D'Arcy Henderson, Allan McWilliams, John Masciuch are a few of the presences looming conspicuously on the horizon. Involved with social, political and ultimately philosophical issues, they are in general not primarily object-oriented (though as artists they may still produce objects); their talk is of life rather than of art *as art*. They are developing on their own; or in the context of the universities which seem to offer the free-wheeling intellectual (rather than craftsmanly) atmosphere their ideas currently demand. Or within the ambience of *Intermedia*, a unique open-ended organization of two-years' standing devoted to bridging the gap between the arts and technology, which provides a building and equipment where artists and technologists may meet for experimentation and the development of ideas.

For such younger artists today the local environment and the possibilities are entirely different from what they were ten years ago. The very existence of *Intermedia* is one aspect of the change. The Art Gallery of Vancouver is able to organize contemporary exhibitions of international calibre and maintain a steady programme of relevant events. The Fine Arts Gallery at the University of British Columbia under the prescient operation of curator Alvin Balkind presents shows that reflect the developing edge of sensibility. The Douglas Gallery with connections in

Los Angeles and New York, now shows major American artists in the city. Word having got round of some action in Vancouver, there is a succession of visiting critics, authorities, and artists from America and abroad. The result is a *first-hand* awareness and a sense of participation in the larger scene and on a more sophisticated level than heretofore possible. In all this the role of the Canada Council has been crucial—in its imaginative and venturesome support of individuals and institutions, its encouragement of the circulation of people, ideas and work in the field of the arts. The important question which remains is whether the local community can catch up soon enough in *its* role of support; chiefly what is needed is the development of collectors on an important scale (virtually nonexistent at present) and the directing of a share of the available philanthropy (in what is by no means a poor if young city) toward contemporary art. Without this the maintenance of the present new level of action cannot be taken for granted.

Vancouver 1969

John Chambers *Toward 401* 1969, oil on mahogany, 6 × 8 ft
Coll: The Isaacs Gallery, Toronto

Greg Curnoe *Spring on the Ridgeway* 1964, oil on wood, small panel plus curtains,
overall size $73\frac{5}{8}$ × $73\frac{5}{8}$ panel, left side $36\frac{1}{4}$ × $27\frac{13}{16}$ in.
Coll: Art Gallery of Ontario

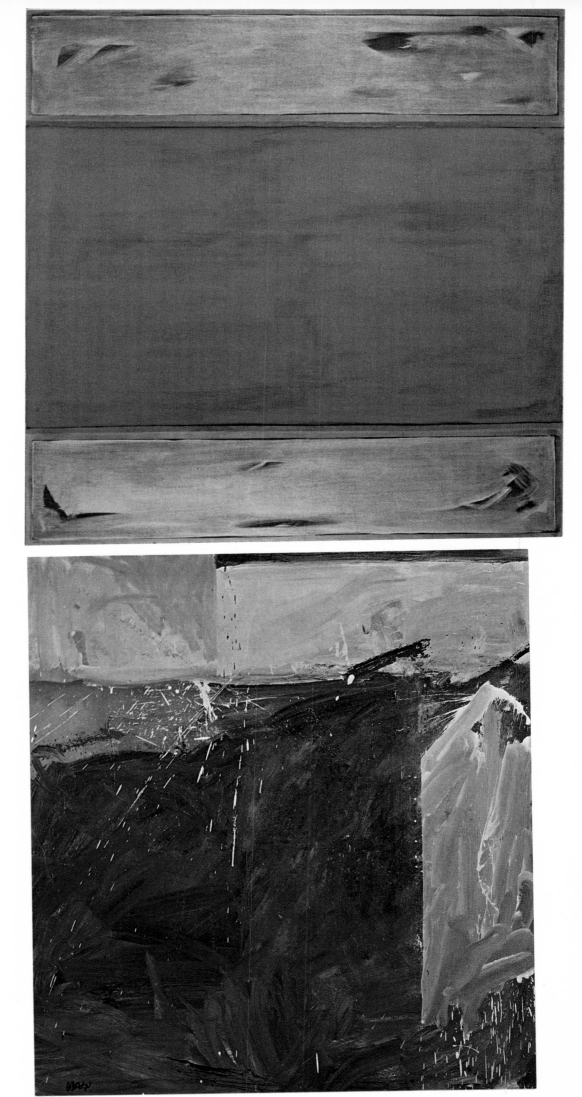

Jean McEwen *Il est encore temps*
De dire
Face a tous
(Beaulieu)
1965, 70 × 72 in.
Photo: Gallery Moos

Charles Gagnon *Homage to*
John Cage 1963, oil on canvas,
58 × 52 in.
Coll: The Canada Council

1
Claude Breeze, *Control centre 4:
The Art collector* acrylic and mixed,
48 × 48 in
Coll: The Vancouver Art Gallery,
photo: Williams Bros Photographers
Ltd, Vancouver

2
Claude Breeze *Island No 9* 1968,
acrylic on canvas, 48 × 72 × 3½ in
Coll: The Vancouver Art Gallery

3
Roy Kiyooka *Barometer* 1964, acrylic
on canvas, 72 × 48 in
Coll: Laing Galleries, Toronto

1

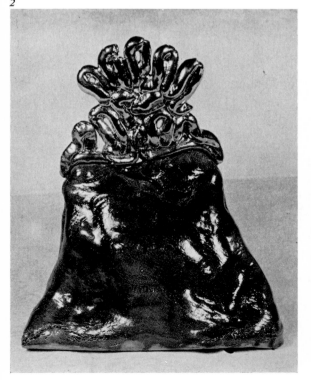

2

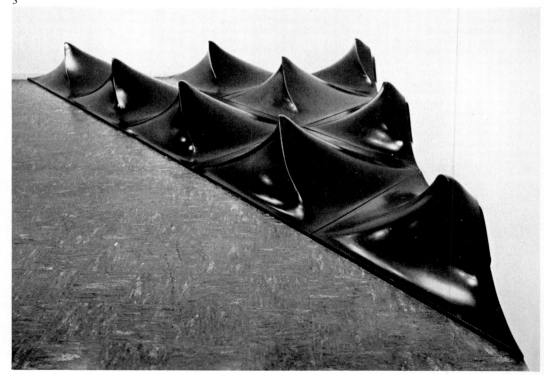

3

1
Glenn Lewis *Open and closed* porcelain, height 10 in
Coll: Mr Kurt Von Meir; photo: The Douglas Gallery, Vancouver

2
Gathie Falk *Red purse* 1968, ceramic, glaze and overglaze lustre
Coll: The Douglas Gallery, Vancouver

3
Glenn Toppings and Dallas Selman *Wave*, fibreglass
Coll: The Vancouver Art Gallery

4
Audrey Capel Doray *Fluorescent seascape* Print 3 in suite of 4, 18 × 18 in
Photo: Peter Thomas, Bau-Xi Gallery, Vancouver

5
Gary Lee-Nova *Menthol filter kings* acrylic on canvas, 60¼ × 48¼ in
Coll: The Vancouver Art Gallery, photo: Williams Bros Photographers Ltd,
Vancouver

6
Gary Lee-Nova *Drawing for sculpture* March 1969

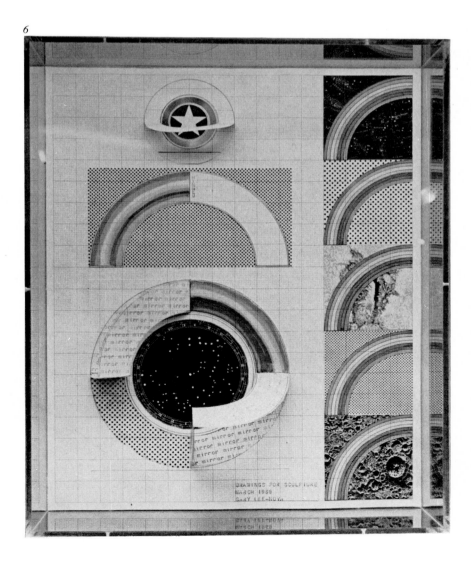

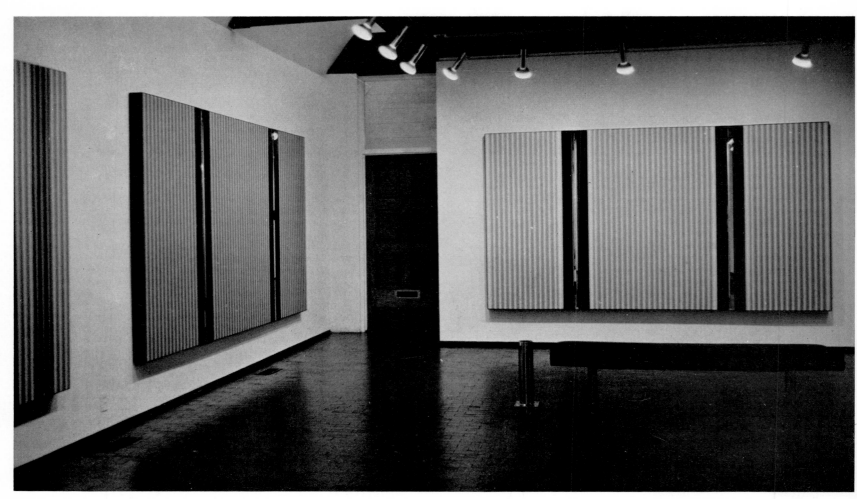

Michael Morris *Installation Shot* The Douglas Gallery 1968
Photo: The Douglas Gallery, Vancouver

Takao Tanabe *Early Autumn* 1968 acrylic on canvas, 60 × 58 in
Coll: Galerie Godard Lefort, photo: Tommy Thompson & Company Ltd,
Montreal

Bodo Pfeifer *Untitled* 1968, acrylic on canvas, 106 × 90 in
Photo: Williams Bros Photographers Ltd, Vancouver

Notes on Three Painters

David Thompson

Roy Kiyooka

In spite of an intensiveness of art-school activity which is considerably more marked in Canada than it is in the United States, even the most influential of Canadian painter-teachers do not group disciples round them. There are not *maîtres* as there are not *écoles*, largely because—with everything in Canadian art happening so much at once—there is not the settled sequence and distinction between generations that allows of that kind of continuity. Instead there is a sharp gap between those whose crucial development 'belongs' to the period since the later 1950s and those who somehow find themselves in the limbo of pre-history before that great awakening. Kiyooka, born in 1926 and a native of Saskatchewan, was a leading member of the Regina Group, and one of those who were not only radically influenced in their own painting by the summer sessions of the Emma Lake workshop, but who were instrumental in turning that experience from one of regional into one of national significance. As a teacher alone, his example has been widely influential (though most concentrated in Vancouver, where he took a teaching post from Regina) in bringing, not a style or a doctrine, but a sense of direction and potential to a newly alert generation of younger painters. His own development, during and since Emma Lake, is in line with his teaching. It shows, that is to say, the direct experience of American 'big attack' painting enlarging a Canadian sensibility without making it any the more American. Running through all Kiyooka's work, and an indication of his Japanese inheritance, is an instinctive response to rhythms and forms that link the painter's own activity with what used to be called 'the world of nature'. His geometry, even at its most formal, is of a kind that has repeatedly been characterized as 'fluid' or 'organic'; a geometry not of the flat circle but of the glowing ellipse. At its most austere, it is marked by serenity, poise and a kind of civilized grace. Like Godwin and McKay of the Regina group, Kiyooka studied at Calgary, and along with most of his contemporaries was involved in the gestural painting of the 1950s, in which organic imagery and densely worked surfaces were primarily an expression of the creative process evolving out of a flowing and muscular brushstroke. At Emma Lake, a more objective structure took control. By 1963 the gestural image was becoming enclosed within a hard-edge geometry, and by 1964 it had given way to large areas of minimal form and within discreetly ordered boundaries. He had now moved to Vancouver, and while there visited Japan on a Canada Council grant, and in some exceptionally beautiful canvases of 1965 the geometry relaxed again, the linear borders becoming tidal edges to the calm central expanse of colour. Since his move to Montreal in that year, Kiyooka's idiom has grown more personal and even more coolly lyrical with the adoption of the oval as a presiding motif and a change to subdued relationships of tone within an over-all colour. It is tempting to try and detect in the career of a painter who has worked in the geographical and cultural extremes of Canada—the isolation of the central provinces, the explosion of a new West Coast awareness, the metropolitan centres of influence in the East—some synthesis of Canadian attitudes. But the speculation would be misplaced. Kiyooka may have been shaped by, as he has himself to some extent helped to shape, a particular Canadian situation. But he is conspicuously not, because of that, a 'Canadian' artist in any narrow sense. The breadth of his experience is possibly reflected in the mature certainty of his work, but the result is not bounded by national frontiers.

Kenneth Lochhead

Canada's landscape-tradition is now past history, something overtaken by events and consciously rejected. But it would be naïve, or else a gross over-simplification of the complex problem of how artists relate their art to the experience of their environment, to argue that, because Canadian art has recently and dramatically hauled itself out of provincial and isolationist attitudes, the physical nature of the country is no longer a relevant consideration. I suggested that urban culture in Canada is possibly not yet deeply ingrained enough in the Canadian consciousness to be wholly assimilated even in those areas of Canadian art that most seem to be the product of it. Canada is not, to reiterate the obvious, the United States. And as I imply below in relation to Greg Curnoe, regionalism is one of the facts of Canadian art, a significant if not a dominant one, which characterize its difference from American art.

Lochhead, like Kiyooka, is one of the leading figures of the generation now in its forties. Central Canada is the background of both, and they shared the experience of the Emma Lake workshop and the years of the Regina Group. Kiyooka has moved away, but Lochhead has remained in the central provinces: he is now at Winnipeg. And it is impossible wholly to dissociate his art or its development from the physical facts of an environment which is almost

obsessive in its singularity. The prairie is of a flatness and endlessness that make even its cities look like aribtrary interruptions of the dominant horizontal, and the dryness of the air adds exceptional clarity to what are already visually exceptional conditions. When Lochhead met painters like Newman and Noland at Emma Lake, it was therefore something more than aesthetic persuasion which converted him to 'big attack' colour-painting, and if his work today looks in some respects closer to the Americans in its command of scale and the totality of the colour-field than is usual in Canadian painting, one might say paradoxically that it was for Canadian reasons.

Vast open spaces had in fact been a theme of his figurative, surrealistically inclined painting of the 1950s. At twenty-four he had been appointed head of the University Art School at the University of Saskatchewan, and in 1952 was joined there by Arthur McKay, and in 1958 by Ronald Bloore, closely followed by Kiyooka. From this initial grouping of forces at Regina, the decision was taken to invite certain American painters annually to Emma Lake in an attempt to break down a frustratingly isolated position. Clement Greenberg's encouragement was particularly influential in Lochhead's own subsequent development, and Lochhead has remained something of a 'Greenberg' painter. As distinct from the colour-contrast painting more widely prevalent in Canada, Lochhead's concern is for the experience of colour as an uninterrupted field, modified or defined in scale by contrasting areas which are usually relatively small, enclosed and confined to corners or edges of the main expanse. Recently he has exploited the spatial drama of this expanse in environmental settings. A mural for York University outside Toronto meets the challenge of the two converging architectural perspectives, but in a set of vertical banners for Winnipeg's new cultural centre, single colours are made to rise spectacularly past an intervening mezzanine floor, so that the terminal incident and full effect of contrast remain unrevealed until the spectator is at close range and can look upwards. Colour becomes not only an experience of the field itself, but an experience of one's distance from it.

Greg Curnoe

Painting is only one expression of Curnoe's absorbed and inquisitive exploration of his environment. He is active in a dozen other fields at once, including nihilist politics, pop music and writing, and is less inclined to admit that any of his activity is to do with art than to claim it as awareness

of a total social commitment. Much of his painting is a highly-flavoured pop art nearer the English variety than the American, although it is liable to erupt into outspoken social or political comment which is largely foreign to either (a large project for a mural at Montreal Airport has run into trouble with the authorities for alleged anti-Americanism). But his best work has a narrower, or at least more localized, commitment. Curnoe's recent and rapid rise to prominence on the Canadian scene has been as the passionate exponent of a particular kind of regionalism—a regionalism which is not sequestered from any of the concerns of the outside world, but which, in accepting part as representative of the whole, is content to work in and from a particular locality; in this case, Curnoe's home town of London, Ontario. He regards it partly with the ironical affection which reminds one of some of the English parallels. He fills his studio with what is in effect the nostalgic bric-à-brac of small town commerce, and uses it for collage objects. But he regards it also like a kind of diarist, objectively recording both visual notations and his own stream of consciousness in a series of what he calls 'lettered landscapes', mostly executed with marking ink and rubber stamps of a forty-year-old local type-face, and based on what he sees from the studio window. One series, *Twenty-four hourly notes*, was painted one an hour for twenty-four consecutive hours. Another consisted of painted constructions made one a day for twenty-eight days. They are intended to be read, not regarded as formal constructions like the lettering of Jasper Johns, but the ambiguity of their stance between a beautifully articulated kind of field-painting and straight *reportage* remains. The description itself has a Robbe-Grillet-like factualness, visual rather than literary, and the double process of reading and seeing, like certain types of concrete poetry, builds up as an integrated experience of imaginatively rich complexity.

December 1968

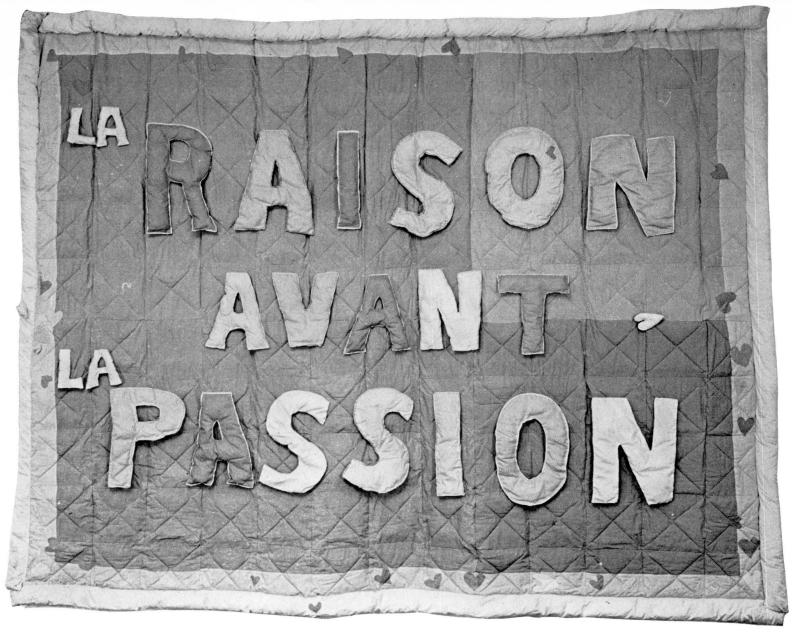

Joyce Wieland *La Raison avant la Passion* 1968, hand dyed cotton hanging, 96 × 108 in. Coll: The Isaacs Gallery, Toronto; photo: Ayriss, Toronto
Michael Snow *Five girl panels* 1964, oil on canvas, 76 × 127 in (five elements). Coll: The Canada Council; photo: Williams Bros Photographers Ltd, Ottawa

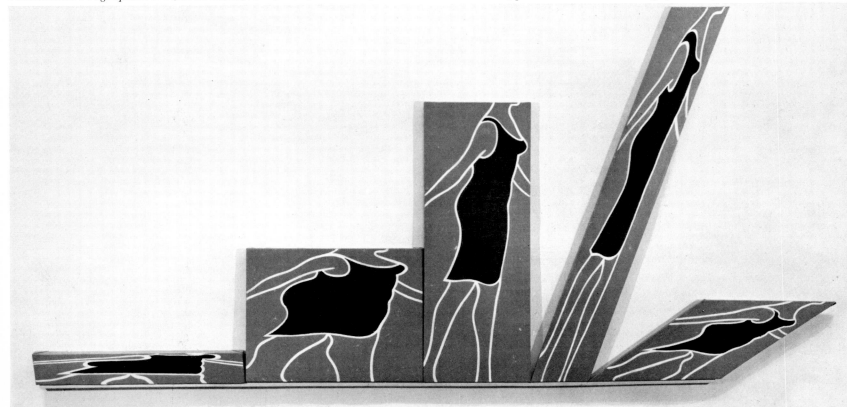

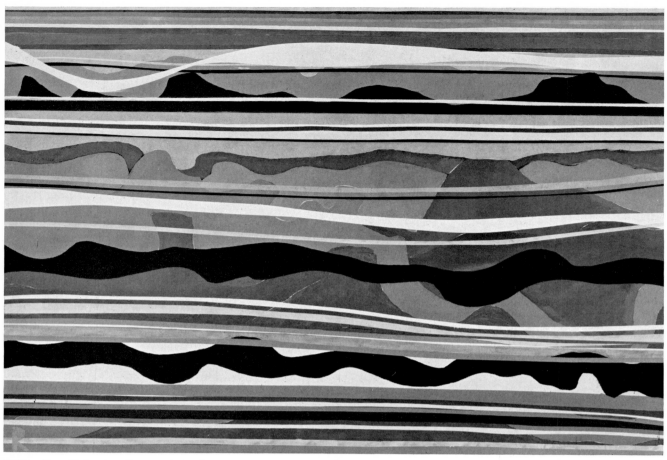

1
Robert Markle *Northern Ontario Sun* 1967, charcoal and tempera
Coll: The Isaacs Gallery, Toronto; photo: Ayriss, Toronto

2
Dennis Burton *Mother, Earth, Love* oil and acrylic copolymer on canvas, 60 × 80 in
Coll: Art Gallery of Ontario

3
Richard Gorman *Kiss goodbye* 1963, oil on canvas, 84 × 68 in
Coll: Art Gallery of Ontario

William Ronald *Gundiga-Uppans*, 1968, oil on masonite, 72½ × 108 in. Coll: the artist

Reg Holmes *Two fold space* 1967, acrylic polymer on canvas, 56⅞ × 137¼ in. Coll: Art Gallery of Ontario

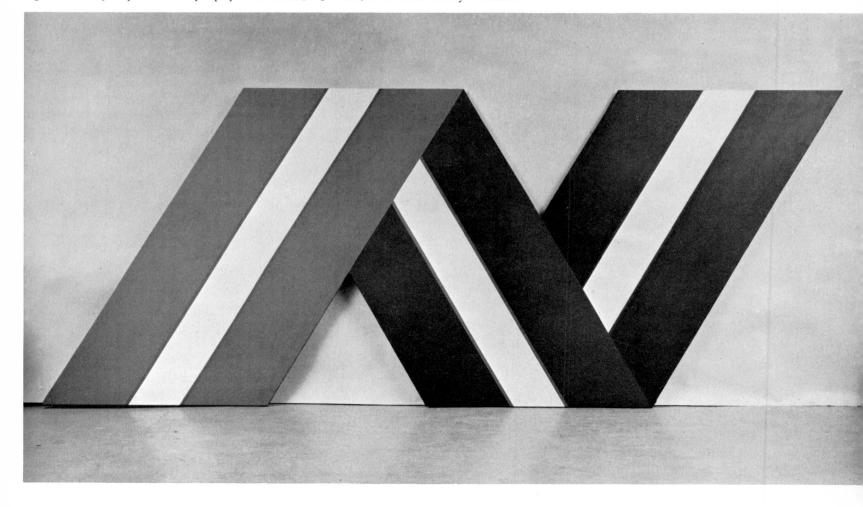

1
Toni Onley *Polar 41* 1962, oil and
canvas collage, 66 × 72 in
Photo: John Evans Photography Ltd,
Ottawa

2
Denis Juneau *Ronds blancs arrongés*
1969, acrylic on canvas, 44 × 44 in
Coll: Galerie de Montréal

3
André Théroux *L'escargoutte* (*série
obliquité à gogo*) 1968, acrylic on
canvas, 48 × 48 in
Coll: Galerie de Montréal

1

2

3

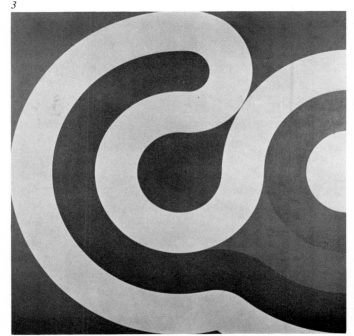

N. E. THING CO. AND LES LEVINE

Charlotte Townsend

Iain Baxter and Les Levine are Canadian North Americans who live and work on opposite sides of the continent. Baxter is President of the N.E. Thing Company in Vancouver and Levine is a communal group of poets, artists, engineers, film-makers, etc., in New York City.

The McLuhanite son of the Group of Seven, Baxter uses new media to catalogue 'visual sensitivity information'. Main sources of information are nature, 'a natural to work with', and the forms, domestic and public, of a man-made environment. To get rid of the artist-art-art gallery syndrome Baxter formed a Company, the objects for which it was set up being:
(1) To produce sensitivity information.
(2) To provide consultation and evaluation service with respect to things.
(3) To produce, manufacture, import, export, buy, sell, and otherwise deal in things of all kinds.

The N.E. Thing Co. is divided into departments which cover anything and everything the President may want to do. Each is equipped with a rubber stamp to mark its products.

Visual sensitivity information received by the Company is processed by the Research Department before being passed on to one of the others for the sort of literal cataloguing which is the Company's trade mark.

Thing Department

The Company claims the largest collection of plastic antiques in North America. In 1965 the President began to vacuum-form plastic bottles, the common pottery of today, some of them crushed. Their simple shapes

Iain Baxter 'Still life—bag of potatoes' 1965, vacuum-formed clear uvex plastic

corresponded to the Morandi-like still lifes he had been doing before. Since then this department has been responsible for treating the landscape in a number of ways. It has bagged it (putting the green, rocky, Pacific coast, blue water and toy boats into bags of clear vinyl), taped it (running the outline of mountain, cloud and lake in plastic tape over wall and floor), and inflated it (blowing up sensuous, vinyl pillows of hill and sky). And now the Company has moved into the landscape, defining the space between two trees with a length of yellow rope, trailing chains over bushes and rubber over rocks to upset expectations. Inflated vinyl was also used for formal pieces. Wearables were developed in 1968 as extensions of the body. (In one example a giant inflated doughnut, 12 ft. in diameter, sits on the shoulders, satin-like folds of green vinyl fall from it to the floor.)

Project Department

'There is a plastic coating around the electronic

Iain Baxter 'Bagged place' installed in the University of British Columbia during February 1966

Iain Baxter 'Bagged landscape with 4 boats' 1966, vinyl, water, toy plastic boats

revolution,' says the President. What is claimed as the first 'environment' in Canada, and, according to Tom Wolfe, the first public celebration of McLuhanism, was 'Bagged Place'. Bagging, as opposed to wrapping, is a North American habit that puts things into their own space. In 1966 the Company put everything commonly found in a four-room suite into plastic bags. Polythene, a sensuous but cool medium, came between people and their environment. Since that year projections have ranged from a white vinyl cap cover for a Rocky Mountain, to be put on when the snow melts, to 'Flow Move', a very slow kinetic piece, steel poles being embedded 50 ft. apart in the Athabasca Glacier, to be revealed in series as the Glacier retreats. Latest completed projects have been the construction of two timber frame walls and a floor on a hillside, and the burial of a deflated thing, to be dug up, inflated and reburied on the moon in a hundred years time.

cop. A Noland chevron had its stripes extended 15 ft. in each direction, a 'carrying case' was made for a Warhol pillow, and a Larry Bell glass box was reconstructed in collapsing clear vinyl. The Cops have been some of the Company's most formally significant products, playing with perception as much as idea.

Iain Baxter, President of N.E. Thing Co. with 'Carrying case for Andy Warhol pillow 1966' air vinyl, cloth, 30 x 48 x 24 in. N.E. Thing Co.

Printing Department

Deals with the third print of a movie, prints in the snow and the imprint left when an object has been lying on a lawn. The department produced Piles, a portfolio of photographs of natural piles, of logs, coils of wire, doughnuts, fifty-nine of them in all. It will also represent the Company at São Paulo with the products of ACT and ART, the two most recently formed departments.

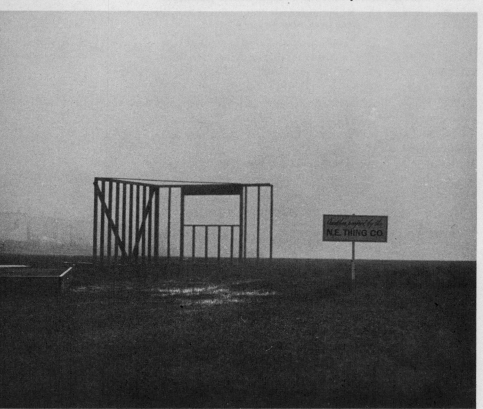

N.E. Thing Co. 'Frame construction—2 walls and a floor' 1968, all 12 x 12 using 2 x 4 lumber

Cop Department

Concerns itself with the work of other artists, which it may choose to extend, invert, disassemble or otherwise

Studies for products of Cop Dept. 1966

78

N.E. Thing Co. 'Chain-taut' 1966–8, Mount Seymour, British Columbia, 25 ft chain ¾ in. gauge, two heavy-gauge turnbuckles, two heavy-gauge eye screws

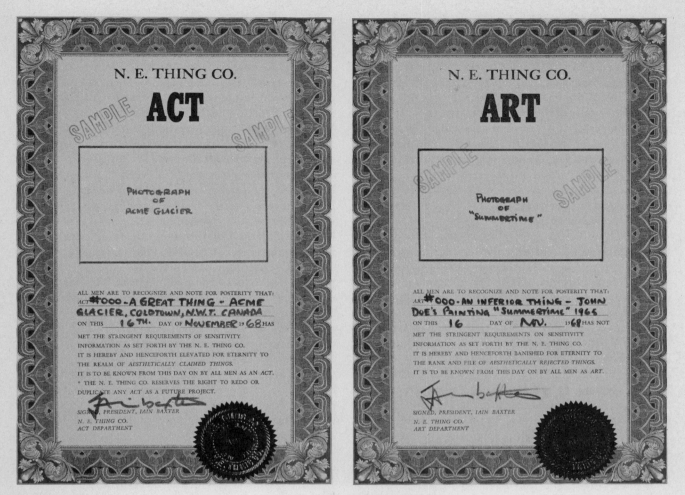

ACT Certificate

ART Certificate

ACT and ART Departments

Designed to make public the way in which the Company assesses the information which is the raw material for all its operations. The President takes photographs, of a supermarket sign, a Donald Judd box, a grain elevator, enlarges it and exhibits it stamped with his Seal of Approval as 'Having met the stringent requirements of Sensitivity Information'. So states the certificate which is sent with the photograph to the owner or maker of every Aesthetically Claimed Thing.

Anything which is not felt to be deserving of a place in eternity is known as an Aesthetically Rejected Thing or ART.

Movie Department

Planned is a 5,000-mile movie to be shot by ten Super-8 cameras from a truck travelling at 60 m.p.h. from one end of the Trans-Canada Highway to the other. Completed are several four-mile sections. For four minutes one is hypnotized by the patterns of rushing wires and trees. To be projected postcard size is a four-minute still life of the tattered border of the maple leaf flag fluttering over a gas station.

N. E. Thing Co., Inflated hillscape-vinyl 1968

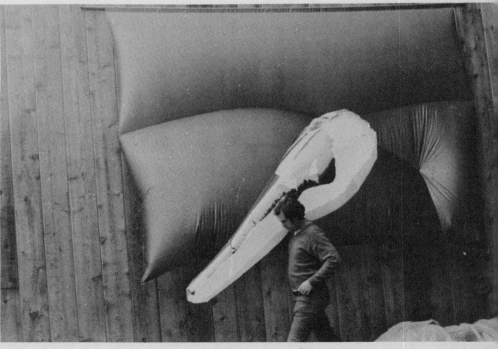

While Baxter stays in Vancouver, formalizing nature and running his commentary on a society which puts everything into bags, Levine has been in New York since 1964 when he moved from Toronto where it was 'too easy to be a sensation, and not much else'. This makes him one of a number of Canadians who are prepared to accept the rigours of the New York scene in order to have its advantages. Physically it seems the right environment for Levine. No less an ideas man than Baxter, he depends even more on technology. Levine is not sending up the commercialized mechanical world, he reproduces it. The situations he creates have all the cool come-on of a car showroom; his work is as sensuously saleable as a car or refrigerator.

In 1963 he began embalming pieces of furniture in taut plastic shrouds. Their superhuman precision finish has been present in all subsequent work which, like our way of living, alternately bores and attracts us with its repetitious image-making, its impermanence and lack of uniqueness.

'Slipcover', created in 1966, epitomized this in transforming a gallery space with mylar and butyrate over walls, floor and ceiling and filling it with heaving cushions of the same stuff. All day slides of the Old Masters that normally hung in the gallery were flashed around, while the sound track, made as people came in, was played back at them a few minutes later. It was impossible to avoid physical contact with and in Slipcover, but it was no lotus-eaters' paradise.

The indulgence of forgetfulness is equally impossible in front of 'Iris'. This is a giant cybernetic eye which sees, sorts out what it has seen, and then projects the images it has digested. The 'seeing' is done by three television cameras located in the centre of Iris's 7½ft high 5ft wide facade. The sorting and 'thinking' are done by her temperature-controlled memory. The results of this process are shown on six television monitors which are encased within Iris's reflective bronze plastic exterior, and covered with vacuum-formed bubbles of red, orange, blue and violet acrylic.

Living with Iris, and she was designed for a living-room, constantly confronted with one's image and reaction to that image, will be a concentration of the relationship between human beings and the mass media. And 'Iris' is not for contemplation. Levine says, 'Contemplation is the extreme negative to an environmental situation as it is intellectually subtractive, disallowing all senses to function at the same level.' He has also said, 'Looking at paintings may be like going to sleep,' the assumption being that environmental art can overcome the change between art time and life time.

Levine made a series of 'T.V. verité' movies in which he trained the camera on people talking and, Warhol-like, let it run. Then he created 'Iris'. When image occurs in his work correspondence between it and viewer must be immediate and one to one, otherwise image equals information. 'Electric Shock', 1968 is perhaps the most 'abstract' environmental piece to date. A series of parallel wires span a room above head level carrying an electrostatic charge. This charge or vibration may be sent from one person to the next by a slight touch of the bodies. It is an important work. You get the shock and that's it; no sophistries about image-making.

The shock is the message of contemporary society, for ever wearing itself out and renewing itself. Auto-destruction is the ultimate elegance of the industrial process. No taste, no excess, property becomes service in the destructible object, in the disposable, transient environment.

The objects for which Levine is best known, his poly-expandable styrene units, and moulded plastic forms 12 × 12 in., were some of the earliest disposable art. They were made in multiples, to be sold cheaply, and should, theoretically, be disappearing fast. Probably they share the fate of the 250 pieces of cake that Oldenberg gave away, only to find that in a few weeks they were being traded as precious objects all over again.

For all that, instant, persistent and disposable Levine's art goes some way towards reconciling humans with a society which has nothing to do with the old humanist values.

Les Levine

1
'Iris', the façade, 7½ ft high × 5 ft wide

2
First day of 'The Process of Elimination'

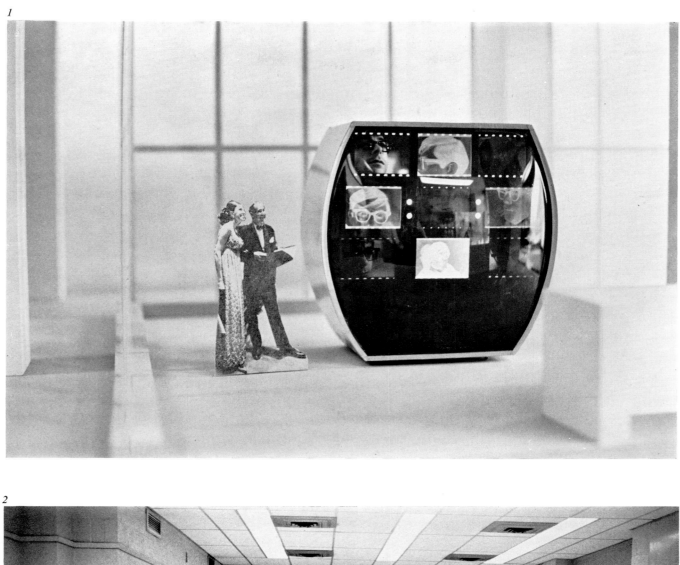

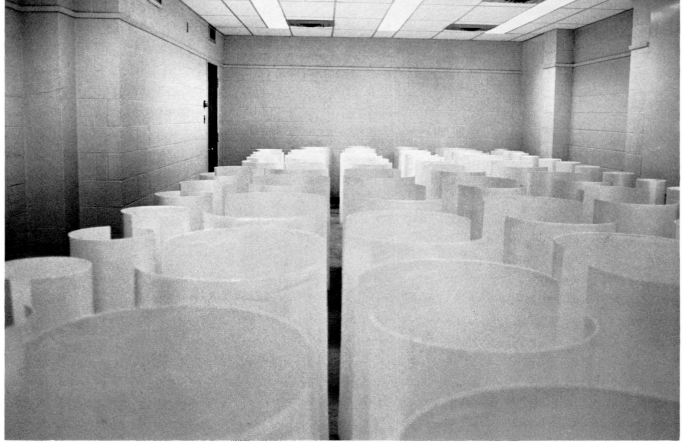

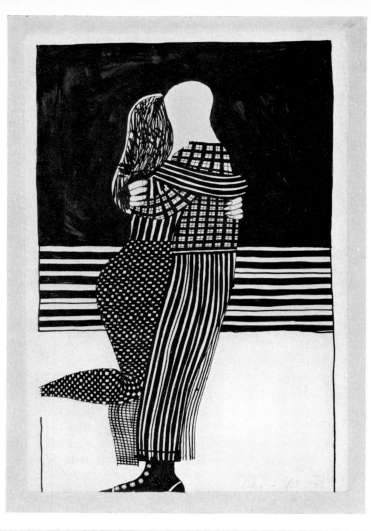

Aug.5.2:11 P.M.1969.The band was good last night.I just knocked a lot of papers on the floor,the type writer carriage hit them.Exley was really funny and Archie sounded good too.Art and John weren't here,Art was at Port and John was back in St.Kitts.So me recent,unfortunate events have underlined the n eed for more people to become concretely involved with the various co-ops that have helped make Lond on a lively and open city.The Spasm Band has enoug h people in it to not have problems of that kind(i t has other problems).Bob McKenzie took over the r unning of 20¢ Magazine.If he hadn't it would have folded.How are people brought into things like 220/ 20 Gallery(a co-operative,artist oriented gallery) or C.A.R.(Canadian Artists' Representation - a loo se grouping of Canadian artists,for collective act ion on issues related to the welfare of artists), and how is the need to keep the co-ops running pas sed on to other people(to the extent of their taki ng over the day to day running of them.C.A.R.,The London Film-makers Co-op,20/20,20¢,and Alpha Centr e(space devoted to poetry readings,puppets,the Lis teners Workshop etc.,organized by Jamie Reaney)all need interested people in order to continue to exi st.This has always been a problem in this city,and leads to the similar problem of the same people wo rking for the various co-ops,creating isolation fr om the community as a whole.Groups of individuals who get together to trade ideas don't have this pr oblem.An interdisiplinary group has been started a t Western(The University of Western Ontario).It co ntainssmembers of the faculties of;computer scienc es,psychology,geography,etc. and in addition artis ts and a disk jockey from the area are involved.(Tom Lodge,who used to be with Caroline South)An el ectrical engineer in town(John Watson)has been hel pful in adapting hearing aid earpieces as micropho nes for the Spasm Band kazoos,he has also helped another artist by making a film of his work.In a c ity this size,with many skilled people and with go od communications,people live fairly close togethe r,know each other,can tell you who to phone for wh

at.People help each other out.Many are aware of th e dangers of an "Art scene" with its surrounding group of intimates.Our band plays to a reasonable cross-section of people,every monday night,at the York(a small hotel).The new Film Co-op catalogue w ill stress the educational aspect of private films because Jack and Frazer Boa are aware of the need to get the films to the wide,school,audience.Aug.5 /69.,20 after 11.A.M.It is hoped that the 20/20 Ga llery can move to a Dundas St. store location,wher e it will be more accessable than it is now.When J amie gets back to town,Alpha Centre will be starte d up again in a smaller,more convenient location.H aving all these things going is basic to the chara cter of what is happening here - there is some kin d of communication with all levels of the communit y - mainly because the people who are involved liv e in neighbourhoods.There is communication with th e various trades and professions,for instance;in t he last year,artists have started working with the computers at Western,and the London Labour Council and the London Public Library have collaborated wi th a group of London artists in the designing and building of a multi-media pad(outside)(to be open to public use)dedicated to the Tolpuddle Martyrs - who settled around London.Also the mass media in t he city are accessable(C.H.L.O.-C.F.P.L.-The Londo n Free Press)Aug.6.wed.10:00 A.M.The problems of p rovincial and federal support.Alpha Centre and 20/ 20 Gallery have recieved direct aid from govt.The London Film-makers Co-op has not recieved aid from the C.F.D.C.(Canadian Film Development Corp.)and is probably healthier because of that,at this po int.Can a non-profit gallery like the 20/20(which originally came into existence because no commerci al gallery could survive in a city the size of Lon don)be expected to become financially secure,espec ially considering the nature of it's exhibitions policy(motorcycles,perpetual motion machines and inventions,quilts,young-difficult-artists)?In fact isn't(10:45 A.M.)the 20/20 an ideal solution for

a community cultural centre,to compliment a larger municipal museum and other institutions of that ty pe.5 to 11:00 A.M.- they all flew away when I walk edwout and sat down - wearing a light blue shirt t his morning.Dirt on the seat of the red chair wher e Owen was putting rocks last night(before throwin g them down the hill).Roger Tory Peterson and Bird s of North America on the purple chair.The sun is very hot.A bluebird?In the l.hand dead tree.It chi ps.Gone.Could have been an indigo bunting - probab ly - a large truck on Wellington Rd. - a cardinal, song is deafening - on the r. hand dead tree - one is to the left as well.He has a bushy tuft on top of his head.Can hear the goldfinches and an occasi onal cicada - a crow - a cricket - a flight of 3 s parrows goes past,about 20 feet above the ground, west to east - the cardinal has changed his song - its higher pitched and he holds his head up - a gr ound-hog runs across the field - a big bird with g rey underside.I knew about cardinals as birds long before I knew that a cardinal was also a religiou s figure etc.2 sparrows in the l.hand dead tree.Th e cardinal has moved to the row of trees behind th e tall house with the steep,brown roof.The other h as moved east.Stereo.All the sounds are mixed toge ther and you can focus on each one - occasionally one over rides the rest;a jet,a car on Weston St., a bird,Sheila,swallows overhead,chattering.Bees,a jet - a cicada - Sheila and Sam come down the lane .Sam lies in the shade in the front of my chair(Ea ton's Cardinal Red).Roll up the shirt sleeves.Do t hese writings only consist of recording and memory ?What Victor was saying.What about imagination?Wha t about saying weird things?A white pigeon flies t hrough the trees behind the houses and stores on t he e.side of Wellington Rd.A crow or grackle - I s till havn't phoned Peter to tell me the difference .3 sparrows in the left hand dead tree.Itchy leg a nd bum - biting finger nail(1st finger,right hand) .I'll work on the computer thisaft.To Western at 1 5 to 4.P.M. - Western Display by 5.00 - my 3rd ti me today.(This section following is material I put

into the computer at Western at 4:07 P.M.)Time to
computer from typewriter,16 min.8 sec.I had a lot
of stuff going on in my head but had to wait to ge
t a terminal when I got here(time sharing re compu
ters and the way Walt and Ed and their have pooled
their resourses at Eagle).I was going to bring She
ila but she didn't think she had time,also,when I
looked at the young kids using the other terminals
,I thought about bringing Owen up here next time.I
still have some of that crap about computers in me
,about how impressive they are etc.Mainly,not bei
ng at ease.I havn't said enough about 20¢ magazine
.It has recieved support from the Canada Council.
A lot of people missed it when Hugh,Robin,Art,and
Tony lost interest and stopped and it stopped comi
ng out,to the extent that McKenzie has had no trou
ble getting material and 20¢ is as healthy as ever
.I would really like to see what would happen if t
he people who exhibit at 20/20 or the people who h
ave films in the co-op or the people in the Spasm
Band or the people who write for 20¢ or the people
who will put on events at the multi-media pad or
C.A.R. etc.began to make their living from those a
ctivities.Would we then find that they would run m
ore smoothly or would things be more difficult.At
least there would be a lot of people concretely in
terested in the survival of the things mentioned.I
certainly that that will be the case someday,and a
lready some of us get a small income from film co-
op rentals and the band's European trip will certa
inly change our thinking about the financial possi
bilities of the band(except Exley).I'll stop in 5
minutes,at 4:00 P.M. - sorry,4:30 P.M.Could that b
e any relation to Rosemary Dawdy?Who is the girl i
n the photo taken by Don at No Haven?Nothing is co
ming into my head right now that I want to put out
.Levy*Strauss,Huserl(sp?).How about that comic boo
k from b.p.nichol(you can't put his name in small
letters on this keyboard)?(teletype)(Little Nemo
In Slumberland)Its like the new Country Joe album
cover or the Quicksilver Messenger Service one.Why
do people like them?It isn't camp anymore,its some

thing else.11:15 P.M.Young people support 20/20 an
d adults leave.Ont.Arts Council reduces its grant
and it looks like the Canada Council will as well.
The way the London office of the N.F.B. has always
helped local film makers.The possibility of a rent
free but not central location(for 20/20).The possi
bility of C.A.R. putting teeth in the enforcment o
f Canadian copyright law and Dominion-wide exhibit
ion rentals for artists(20/20 pays an artist 30$
per show plus expenses),the film co-ops attitude t
o a proposed national film co-operative(so far the
feeling is that the idea offers nothing concrete a
nd larger administrative problems).Observers will
be sent to a conference in the fall re nat.co-op.
The continuing existence of the Beal Tech.art dept
.,Fanshawe College art.dept. and the U.W.O. fine
arts programme.Aug.7.2:08 P.M.It is extremely humi
d these days.London is supposed to be one of the
most humid spots in Ontario.Several London artists
work with fabricators in the city.I was looking at
Bodmus' Leslie yesterday(one of the best Rock band
's in town)They all live together in a house in B
yron,across the road from Mrs.Abbott.I would like
to fill one more page.First names refer to:Bill Ex
ley,Archie Leitch,Art Pratten,John Boyle,Bob McKen
zie,Jamie Reaney,Jack Chambers,Matt Wherry,Sheila
Curnoe,Owen Curnoe,our cat,Victor Coleman,Peter de
nny,Walt Redinger,Hugh McIntyre,Robin Askew,Tony F
enikett,Ed Zelenak,Don Vincent,Joe McDonald,many p
eople are not mentioned who should be,maybe someon
e will come out with a directory.Wind chimes knock
ing against the 2nd from the north window on the
east wall,the de-humidifier rattles.

above
Greg Curnoe *Twenty-eight daily notes* 1966 painted one a day for 28 consecutive days, painted constructions, 11 × 11 in
Coll: The Isaacs Gallery; photo: Ron Vickers Ltd, Toronto
top left
Hugging Diana 1963, ink on paper, 13½ × 18½ in
Coll: The Canada Council; photo: John Evans Photography Ltd, Ottawa

From a Diary. London, Ontario *Greg Curnoe*

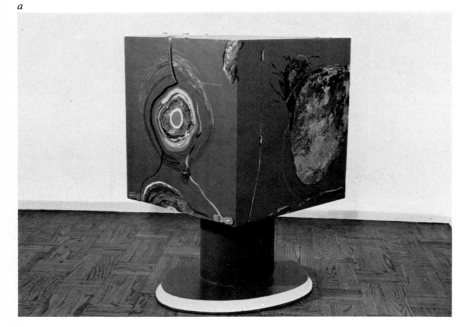

Tony Urquhart *Opening box-phoenix*
a closed
b open
Coll: The Isaacs Gallery,
photo: Ayriss, Toronto

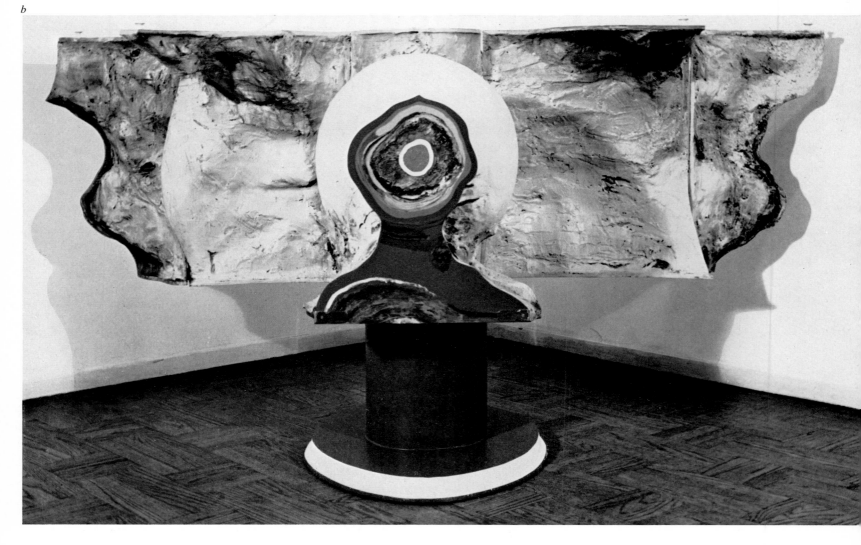

David Milne

Extracts from hitherto unpublished letters from David Milne, in the possession of the National Gallery of Canada

To Dr H O McCurry Palgrave, Thursday ? [1931?]

'I don't know how many men there are in Canada who give a substantial part of their time to art, without painting, but they are all too few, and should be encouraged.'

 Palgrave, Ont. January 7, 1932

'All of the Seven proper are extremely proficient . . . All of the Seven are master craftsmen. Have they more than this? After all, craftsmanship is a low measure to judge artists by. Have they courage, that highest quality of the human race, creative courage? Have they anything to say on their own authority or is it all borrowed. This is the highest of standards and I rather think at least two of them measure up to it. This courage business is important because I think we as a people, even more than the Americans, lack it. We are clever, imitative (?), but we seem to wait for someone else to show us the way, then we follow him, instead of carving out a path for ourselves. Just at the moment I can't think of a single creative work that can be credited to a Canadian. . . in art, architecture, literature, engineering or anything else. No doubt there are some, but nothing sticks out very strongly when measured by the old country, Europe or even the United States.'

'Whatever the value of the Group of Seven in art, there is no doubt about their value to Canada. Mr Bennet could very nicely vote the seven, a million dollars each, and the country would still be in their debt.'

To Mrs Massey Severn Park. January 17, 1935

'There is no particular similarity between my life or character and Van Gogh's, but looking back (particularly on some of it) I get the same nightmarish feeling I get from reading Vincent's letters, that nothing would induce me to live it over again.'

'Meeting fine people, and seeing exhibitions, and fussing with exhibitions is very nice, too nice, it doesn't mix with painting. Pictures are by-products, and not to be taken too seriously after they are done.'

To Mrs Massey Severn Park. February 3, 1937

'Pictures rarely sell themselves, nearly always there is another connecting link between the patron and the painter besides the one through the pictures. Just twice in my long painting life have pictures sold themselves without this.'

To Mrs Massey Severn Park. August 2, 1937

'You know how a new wooden box looks inside when it comes with things from Eatons, clean new-cut wood, peach color and flesh color. Well, that is the starting point of both pictures.'

To Mrs Massey January 25, 1938

(dealer) 'Unfortunately the painter, too, is a necessary part of the set-up, and it doesn't do to let him fade out.'

Reproduced by kind permission of David Milne Jr.

Jack Bush

**in conversation with
William Townsend, Toronto 1969**

'When I came back from two months in Europe on a Canada Council Senior Fellowship in 1962, I had a month in New York as part of the plan, staying there in the same hotel with Ken Noland. He asked "What did you see in Europe that impressed you?" I mentioned some of the old masters. "Yes, of course, but what for now?" "Well, I was bowled over in Basle by the forty-foot Matisse." Ken Noland laughed and said "Yeah, he's pretty good, isn't he? Why don't you go out and beat him?" The whole idea of being a painter is to "knock the ball out of the park". Not to beat someone else but to score and be the best painter you can be. That is competitive and "competitive" may sound wrong but it means being the best you can with the powers you have. At least when you've finished you've tried it all out. I am sure this is what John Lyman brought back to Montreal from Paris, and I'm sure that's what Borduas meant. It's something like that that Milne meant and Cézanne meant. And sometimes I'm not so sure! But then I look around and *am* sure!'

Manifeste des Plasticiens

Février 1955
. . . an extract

Les Plasticiens sont des peintres qui se sont réunis quand ils ont constaté que la similitude d'apparence de leurs peintures relevait d'une concordance dans leur conduite de peintre, dans leur démarche picturale et dans leurs attitudes envers la peinture, per se et dans la société humaine.

Comme le nom qu'ils ont choisi pour leur groupe l'indique, les Plasticiens s'attachent avant tout, dans leur travail, aux faits plastiques: ton, texture, formes, lignes, unité finale qu'est le tableau, et les rapports entre ces éléments. Éléments assumés comme fins.

Cette conception de la peinture se passe de justification, ou plutôt elle la trouve dans ce fait en apparence banal: les Plasticiens font de la peinture parce qu'ils aiment ce qui est particulier à la peinture. C'est, en outre, une conception qui correspond à la liberté isolée du peintre dans le monde contemporain.

En étant arrivés à renoncer à peu près entièrement à toute attitude romantique de la peinture comme moyen d'expression conscient, les Plasticiens peuvent retrouver cette naïveté artisanale que caractérise l'absence de tout l'orgueil généralement associé avec une prise de conscience partielle de soi.

Les peintures des plasticiens ne sont pas les visages de choix, mais ceux d'ultimes nécessités, d'inévitables obsessions, de réductions transcendantales. Le niveau de connaissance auquel ces peintures font appel, dans leur genèse et dans leur unité est en définitive celui de l'intuition, et non pas de la science. Si leur nécessité apparaît plus logique qu'intuitive, c'est que la simplification des moyens conduit à un résultat épuré conventionnellement admis comme excluant la personnalité.

La portée du travail des Plasticiens est dans l'épurement incessant des éléments plastiques et de leur ordre; leur destin est typiquement la révélation de formes parfaites dans un order parfait.

Leur destin et non pas leur but, étant donné qu'ils travaillent dans l'amour du moment présent.

Les Plasticiens n'admettent pas la postulation a priori de ce qui est élémentaire et de ce qui est parfait. Pour eux, ce ne sont pas là des données, mais des acquisitions que seul le travail individuel dans la plus entière liberté peut permettre de faire. Leurs découvertes peuvent coïncider mais ils n'en croient pas pour autant avoir touché à une vérité objective.

Les Plasticiens ne se préoccupent en rien, du moins consciemment, des significations possibles de leurs peintures. Mais comme en ne cherchant pas à lui donner une valeur littérale, ils n'excluent aucune des significations inconscientes possibles, elle devient de ce chef le reflet de leur propre humanité.

En somme, les Plasticiens obéissent à la nature, et c'est pourquoi leurs peintures tendent vers une complète autonomie en tant qu'objets.

Les Plasticiens ne prétendent pas apporter des apparences tout à fait nouvelles, ni immuables. Malraux a écrit que les tableaux naissent des tableaux. L'intuition même la plus pure s'exprime toujours à un certain degré par le truchement de souvenirs.

Le travail des Plasticiens s'inscrit également dans l'histoire de la peinture au Canada et plus spécifiquement à Montréal. La peinture non-figurative a acquis à Montréal ses droits de cité depuis les premières expositions automatistes. Elle a pu naître ailleurs avant, mais elle est véritablement née ici alors. Dans la solution qu'apportent les Plasticiens au problème posé par leur désir de peindre, la révolution automatiste amorcée par Borduas apparaît comme germinale.

La renaissance avait libéré les arts de la servitude à un rituel spirituel. Les divers grands mouvements du XIXe siècle et finalement le Dadaïsme, le Surréalisme et l'Automatisme les ont libérés de la servitude à un rituel matérialiste. Mondrian a permis de réduire l'ultime aliénation de l'oeuvre peinte, l'extériorisation de la concentration sur soi-même.

Le vériable rôle de l'artiste est d'engendrer la soif de la vérité. Le sens des oeuvres est toujours faussé par leur publication. Aussi la mise-au-monde doit-elle le plus possible coïncider avec la création.

Il faut travailler à engendrer un climat d'inquiétude vis-à-vis des arts de la part du public, et non pas simplement une familiarité qui tourne facilement au mépris.

Il ne reste de spirituel que l'angoisse.

Il n'y a pas en 1955 d'art sacré: l'art est sacré.

La création qui est aussi intuition est l'unique forme de la vérité.

Est respectable dans son intégrité tout art vrai.

Est respectable dans son intégrité toute oeuvre dont j'ai l'intuition qu'elle est vraie pour son créateur.

C'est là qu'on appelle l'amour du prochain, l'existence de l'autre.

Une oeuvre peut n'être pas la création de celui qui l'exécute, mais de celui qui la regarde ou d'une collectivité, plus simplement.

Ce mode d'existence d'une oeuvre aussi la rend respectable.

Une oeuvre peut être le moment de vérité d'un peuple, d'une civilisation.

Mais le goût, la propension, l'acceptation ne peuvent pas être critères de vérité: seule l'intuition intuitionnée l'est.

LES PLASTICIENS

Jauran, Toupin, Belzile, Jérome

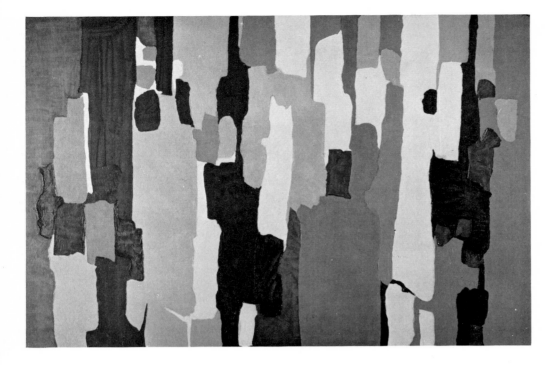

Lise Gervais *Cynétique contre-op* 1967, oil on canvas, 48 × 72 in

Guy Monpetit *Il ne faut pas mourir pour ca* (*Serie Q No 1*) 1968, acrylic, 36 × 48 in
Coll: private, Montreal; photo: Galerie de Montréal

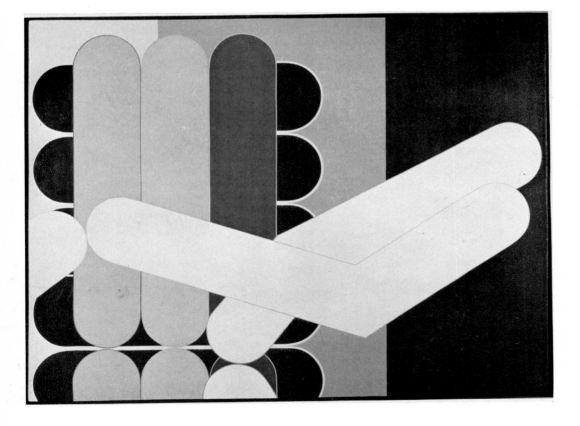

Jacques de Tonnancour
L'aube 1969, 36 × 36 in
Coll: Galerie Godard Lefort;
photo: Photographes
Associés Place Bonaventure,
Montreal

Jacques Hurtubise *Juliette*
1966, acrylic on canvas,
64 in to side, 91 in diagonal
Coll: Art Gallery of Ontario

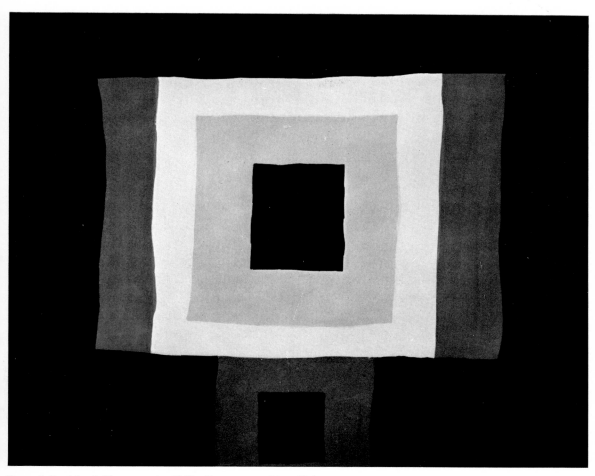

Kenneth Lochhead *Blue extension* 1963, oil on canvas, 80 × 98 in
Coll: The Canada Council; photo: John Evans Photography Ltd, Ottawa

Ronald Bloore *Untitled* 1965–6, oil on masonite, 47½ × 95½ in
Coll: The Canada Council; photo: John Evans Photography Ltd, Ottawa

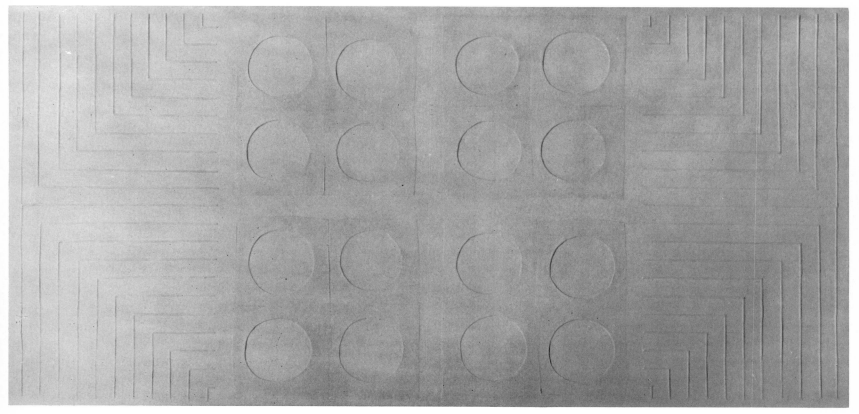

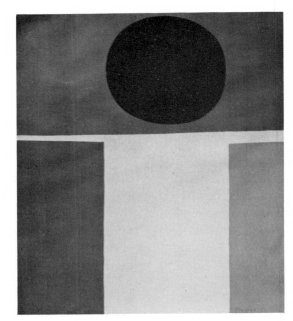

William Perehudoff *Zephrus No 15* 1968, liquitex on canvas, 63½ × 79¼ in
Coll: the artist

Marion Nicoll *January 1968*, oil on canvas, 45 × 54 in
Photo: John Braun, Calgary

Douglas Morton *Diagonal blue* 1964, canvas, 57 × 81 in

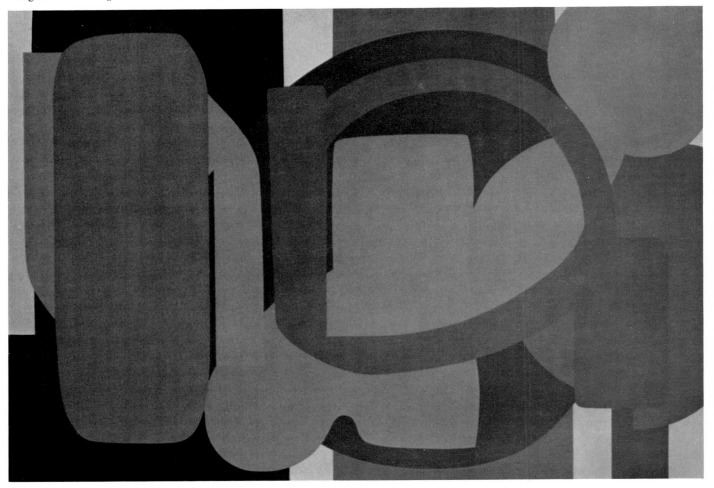

90

Peter Daglish *Untitled* (left) wood, cardboard, plastic tubing, ribbons, 80 × 46 × 17 in (centre) same materials, 41 × 3 × 9 in (right) 80 × 52 × 28 in
Coll: the artist

Sherry Grauer *Puddle* 1965, plaster and sewn canvas, 15½ × 11¼ in
Coll: The Canada Council; photo: John Evans Photography Ltd, Ottawa

David Samila *Vista* 1967, acrylic on canvas on board, 48 × 48 in
Coll: Dunkelman Gallery; photo: Ron Vickers Ltd, Toronto

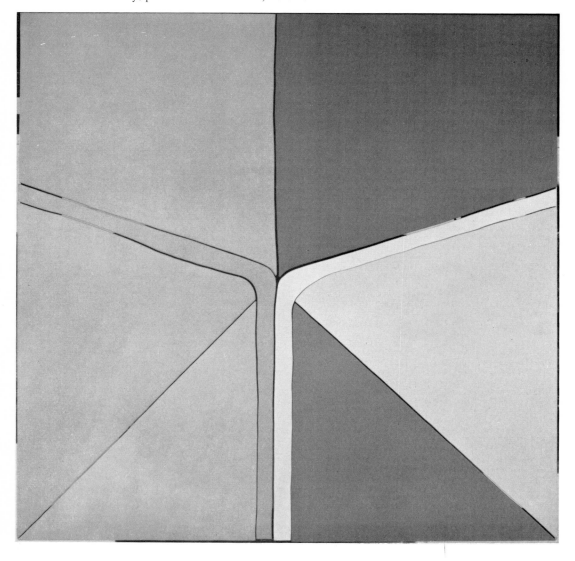

1
Esther Warkov *Cousin Lydia's dream ride* oil on canvas
Coll: Galerie Godard Lefort; photo: Tommy Thompson & Co Ltd, Montreal

2
Maxwell Bates *The beach* 1966, oil on canvas, 48 × 72 in
Coll: The Canada Council; photo: John Evans Photography Ltd, Ottawa

3
William Kurelek *Manitoba party* 1964, oil, 48 × 60 in
Coll: The Isaacs Gallery, Toronto

1
Ivan Eyre *White collar* 1969, acrylic on canvas, 62 × 62 in
Coll: C.I.L.

2
Albert Dumouchel *Les Pavillons* 1951 aquatint and etching
Coll: The National Gallery of Canada

3
Ivan Eyre *Rose pink and rose yellow* 1967, oil on canvas,
33 × 50 in
Coll: the artist

Charles Stegeman *Beach crowd during solar eclipse*
1968, oil on canvas, 43 × 41 in

Françoise André *Monologue ♯ 6* (diptych) 1968, oil on canvas, 39 × 64 in
Coll: the artist

Richard Turner *U8* 1969, coloured ink, card, spraygun, 41 × 28 in
Coll: Bau-Xi Gallery, Vancouver

Christopher Pratt *Shop on Sunday* 1968, oil on masonite, 26 × 46 in
Coll: the artist

opposite
1
Jan Menses *Kippoth Series 153* tempera on paper, 22 × 30 in
2
Michael de Courcy, exhibit at Intermedia's Electrical Connection Week
at the Vancouver Art Gallery, April 1969
3
Robert Arnold *Tunnel* 1969, cardboard box modules 12 × 12 × 36 in;
5 incandescent lights operated sequentially; a wheel chair guided by
2 iron tracks; height 6 ft, width 5 ft, length 35 ft. Exhibit at Inter-
media's Electrical Connection Week at the Vancouver Art Gallery,
April 1969. Photo: Taras Masciuch
4
Dave Rimmer, exhibit at Intermedia's Electrical Connection Week at
The Vancouver Art Gallery, April 1969

94

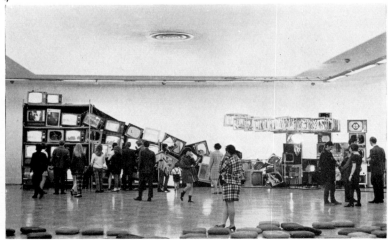

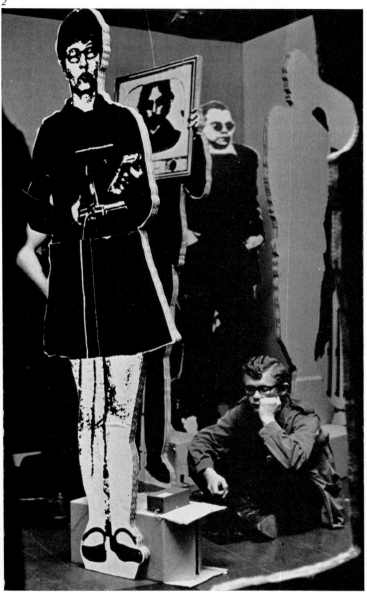

Serge Tousignant *Exit* 1968, painted
steel, 80 × 16 × 16 in
Coll: The Canada Council

Ulysse Comtois *Colonne 8* 1967,
aluminium, 21¾ × 8 in
Coll: The Canada Council

Gino Lorcini *Theta 20* 1968, original structural relief 1/5, 38 × 46 in
Coll: Gallery Moos Ltd; photo: Robert Title, Toronto

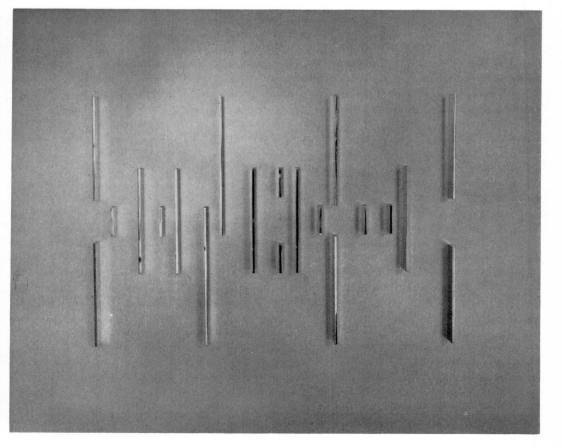

1
Françoise Sullivan
Coll: Galerie Sherbrooke; photo: Michiko Yajima,
Montreal

2
Serge Tousignant *Princes vertes* 1967, polished stainless
and enamelled steel, 17 × 28 × 80 in
Coll: Galerie Godard Lefort; photo: mathieu, Montreal

3
Hugh Leroy *After* 1967, fibreglass, $34\frac{1}{2} \times 34\frac{1}{2} \times 16$ in
Coll: The Canada Council

4
Henry Saxe *Untitled* 1968, aluminium coated with
polyvinyl chloride, 50 ft long, 50 links
Coll: Dunkelman Gallery; photo: Ron Vickers Ltd,
Toronto

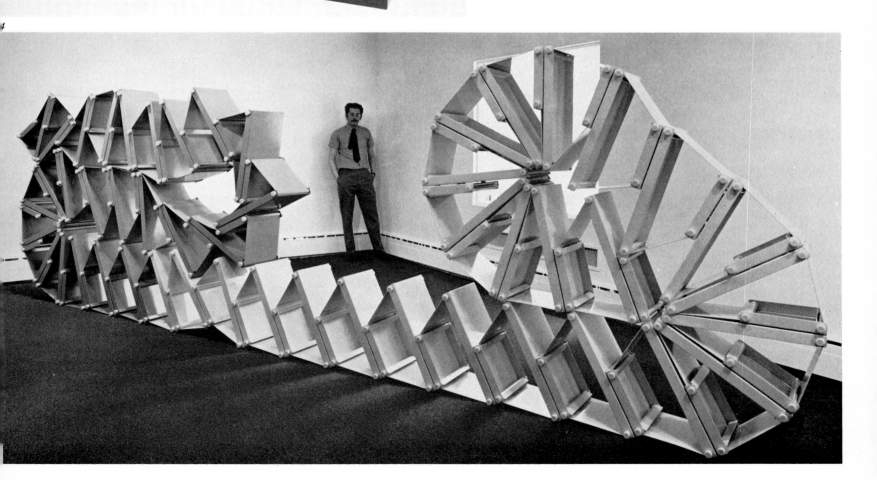

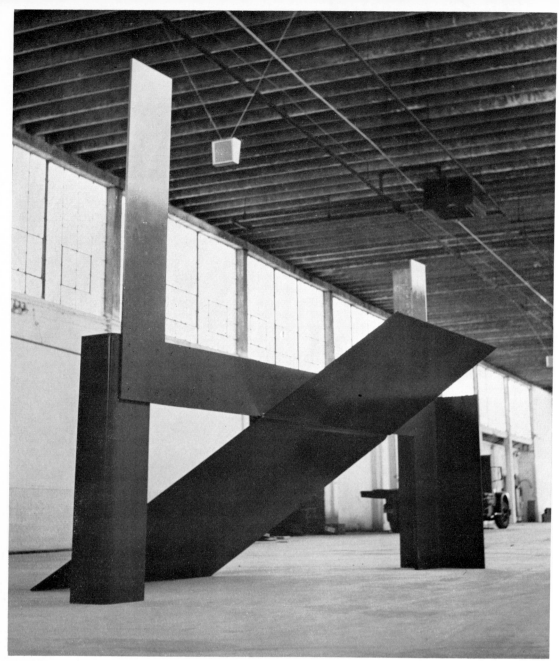

1 opposite
Nobuo Kubota *Dissection 111* 1968, plywood painted,
32 × 32 × 66 in

2
Peter Kolisnyk *5 piece dark brown space columns* 1968,
formica and wood, 96 × 12 × 24 in each column

3
Karl Beveridge *Chain and steel rods* 1969, 8 × 8 ft
Coll: Carmen Lamanna Gallery, photo: Ron Vickers Ltd,
Toronto

4
Karl Beveridge *LS689* 1968, wood—to be executed in
aluminium, approx. 72 × 120 × 30 in

5 right
Robert Downing *Corners related* 1968, aluminium,
60 × 64½ × 64½ in
Coll: Art Gallery of Ontario

5 left
Cube Edge 1 aluminium, *c.* 1968, 46 × 66 × 66 in

6
Ted Bieler *Wave* 1967, fibreglass reinforced plastic,
24 × 192 × 288 in

Robert Murray
Becca's H 1969, steel and aluminium painted grey, height 13 ft, length 18 ft.
Coll: David Mirvish Gallery

Arroyo 1968, ½ aluminium plate painted umber, length 14 ft.
Coll: David Mirvish Gallery

Chinook 1968, aluminium painted dark blue, height 12 ft
Coll: Mr Michael Walls; photo: David Mirvish Gallery and John A Ferrari

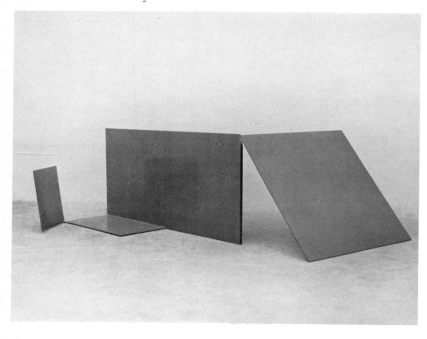

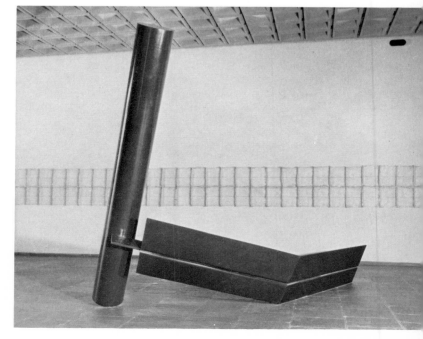

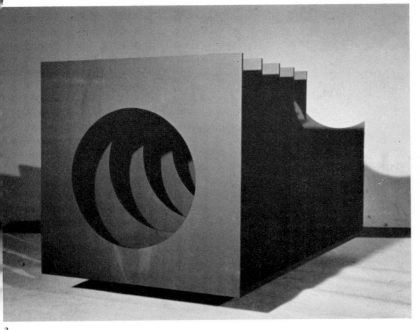

2

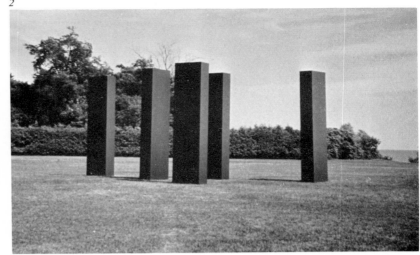

3

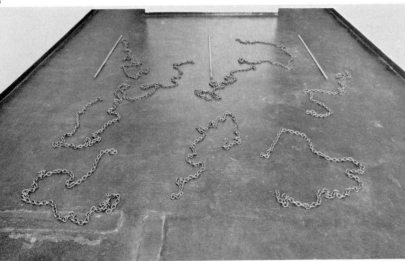

4

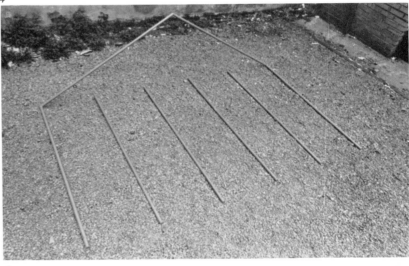

5

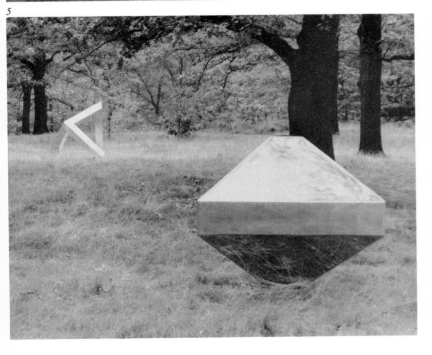

6

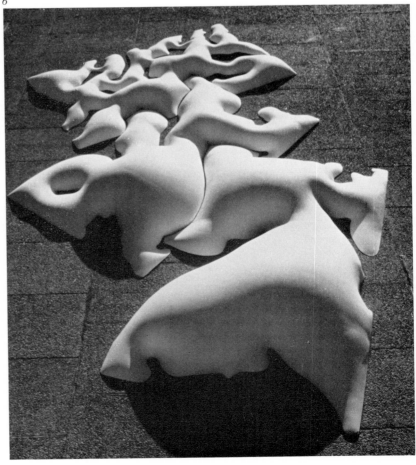

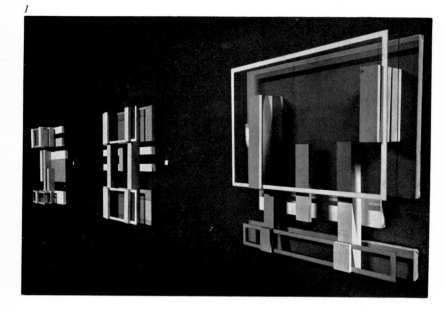

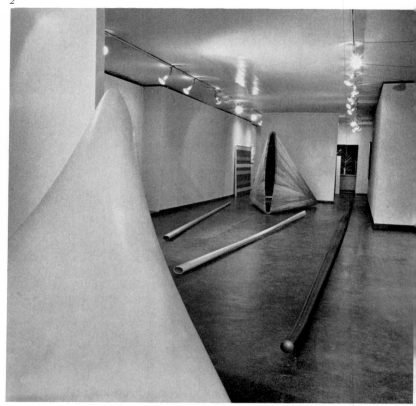

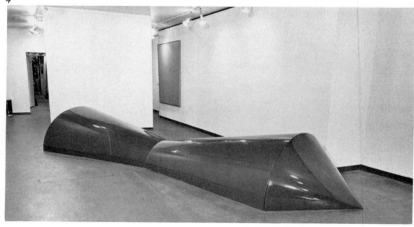

1
Zbigniew Blazeje *3 sonata variations* fluorescent paint on wood, plastic
Coll: Carmen Lamanna Gallery, Toronto

2
David Rabinowitch *Basswood tube* 1969, 6 × 5 × 10 ft
Coll: Carmen Lamanna Gallery; photo: Ron Vickers Ltd, Toronto

3
Walter Redinger *Genesis No 2* 1968, fibreglass on wooden support,
$34\frac{1}{2}$ × 72 × 126 in
Coll: Art Gallery of Ontario; photo: Ron Vickers Ltd, Toronto

4
Royden Rabinowitch *The green conic* 1968, steel and acrylic lacquer,
20 × $4\frac{1}{2}$ × $2\frac{1}{2}$ ft
Coll: Carmen Lamanna Gallery, Toronto

5
Ed Zelenak, group of large sculptures at West Lorne, Ontario
Coll: the artist; photo: Tom Wakeyama and *artscanada*

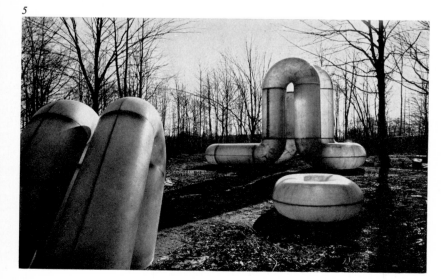

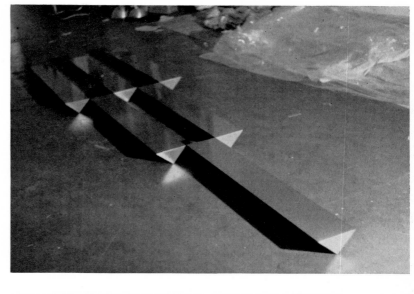

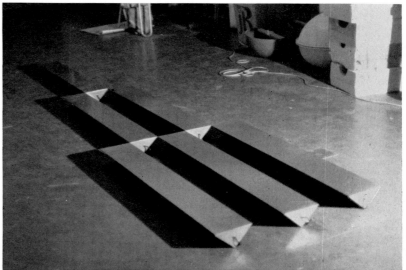

```
        THIS
        IS
        A

     FLOOR
     PIECE.
        'LASTYEAR'
     IS MADE OF
                  CHIPBOARD
                  PLASTIC
                  LIGHT

                  AND
                  IT
                  IS
                  PURPLE
        12COATS
           OF
           PLUM LACQUER
        ON CHIPBOARD SIDES
              WITH
           PEARLESCENT
           PLASTIC
           TOPS.
     DIMENSIONS ARE
     VVV    VVV    VVV ↑
     VVV    VVV    VVV
     VVV    VVV    VVV
     VVV    VVV    VVV
           VVV    VVV
           VVV    VVV
           VVV    VVV
           VVV    VVV   153″
                 VVV
                 VVV
                 VVV
                 VVV
     ←————35 5/8″————→
     MODULES ARE 3 3/4″ HIGH
                 51″ LONG
                 7 1/8″ WIDE.
           EACH MODULE IS LIT
           BY 1-15AMP
           BULB
           PLACED
           AT
     ONE
        END
     LIT
     RANDOMLY
     BY
        BLINKERS.
```

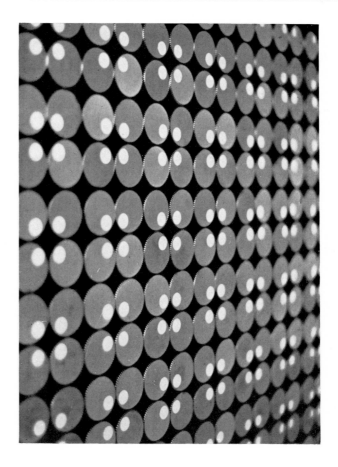

above
Phil Harrison *Lastyear*

right
Roger Vilder *Pulsation 5*, 1967, aluminium, wood,
steel gears, DC motor with variable speed control,
$31\frac{1}{2} \times 33\frac{1}{2} \times 9\frac{1}{2}$ in

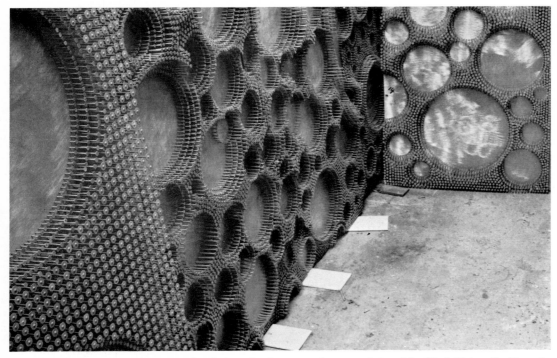

David Partridge *Craters and strata* sectional view of nail construction commissioned for York University, Toronto
Photo: J S Markiewicz, London, England

Gerald Gladstone *Sculpture at Expo 67*
Photo: Dunkelman Gallery, Toronto

Sorel Etrog *Pulchinella* 1965–7, bronze sculpture, approx 9 ft high
Coll: Gallery Moos Ltd, Toronto; photo: Rugoni, Florence

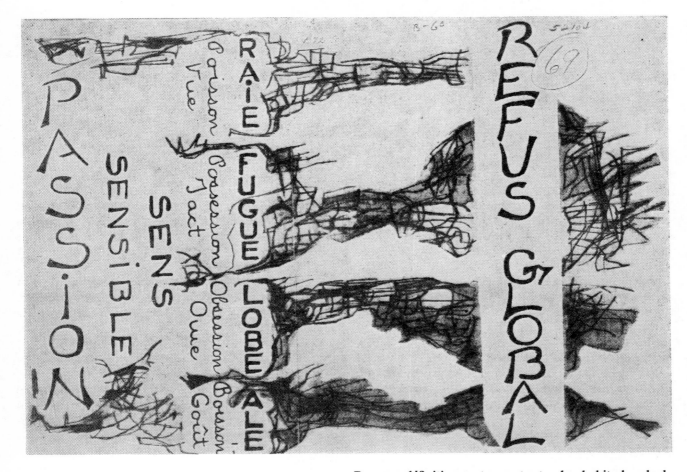

Rompre définitivement avec toutes les habitudes de la société, se désolidariser de son esprit utilitaire. Refus d'être sciemment au-dessous de nos possibilités psychiques et physiques. Refus de fermer les yeux sur les vices, les duperies perpétrées sous le couvert du savoir, du service rendu, de la reconnaissance due. Refus d'un cantonnement dans la seule bourgade plastique, place fortifiée mais trop facile d'évitement. Refus de se taire—faites de nous ce qu'il vous plaira mais vous devez nous entendre—refus de la gloire, des honneurs (le premier consenti): stigmates de la nuisance, de l'inconscience, de la servilité. Refus de servir, d'être utilisables pour de telles fins. Refus de toute INTENTION, arme néfaste de la RAISON. A bas toutes deux, au second rang!

PLACE A LA MAGIE! PLACE AUX MYSTERES OBJECTIFS!
PLACE A L'AMOUR!
PLACE AUX NECESSITES!

Au Refus global nous opposons la responsabilité entière.

L'action intéressée reste attachée à son auteur, elle est mort-née.

Les actes passionels nous fuient en raison de leur propre dynamisme.

Nous prenons allègrement l'entière responsabilité de demain.

**excerpts
from
Refus global 1948**

103

A vous la curée rationnellement ordonnée (comme tout ce qui est au sein affectueux de la décadence); à nous l'imprévisible passion; a nous le risque total dans le Refus global.

Des gens aimables sourient au peu de succès monétaire de nos expositions collectives. Ils ont ainsi la charmante impression d'être les premiers à découvrir leur petite valeur marchande.

Si nous tenons exposition sur exposition, ce n'est pas dans l'espoir naïf de faire fortune. Nous savons ceux qui possèdent aux antipodes d'où nous sommes. Ils ne sauraient impunément risquer ces contacts incendiaires.

Dans le passé, des malentendus involontaires ont permis seuls de telles ventes.

Nous croyons ce texte de nature à dissiper tous ceux de l'avenir.

Si nos activités se font pressantes, c'est que nous ressentons violemment l'urgent besoin de l'union.

Là, le succès éclate!

Hier, nous étions seuls et indécis.

Aujourd'hui un groupe existe aux ramifications profondes et courageuses; déjà elles débordent les frontières.

Un magnifique devoir nous incombe aussi: conserver le précieux trésor qui nous échoit. Lui aussi est dans la lignée de l'histoire.

Objets tangibles, ils requièrent une relation constamment renouvelée, confrontée, remise en question. Relation impalpable, exigeante qui demande les forces vives de l'action.

Ce trésor est la réserve poétique, le renouvellement émotif ou puiseront les siècles à venir. Il ne peut être transmis que TRANSFORME, sans quoi c'est le gauchissement.

Que ceux tentés par l'aventure se joignent à nous.

Au terme imaginable, nous entrevoyons l'homme libéré de ses chaînes inutiles, réaliser dans l'ordre imprévu nécessaire de la spontanéité, dans l'anarchie, resplendissante, la plénitude de ses dons individuels.

D'ici là, sans repos ni halte, en communauté de sentiment avec les assoiffés d'un mieux être, sans crainte des longues échéances, dans l'encouragement ou la persécution, nous poursuivrons dans la joie notre sauvage besoin de libération.

Paul-Emile BORDUAS

Magdeleine ARBOUR, Marcel GARBEAU, Bruno CORMIER, Claude GAUVREAU, Pierre GAUVREAU, Muriel GUILBAULT, Marcelle FERRON-HAMELIN, Fernand LEDUC, Thérèse LEDUC, Jean-Paul MOUSSEAU, Maurice PERRON, Louise RENAUD, Françoise RIOPELLE, Jean-Paul RIOPELLE, Françoise SULLIVAN.

Bibliography

This selected bibliography is limited to publications since 1945 that deal with the subject matter of this book. Those interested in Canadian art before 1945 are referred to the bibliography in J Russell Harper's 'Painting in Canada,' a history. The list of articles in periodicals is intended to record the interest in Canadian art as evidenced in British and American art journals.

Canadian art magazines
artscanada (until December 1966 *Canadian Art*)
Ottawa, bi-monthly

Vie des Arts
Montreal, quarterly

The Structurist (founded and edited by Eli Bornstein 1960).
Saskatoon, annual

The Five-cent Review (founded 1969)
Montreal, monthly

General

D W Buchanan	*The Growth of Canadian Painting* Toronto: Collins 1950
J Russell Harper	*Painting in Canada, a History* University of Toronto Press 1966 The latest and most comprehensive survey of Canadian painting. Well documented, with bibliography. The essential work of reference
R H Hubbard	*The Development of Canadian Art* Ottawa: National Gallery of Canada 1963 A short and authoritative introduction to architecture, painting and sculpture
Colin S Macdonald	*A Dictionary of Canadian Artists* Canadian Paperbacks Ottawa Vol. I, A–F. 1967
Guy Viau	*La Peinture Moderne au Canada français* Quebec: Ministère des Affaires Culturelles 1964

Monographs and biographies

D W Buchanan	*Alfred Pellan* Toronto: Society for Art Publications, McLelland and Stewart Ltd 1962.
A Y Jackson	*A Painter's Country* Toronto: Clerke, Irwin & Co Ltd 1958

Autobiography with valuable account of the Group of Seven

Alan Jarvis	*David Milne* Toronto: Society for Art Publications, McLelland and Stewart Ltd 1962
John A B McLeish	*September Gale* Toronto/Vancouver: J M Dent & Sons (Canada) Ltd 1955. A study of Arthur Lismer and the Group of Seven
Guy Robert	*Alfred Pellan: sa vie et son oeuvre* Montreal: Editions du Centre de Psychologie et de Pédagogie 1963
Jack Shadbolt	*In Search of Form* Toronto: McLelland & Stewart Ltd 1968
Evan H Turner and Guy Viau	*Paul-Emile Borduas 1905–60* Catalogue of exhibition at the Montreal Museum of Fine Arts, the National Gallery of Canada, the Art Gallery of Toronto, 1962. With a detailed chronology of Borduas' life and excerpts from his writings
William Withrow	*Sorel Etrog Sculpture* (Preface by Sir Philip Hendy) Wilfeld Publishing Co Ltd Toronto 1967
Ross G Woodman	*Chambers* (John Chambers interviewed by Ross G Woodman) Toronto: The Coach House Press 1967

Periodicals
Recent articles in British and American art journals

Apollo London	William Johnstone 'Morrice: A Canadian abroad' June 1967
Artforum New York	Terry Fenton 'Arthur McKay' December 1968
Art News New York	Walter H Abell 'Canadian Coast to Coast' Summer 1949 (Vol. 48, No. 4) Frank O'Hara 'Riopelle: Interna-

tional Speedscapes'
April 1963 (Vol. 62, No. 2)
Lucy R. Lippard 'Vancouver'
September 1968 (Vol. 67, No. 5)

David Silcox 'Yves Gaucher'
February 1969
William Townsend 'Les Levine'
May 1969
Bryan Robertson 'Robert
Downing' July–August 1969

The Connoisseur
London

Janine Smiter 'Tapawingo,
Canada's place of Joy'
January 1967
David Silcox 'First-hand famili-
arity with Canadian art at the
Edinburgh Festival'
August 1968

Art in America
New York

Barry Lord 'Discover Canada'
May–June 1967
Barry Lord 'Canada: After Expo,
What?'
March–April 1968
Barry Lord 'Canada: The Stir in
Vancouver'
May–June 1968
Barry Lord 'Three Young
Canadians'
January–February 1969
Barry Lord 'New York from
Montreal'
May–June 1969
Barry Lord 'In Ontario'
September–October 1969

Studio International
London

Charles Spencer 'Toronto com-
mentary'
December 1967
William Townsend 'Painting in
Canada' (review article on J
Russell Harper's *Painting in
Canada, a History*) March 1968
David Thompson 'A Canadian
scene'
October 1968, November 1968,
December 1968

Biographies

Abbreviations

São Paulo (with date)	São Paulo Bienal
Venice (with date)	Venice Biennale
Tate 64	Canadian Painting 1939–1963. An exhibition organized by the National Gallery of Canada. February–March 1964 at The Tate Gallery, London. (Catalogue introduction by R H Hubbard)
VI	Sixth Biennial Exhibition of Canadian Painting 1965. The National Gallery of Canada. (Organizer, and catalogue introduction by, William Townsend)
Expo 67	Painting in Canada. Canadian Government Pavilion, Expo 67, Montreal. (Exhibition organized and catalogue written by Barry Lord)
Paris 1968	Canada. Art d'aujourd'hui. Musée d'Art Moderne Paris 1968. (Preface by Jean Sutherland Boggs)
Edinburgh 1968	Edinburgh 101. Edinburgh International Festival, Edinburgh, 1968. (Artists selected by Richard Demarco)
VII	Seventh Biennial of Canadian Painting. The National Gallery of Canada 1968. (Juror, and catalogue introduction by, William C Seitz)
Canada 68	Canadian Artists 68. Art Gallery of Ontario, Toronto. (Exhibition selected by Richard Hamilton and William Turnbull)
CC	The Canada Council

Assistance derived from the catalogues of the above exhibitions in compiling these biographical notes is gratefully acknowledged.

Where Canadian universities are named the art schools or departments of fine arts of these universities are normally implied.

Ralph Allen, b. 1926 Raunds, Northamptonshire. Sir John Cass College and Slade School. To Canada 1957. Teaches at Queen's University, Kingston. CC fellowship 1968. First Canadian exhibition, Ottawa 1959. VI. VII.

Edmund Alleyn, b. 1932 Quebec. Ecole des Beaux Arts, Quebec. Paris 1956. Guggenheim International 1958. São Paulo 1959. Venice 1960. VI. Lives Paris.

Françoise André, b. 1926 Les Sables d'Olonne, France. Brussels and Antwerp; later in Paris with Marcel Gromaire. To Canada 1951. Worked in Vancouver. Teaches at summer schools of Banff School of Fine Arts. Married to Charles Stegeman. Lives USA. *94*

Louis Archambault, b. 1915 Montreal. Ecole des Beaux Arts Montreal, in ceramics. Sculptor. Public commissions include Festival of Britain 1951, World's Fair Brussels, 1958. Venice 1956. CC award 1959. Lives Montreal.

Robert Arnold, b. 1945 Los Angeles. Raymond College Stockton. Exhibited with 'Younger Vancouver Sculptors', UBC, Vancouver 1968. Lives Vancouver. *95*

Marcel Barbeau, b. 1925 Montreal. Ecole du Meuble, Montreal, under Borduas. Exhibited with Automatistes, 1946. CC fellowship to Italy 1962. VI. VII. Expo 67. Edinburgh 1968. Was a signatory of *Refus global* in 1948. Lives in New York. *24*

Maxwell Bates, b. 1906 Calgary. Provincial Institute of Technology, Calgary. To England 1931; studied architecture; exhibited with Artists International Association, RA, etc. Returned Calgary 1946. Studied with Max Beckman, Brooklyn, 1949–50. VII. Lives Victoria. *92*

Iain Baxter, b. 1936, Middlesbrough, England. President The N. E. Thing Co. To Canada 1937. Univ. of Idaho, BSc (Zoology), MEd, Japan 1961–2. MFA from Washington State Univ. 1964. Since 1966 Resident in Visual Arts Communication Centre Simon Fraser Univ. Exhibitions: Kyoto 1961, *Bagged Place* 1966 and *Piles* 1968, Vancouver. VI. Paris 1968. Edinburgh 1968. VII. Canada 1968. National Gallery of Canada 1969. Lives Vancouver. *77*

Karl Beveridge, b. 1945 Ottawa. New School of Art, Toronto. First exhibition Toronto 1968. Sculptor. Canada 68. Lives New York. *99*

Ted Bieler, b. 1938 Kingston. Univ. of Toronto; Cranbrook Academy, NY. First exhibition Isaacs Toronto 1964. City Hall, Toronto 1967. Sculptor. Canada 68. Lives Toronto. *99*

B C Binning, b. 1909 Medicine Hat, Alberta. Vancouver School of Art, Art Students' League, New York and England. Influential teacher since 1939 at Vancouver School of Art and then Univ. of BC. Lives Vancouver.

Zbigniew Blazeje, b. 1942 USSR of Polish parents. To Canada via India and Mexico as an infant. Briefly at Ontario College of Art; largely self taught. Production

technician in television studios. Works mainly in field of audio-kinetic construction. Expo 67. Lives Toronto. *100*

Ronald Bloore, b. 1925 Brampton, Ontario. Univs. of Toronto, New York, Washington St Louis, in art and archaeology; and in Europe. Director, Norman Mackenzie Art Gallery, Regina. Member of Regina group. CC fellowship in Greece, 1962–3. From 1966 Director of Art York Univ. Toronto. São Paulo 1961. Tate 1964. VII. *48, 89*

Bruno Bobak, b. 1923 Poland. To Canada 1927. Central Technical School, Toronto. Painter. Official war artist 1944–6. CC fellowships, Europe, Norway. Artist in Residence Univ. of New Brunswick.

Molly Bobak, b. 1922 Vancouver. Vancouver School of Art. Married to Bruno Bobak. Painter. Lives Fredericton.

David Bolduc, b. 1945 Toronto. Ontario College of Art, Toronto and Montreal Museum of Fine Arts School. First exhibition 1966. VII. Paris 1968. Lives Toronto. *39*

Henry Bonli, b. 1927 Lashburn, Sask. Univ. of Saskatchewan, Alberta College of Art and Los Angeles. Painter and designer. Emma Lake with Greenberg. VI. Lives Toronto.*47*

Paul-Emile Borduas, 1905–60, b. Saint-Hilaire, Quebec. Began working Ecole des Beaux Arts, Montreal; teaching there 1927. Paris 1928 with Maurice Denis. In 1937 again teaching at Ecole des Beaux Arts, Montreal, formed the group Les Automatistes; in 1948 published *Refus global* and was dismissed. To New York 1953 and Paris 1955. Died in Paris. Stedelijk, Amsterdam, Memorial Exhibition 1960. Tate 1964. Paris 1968. *20, 22*

Eli Bornstein, b. 1922 Milwaukee, Wisconsin. Univ. of Wisconsin, Chicago Art Institute, Univ. of Chicago and in Paris with Léger. After teaching in USA has taught at Univ. of Saskatchewan, Saskatoon, since 1950. Head of Dept. of Art since 1963. Founder 1960 and editor of *The Structurist*. Large structurist relief for Winnipeg airport 1962. VI. VII. Lives Saskatoon. *55*

James Boyd, b. 1928 Ottawa. National Academy of Design, Art Student's League and Contemporaries Graphic Workshop, New York. Print-maker. First prize in First Burnaby National Print Show 1961. Lives Ottawa.

John Boyle, b. 1941 London, Ontario. Self-taught. Painter, film-maker, writer. First one-man exhibition, London 1967. Lives London, Ontario.

Claude Breeze, b. 1938 Nelson, BC. Univ. of Saskatchewan School of Art, Regina and Vancouver School of Art. A leading Western figurative painter. VI. Expo 67. Edinburgh 1968. Lives Vancouver. *59, 67*

Tom Burrows, b. 1940 Galt, Ontario. Univ. of British Columbia, St. Martin's, England. Sculptor. Exhibited Vancouver since 1965, Expo 67, Edinburgh 68. Now teaching in Vancouver.

Dennis Burton, b. 1933 Lethbridge, Alberta. Ontario College of Art, Univ. of Southern California and with Ben Shahn. First exhibition Toronto 1957. VI. VII. Canada 68. Lives Toronto. *75*

Jack Bush, b. 1909 Toronto. Montreal and Ontario College of Art. Member of Painters Eleven. Until recently a professional advertising artist. CC fellowship to Europe and USA, 1962. London exhibitions at Waddington Galleries. Represented in Tate Gallery. VI. Expo 67. Paris 1968. São Paulo 1967. VII. Edinburgh 1968. Lives Toronto. *38, 42*

Emily Carr, 1871–1945, b. Victoria, BC. San Francisco School of Art, Westminster School of Art (Eng.) 1910 in France with Frances Hodgkins. Influenced by Fauves. Worked in isolation in British Columbia but with encouragement from Group of Seven and Mark Tobey. The pioneer figure of painting in Western Canada. Died in Victoria.

John Chambers, b. 1931 London, Ontario. H B Beal Technical School, and in Madrid. A member of the important group of artists now working in London, Ontario. Work has surrealist associations and recently with surrealist film techniques. Expo 67. Paris 1968. Canada 68. Lives London, Ontario. *65*

Jacques Edouard Cleary, b. 1945 Montreal. Egypt 1966. Sculptor. Canada 68. Lives Montreal.

Alexander Colville, b. 1920 Toronto. Art school of Mount Allison Univ. New Brunswick where he taught 1946–63. Principal figure of the Canadian 'magic realists'. São Paulo 1961. Tate 64. Venice 1966. Expo 67. VII. Designer of Canadian coinage. Lives Sackville. *23*

Charles F Comfort, b. 1900 Edinburgh. To Canada 1912. Winnipeg and Art Students' League, New York. Official war artist 1943–6. Notable teacher, Ontario College of Art; professor of art Univ. of Toronto. Director of National Gallery of Canada 1960–5. Lives Hull, Quebec.

Ulysse Comtois, b. 1931 Granby, Quebec. Ecole des Beaux Arts, Montreal. Painter and sculptor. Venice 1968 (sculpture). Lives Montreal. *96*

Carol Condé, b. 1940 Hamilton, Ontario. Ontario College of Art. CC grant 1968. First one-man exhibition Pollock, Toronto 1968.

Graham Coughtry, b. 1931 St Lambert, Quebec. Montreal Museum of Fine Arts and Ontario College of Art. Painted in France and Spain. C.C. fellowship to Europe 1960. São Paulo 1959. Venice 1960. Tate 64. Leicester Galleries, London. Lives Majorca. *37*

Serge Cournoyer, b. 1943 Shawinigan, Quebec. Ecole des Beaux Arts, Montreal. Canada 68.

Reta Cowley, influential teacher in Saskatoon. Painter Lives Saskatoon.

Greg Curnoe, b. 1936 London Ontario. Beal Technical School and Ontario College of Art. First exhibition, Toronto 1958. Organized happenings from 1961. President of Nihilist Party of London, co-founder Nihilist Spasm Band. VI. Expo 67. Paris 1968. Edinburgh 1968. VII. Canada 68. São Paulo 1969. Lives London, Ontario. *65, 82, 83*

Peter Daglish, b. 1930 Gillingham, England. To Canada 1955. Ecole des Beaux Arts, Montreal. Printmaking with Dumouchel and 1964 Slade School with Lynton Lamb. Returned to Canada 1969. University of Victoria. *91*

François Dallegret, b. Morocco 1937. Studied architecture in Paris. To Canada 1964. Painter, designer, print-maker. First exhibitions Montreal 1965, Moos, Toronto 1966. Expo 67. Lives Montreal.

Jean-Marie Delavalle, b. 1945. Ecole des Beaux Arts, Montreal. Sculptor. Has exhibited at Pavillon de la Jeunesse, Expo 67. Musée d'art contemporain, Montreal.

François Déry, b. 1941 Montreal. Sir George Williams Univ. Montreal. Sculptor. Canada 68.

Audrey Capel Doray, b. 1931 Montreal. McGill Univ. with John Lyman and Atelier 17 Paris, with S W Hayter. VI. Lives Vancouver. *69*

Robert Downing, b. 1935 Hamilton, Ontario. USA 1964–6. First one-man exhibition Toronto and Montreal 1968. Major show at Whitechapel Art Gallery London, England 1969. Sculptor. Canada 68. Lives Toronto. *99*

Albert Dumouchel, b. 1916 Valleyfield, Quebec. Studied print making in Paris. Member of Association des artistes non-figuratifs de Montréal. Worked in Europe 1955–7. An influential teacher of graphics at Ecole des Beaux Arts, Montreal. CC fellowship 1966. VI. VII. Lives Montreal. *93*

Glen Elliott, b. 1944 Regina. Univ. of Saskatchewan. First one-man exhibition Pollock, Toronto 1968. VII. Canada 68.

John K Esler, b. 1931 Pilot Mound, Manitoba. Univ. of Manitoba. Printmaker and teacher of graphics in Calgary and Winnipeg. Expo 67. Lives Winnipeg.

Sorel Etrog, b. 1933 Jassy, Roumania where he studied. To Israel 1950. Institute of Painting and Sculpture, Tel Aviv. New York 1958. First one-man exhibition in Canada, Moos Toronto, 1959. Venice 1966. Sculptor. Many public commissions including Expo 67. Lives Toronto. *102*

Paterson Ewen, b. 1925, Montreal. Art Association of Montreal, McGill Univ. with John Lyman, Montreal Museum of Fine Arts. First Exhibition, Montreal 1955. Turned to abstraction under influence of Borduas. CC fellowship 1964. VII. Lives London, Ontario.

Ivan Eyre, b. 1935 Saskatchewan. Univs. of Saskatchewan, Manitoba and North Dakota. Painter and sculptor. First exhibition, Winnipeg 1961. VI. Canada 68. Lives Winnipeg. *93*

Gathie Falk, b. 1928. University of BC. First one-man show Douglas, Vancouver 1968. Ceramics and transformed objects in mixed media. Lives Vancouver. *68*

Marcelle Ferron, b. 1924 Louiseville, Quebec. With Lemieux and Paris Atelier 17 with S W Hayter. Member Association des artistes non-figuratifs de Montréal. CC award. São Paulo 1961. From 1953 lives in Paris.

Brian Fisher, b. 1939 Uxbridge, England. To Canada 1940. Univ. of Saskatchewan with Bloore, McKay, Lochhead, Kiyooka and Vancouver School of Art. In Rome 1963–4. First exhibition, Vancouver 1965. Expo 67. VII. Lives Vancouver. *57*

Paul Fournier, b. 1939 Simcoe, Ontario. Self-taught. Painter. First exhibition, Hamilton 1962. Lives Toronto.

John Fox, b. 1927 Montreal. Studied at Museum of Fine Arts Montreal, Slade School London, England. Painter. Lives Montreal.

Carol Fraser, b. 1930 Superior, Wisconsin. To Canada 1961. Univ. of Minnesota. VI. Edinburgh 1968. Lives Halifax.

Charles Gagnon, b. 1930 Montreal. Parsons School New York (graphics and interior decoration) and Art Students' League. Returned to Montreal, 1960 and first exhibition same date. Painter, sculptor and film maker. Designed the Christian Pavilion, Expo 67. Paris Biennale 1961. VI. Paris 1968. VII. Edinburgh 1968. CC fellowship 1968. Lives Montreal. *66*

Yves Gaucher, b. 1934 Montreal. Largely self-taught. First reputation as a print–maker. Founder member de Association des peintres-graveurs de Montréal. First exhibition New York 1963. Grenchen International 1964. VI. Venice 1966. Expo 67. Paris 1968. Edinburgh 1968. VII. CC fellowship 1966. Canada 68. Whitechapel, London, 1969. Lives Montreal. *29*

David Geary, b. 1943. Studied Univ. of Saskatchewan, Saskatoon. Structurist. Medical illustrator, film maker. Lives Saskatoon. *56*

Lise Gervais, b. 1933 Saint-Césaire, Quebec. Ecole des Beaux Arts, Montreal. VI. Sculpture 67 (National Gallery of Canada), Toronto. Painter and sculptor. Lives Montreal. *87*

Tom Gibson, b. 1930 Edinburgh. To Canada 1952. Briefly Ontario College of Art, mainly self-taught. Television designer, painter. First exhibition, Toronto 1962. Now practising as a photographer.

Gerald Gladstone, b. 1929 Toronto. Largely self-taught. first exhibition Toronto 1957. CC grant to London 1961. Molton Gallery, 1962. New York 1962/3. Sculptor. Many large public commissions, including Expo 67. Lives Toronto. *102*

H G Glyde, b. 1906 England. Royal College of Art. To Canada 1935. Influential teacher in Alberta, at Provincial Institute of Technology, Calgary 1936–46, and as Head of Department of Fine Art, Univ. of Alberta 1946–65, and at Banff. Lives BC.

Ted Godwin, b. 1933 Calgary. Provincial Institute of Technology, Calgary. One of the Regina group, teaches at the Univ. of Saskatchewan School of Art, Regina. CC fellowship to Greece 1962–3. VI. Expo 67. Canada 68. Lives Regina. *19*

Jean Goguen, b. 1927 Montreal. Ecole des Beaux Arts, Montreal. Exhibitions in Montreal since 1955 and New York from 1960. (Geometric abstraction in Canada.) Lives Montreal. *30*

Claude Goulet, b. Montreal 1925. Univ. of Montreal (in Chemistry) and Ecole des Beaux Arts. Painter. Expo 67. VII. CC award 1968. Lives Montreal.

Richard Gorman, b. 1935 Ottawa. Ontario College of Art. Painter and print–maker. Expo 67. Lives Toronto. *75*

Sherry Grauer, b. 1939 Toronto. Ecole du Louvre, Paris and San Francisco Art Institute. Paintings and figurative constructions. Lived and worked in Vancouver, now Montreal. Expo 67. *91*

Arthur Handy, b. 1933 New York. To Canada 1960. Head of Ceramics Department, Ontario College of Art 1960–66. Potter and sculptor. First exhibition Isaacs, Toronto 1963. CC award 1968. Lives Toronto.

Lawren P Harris, b. 1910 Toronto, son of Lawren S Harris. Central Technical School, Toronto & Museum of Fine Arts, Boston. War artist. Head of School of Art, Mount Allison Univ. since 1946. CC fellowship to England 1957–8. VI. VII. Lives Sackville, NB.

Lawren S Harris, b. 1885 Brantford, Ontario. Univ. of Toronto, Berlin and Munich. Founding member of the Canadian Group of Painters, 1933. A leading figure in the development of the Canadian nationalist landscape style of the Group of Seven. Lives Vancouver.

Philip Greig Harrison, b. 1942 Port Alberni, BC. Vancouver School of Art. Slade School, London, on a Leverhulme scholarship 1966–8. Maker of constructions in mixed media including graphic processes. Sculptor. Lives Victoria. *101*

Michael Hayden, b. 1943 Toronto. First one-man exhibition Moos, Toronto 1966. Producer of presentations, environments, multi-media objects and notably of hydrostatic sculptures. Lives Toronto.

Douglas Haynes, b. 1936 Regina. Provincial Institute of Technology, Calgary and at The Hague. Member of the Focus group, Edmonton. CC fellowship in Europe 1967. VI. Lives Edmonton.

Bruce Head, b. 1931 St Boniface, Manitoba. Univ. of Manitoba School of Art. Graphic artist for Canadian Broadcasting Corporation. VII. Lives Winnipeg.

Robert Hedrick, b. 1930 Windsor, Ontario. H B Beal Technical School, London, Ontario. Mexico 1953-4 and

1956–7. CC grant to Spain 1961. Painter and sculptor. Lives Toronto.

D'Arcy Henderson, b. 1940 Princeton, BC. Vancouver School of Art. First one-man exhibition Douglas, Vancouver 1968. Canada 68. Lives Vancouver.

Tom Hodgson, b. 1924 Toronto. Central Technical School, Toronto and Ontario College of Art. Member of Painters Eleven. Canadian Group of Painters 1957. CC fellowship 1963. Lives Toronto.

Reg Holmes, b. 1934 Calgary. Vancouver School of Art where he taught from 1959–67. CC travelling award 1967. Edinburgh 1968. VII. Lives New York. *74*

Jacques Hurtubise, b. 1939 Montreal. Ecole des Beaux Arts with Dumouchel and de Tonnancour. New York 1961–2. First exhibition Montreal 1962. VI. São Paulo 1965 and 1969. Paris 1968. Edinburgh 1968. VII. Canada 68. Lives Montreal. *88*

Gershon Iskowitz, b. 1921 Poland. Studied in Warsaw and Cracow. Detained in concentration camps. On release studied with Kokoschka and in Munich. To Canada 1949. First one-man exhibition Moos, Toronto, 1956. VI. Lives Toronto.

Alexander Young Jackson, b. 1882 Montreal. Montreal, Chicago, Paris. Member Group of Seven, 1920. Member Canadian Group of Painters 1933. A notable war artist in the First World War and the Grand Old Man of Canadian nationalist landscape painting. Lives Toronto.

Ann James, b. Hove, England. Brighton School of Art. Univ. of Saskatchewan. Emma Lake workshops. First solo exhibition, Regina 1963. Ceramic sculpture and mixed media. Lives Regina.

Donald Jarvis, b. 1923 Vancouver. Vancouver School of Art, where he now teaches, and in New York with Hans Hofmann. Painter. VI. Lives Vancouver.

Don Jean-Louis, b. 1937 Ottawa. Painter and engraver. First exhibition Isaacs, Toronto 1961. Lives Toronto.

Denis Juneau, b. 1925 Montreal. Ecole des Beaux Arts, Montreal with Dumouchel and de Tonnancour, and Italy. First exhibition Montreal 1958. CC grants 1961, 1963, 1968. VII. Lives Montreal. *76*

Anna Kahane, b. 1925 Montreal. Cooper Union, New York. Sculptor. Award in Unknown Political Prisoner Competition, England 1953, and many since. Venice 1958. CC award 1961. Expo 67. People in the Park, 1969. Lives Toronto.

Duncan de Kergommeaux, b. 1927 Premier, BC. Banff School of Fine Arts, with Jan Zack in Victoria and with Hans Hofmann. CC scholarship to Mexico, 1958. Runs an art gallery in Ottawa where he lives. VI. Canada 68.

Harry Kiyooka, b. 1928 Calgary. Art schools of the Univs. of Alberta, Manitoba, Michigan State and Colorado. CC scholarships to Europe 1958–60. VI. Edinburgh

1968. VII. President of Alberta Society of Artists. Lives Calgary.

Roy Kiyooka, b. 1926 Moose Jaw, Saskatchewan. Provincial Institute of Technology, Calgary and Mexico. Painter-sculptor, poet. At Emma Lake workshops with Will Barnet, Barnett Newman and Clement Greenberg. CC fellowship. Influential teacher in Regina and Vancouver and at Sir George Williams Univ. Montreal. VI. Expo 67. VII. Edinburgh 1968. Canada 68. Lives Vancouver. *60, 67*

Dorothy Knowles, b. 1927 Unity, Saskatchewan. With Eli Bornstein in Saskatoon; at Emma Lake workshops with Will Barnet, Joe Plaskett, Clement Greenberg. VII. Lives Saskatoon. *50*

Peter Kolisnyk, b. 1934 Toronto. Western Technical School, Toronto. Sculptor. First one-man exhibition Jerrold Morris, Toronto 1967. Canada 68. *99*

Ronald Kostyniuk, b. 1941 Saskatchewan. With Eli Bornstein in Saskatoon and Univ. of Alberta, Edmonton. Structurist. First exhibition 1966. VII. Lives Edmonton. *56*

Nobuo Kubota, b. 1932 Vancouver. Univ. of Toronto. Sculptor. Canada 68. *99*

William Kurelek, b. 1927 Whitford, Alberta. Univ. of Manitoba and Ontario College of Art. Painter. In England 1952–5. First exhibition, Toronto 1960. VI. VII. *92*

Richard Lacroix, b. 1939 Montreal. Fusion des Arts. Institut des Arts Graphiques with Dumouchel and Ecole des Beaux Arts, Montreal. CC fellowship to Paris, Atelier 17 with S W Hayter. Founded Atelier Libre de Recherches Graphiques, 1964. Co-founder of Fusion des Arts, 1964. Founded Graphic Guild, 1966. Kinetic sculpture at Expo 67. VII. Lives Montreal.

Mollie Lawrence. Painter. Lives Saskatoon. *50*

Fernand Leduc, b. 1916 Montreal. Ecole des Beaux Arts, Montreal and Paris 1947–53, with Bazaine. Associated with the Automatistes. Joined Plasticiens, 1956. Founding president of Association des Artistes non-figuratifs de Montréal. VII. Since 1959 lives mostly in Paris. *30*

Gary Lee-Nova, b. 1943 Toronto. Vancouver School of Art and Coventry College of Art, England. Painter who works also with electronic media and film. Edinburgh 1968. VII. Canada 68. Lives Vancouver. *69*

Jean-Paul Lemieux, b. 1904 Quebec. Ecole des Beaux Arts, Montreal, London and Paris. Influential teacher for many years at Ecole des Beaux Arts, Montreal. CC. Painter of symbolic landscape and folklore. Venice 1960. Tate 64. VI. Expo 67. Lives Quebec. *23*

Serge Lemoyne, b. 1941 Montreal. Ecole des Beaux Arts, Montreal. First one-man exhibition Galerie Libre, Montreal 1966. Lives Montreal.

Hugh Leroy, b. 1939 Montreal. Sir George Williams Univ., Montreal. First one-man exhibition Waddington, Mon-

treal. Ex. City Hall, Toronto 1967. Canadian Pavilion Expo 67. Sculptor. Canada 68. Lives Montreal. *97*

Rita Letendre, b. 1929 Drummondville, Quebec. Ecole des Beaux Arts, Montreal. CC grants 1962, 1963. VI. Lives San Francisco.

Les Levine, b. 1936 Dublin. Central School of Arts and Crafts, London. To Canada 1958. In USA 1961–2. Created mylar kinetic environment, Art Gallery of Ontario, 1966. VI. Expo 67. Edinburgh 1968. Canada 68. One-man show at Rowan Gallery, London 1969. Also maker of multiples, disposable objects, films. Lives New York since 1964. *39, 81*

Glenn Lewis, b. 1935 Chemainus, BC. Vancouver School of Art and Univ. of BC. England 1961–4. Japan 1967. First one-man exhibition Douglas, Vancouver 1967. Constructions in mixed media with ceramic groups. Canada 68. Lives Vancouver. *68*

Ernest Lindner, b. 1897 Vienna. To Canada 1926 as a farmer. Studied at Technical Collegiate, Saskatoon, and taught there from 1931 to 1962. CC grant to Europe 1959–60. Water-colourist. VII. Lives Saskatoon. *50*

Arthur Lismer, 1885–1969 b. Sheffield. Sheffield School of Art and Antwerp. To Canada 1911. Commercial artist. Member Group of Seven 1920, Canadian Group of Painters, 1933. Taught for sixty years, notably as Principal of the School of Montreal Museum of Fine Arts from 1946.

Gino Lorcini, b. 1923 Plymouth, England. To Canada 1947. Gordon Payne School of Art, Toronto and Montreal Museum of Fine Arts with Lismer. First exhibition 1963. Structurist mainly working in aluminium. Teaches McGill Univ. VII. Lives London, Ont. *96*

Kenneth Lochhead, b. 1926 Ottawa. Pennsylvania Academy and Barnes Foundation, USA. Painted documentary pictures for the army 1949. Director of school of Art, Regina College, 1950–64. Teaches Univ. of Manitoba. VI. Edinburgh 1968. Lives Winnipeg. *47, 60, 89*

Duane Lunden, b. 1946, Elk Point, Alberta. Univ. of BC. 'Conceptual artist', joint editor of Free Media Bulletin, Vancouver. First one-man exhibitions Bau-Xi, Vancouver and Los Angeles 1969. Lives Vancouver.

John Lyman, b. 1886 Maine, d. 1967 West Indies. To Canada as a child. Studied in Paris, at the Royal College of Art, London, and again in Paris as a pupil of Matisse. Friend of Matthew Smith and J W Morrice. Exhibition in Montreal, 1913, was badly received. In Europe, North Africa and West Indies until return to Montreal, 1931. Met Borduas 1938. Founded Contemporary Art Society, 1939. Taught McGill Univ. *21*

Gerald McAdam, b. 1941 Oshawa. Central Technical School. First exhibition, Pollock, Toronto 1964. Lives Toronto.

Jean McEwen, b. 1923 Montreal. Mainly self-taught but had contacts with Borduas. Paris 1951–3, where he exhibited with Mathieu, Sam Francis and Riopelle. President of the Association des Artistes non-figuratifs de Montréal 1959. CC grant 1961. Greece 1963. Painter and poet. Tate 64. VI. Expo 67. VII. Lives Montreal. *66*

J W G (Jock) Macdonald, b. 1897 Scotland, d. 1960 Toronto. Edinburgh College of Art. To Canada 1926. A teacher of major influence in Vancouver, Banff, Calgary and especially from 1947 at the Ontario College of Art. Member of Painters Eleven.

John MacGregor, b. 1944 Dorking, England. To Canada 1948. Central Technical School. First one-man exhibition Hart House Toronto 1967. Canada 68. Lives Toronto. *37*

A F McKay, b. 1926 Nipawin, Saskatchewan. Provincial Institute of Technology, Calgary and Paris and Regina College. CC grant to USA 1957 and fellowship 1963. One of the Regina group, teaching at school of art, Univ. of Saskatchewan, Regina. VI. Expo 67. *48*

Robin Mackenzie, b. 1938 Toronto. CC grants 1967–9. First exhibition of kinetic structures, Carmen Lamanna, Toronto 1969.

Donald McNamee, b. 1938. Univ. of Saskatchewan, Saskatoon. Ohio State Univ. Structurist. One-man exhibition Kazimir Gallery, Chicago 1967. Saskatoon 1968. Lives Saskatoon. *56*

Allan McWilliams, b. 1945. Vancouver School of Art. Sculptor. Canada 68. Lives Vancouver.

Marcelle Maltais, b. 1933 Chicoutimi, Quebec. Ecole des Beaux Arts, Quebec. First exhibition Quebec 1955. Paris 1958–60. CC grant to Greece 1960–1. VI. Lives Paris.

Robert Markle, b. 1936 Hamilton, Ontario. Painter. Instructor at the New School of Art, Toronto. First exhibition Isaacs, Toronto 1963. Lives Toronto. *75*

John Mascuich, b. 1944 Ottawa. Worked in Edmonton and since 1968 in Vancouver. First one-man exhibition Douglas, Vancouver 1968. Associated with Intermedia, Vancouver.

Jan Menses, b. 1933 Rotterdam. Printmaking in Rotterdam, painting at The Hague. Lived in Morocco 1962. VII. Lives Montreal. *95*

John Meredith, b. 1933 Fergus, Ontario. Ontario College of Art. Painter. First exhibition, Toronto 1958. VI. Expo 67. Paris 1968. Edinburgh 1968. Canada 68. Lives Toronto. *41*

David B Milne, b. 1882 Paisley, Ontario, d. 1953 Toronto. Art Students' League, New York. Only Canadian included in the Armory show, 1913. Painted in USA and Canada for some years; after 1928, in isolation from main currents, in villages of Ontario. *21*

Guido Molinari, b. 1933 Montreal. Ecole des Beaux Arts Montreal, and Montreal Museum of Fine Arts. Member of the Association des Artistes non-figuratifs de Montréal.

A leading hard-edge painter since mid 1950s. CC fellowship 1968. VI. Expo 67. Paris 1968. Edinburgh 1968. VII. Venice 1968. Canada 68. Lives Montreal. *2, 31*

Guy Montpetit, b. Montreal 1938. Ecole des Beaux Arts Montreal. Painter and teacher, specializing in teaching of deaf-mutes. First one-man exhibition, Camille Hébert Montreal 1964. 1964–65 in Paris at Atelier 17 with Hayter and Sorbonne. CC award 1968. Lives Montreal. *87*

James Wilson Morrice, b. 1865 Montreal, d. 1924 Tunis. To Paris about 1889. Lived in Paris with frequent returns to Canada. Friend of Prendergast, Conder, Whistler. Painted in North Africa with Matisse and Marquet. *21*

Michael Morris, b. 1942 Saltdean, England, of Canadian parents. To Canada 1946. Studied Victoria, Vancouver School of Art and Slade School, England. VI. Edinburgh 1968. Canada 68. Lives Vancouver. *70*

Douglas Morton, b. 1926 Winnipeg. Winnipeg, Los Angeles, Paris with André Lhote (1947–9) and Camberwell School of Art, London, with Martin Bloch. One of the Regina group. First exhibition, Regina 1955. Emma Lake workshops with Will Barnet and Barnett Newman. Director of School of Art, Univ. of Saskatchewan, Regina, where he lives. VI. VII. *90*

Wynona Mulcaster. Teacher and painter. Lives Saskatoon.

Robert Murray, b. 1936 Vancouver. Univ. of Saskatchewan. Emma Lake with Will Barnet, Barnett Newman, John Ferren, Clement Greenberg, 1957–62. Sculptor. First exhibition New York, 1965; in Canada, Mirvish, Toronto, 1967. Paris 1968. São Paulo 1969. *98*

N. E. Thing Co. (founded 1966) see Baxter.

Kazuo Nakamura, b. 1926 Vancouver. Central Technical School, Toronto. Member of Painters Eleven. Notable printmaker as well as painter. VI. VII. Canada 68. Lives Toronto.

Marion Nicoll, b. 1909 Calgary. Ontario College of Art, Provincial Institute of Technology, Calgary and in London and New York. Painter. CC Fellowships. 1959, 1965. Influential teacher for many years at Alberta. College of Art, Calgary. VI. VII. Lives Calgary. *90*

Jean Nöel, b. 1940 Montreal. Ecole des Beaux Arts, Montreal. Member of Association des Sculpteurs de Québec. First exhibition 1968. VII. Lives Montreal.

Toni Onley, b. 1928 Isle of Man. Douglas School of Art. To Canada 1948. Doon School of Art with Schaefer, and Mexico. First exhibition Calgary and Vancouver 1958. Lived in Vancouver, now artist in residence, Univ. of Victoria. VI. Expo 67. *76*

Frank Palmer, b. 1921 Calgary. Vancouver School of Art, Ontario College of Art and Los Angeles. Painter. VI. Lives Calgary.

Bruce Parsons, b. 1937 Montreal. Ontario College of Art. Emma Lake workshops with Kenneth Noland and Jules Olitski. Painter. Europe 1962. Worked in Regina until 1968. VI. Canada 68. Lives Toronto. *49*

Roger Paquin, b. 1942. Ecole des Beaux Arts, Montreal. Sculptor. Expo 67. Lives Montreal.

David Partridge, b. 1919 Akron, Ohio. In England from 1928. To Canada 1935. Hart House, Univ. of Toronto; Queen's Univ., Art Students' League New York, Slade School England, Atelier 17 Paris. First exhibition, 1956. Best known for his nail-configurations. Now living in London, England. *102*

Alfred Pellan, b. 1906 Quebec. Ecole des Beaux Arts, Quebec and Paris. Participated in French Surrealist Movement. Returned to Montreal on fall of France, 1940. Powerful influence on development of modern art in Canada through Contemporary Art Society and his teaching at the Ecole des Beaux Arts, 1943–52. In Paris, 1952; one-man exhibition at Musée d'Art Moderne. Tate 64. Expo 67. VI. *22*

William Perehudoff, b. 1919 Langham, Saskatchewan. Colorado, New York. Emma Lake workshops with Barnet, Herman Cherry, Noland, Greenberg. First exhibition, Saskatoon 1948. Europe 1962. VI. VII. Canada 68. Lives Saskatoon. *90*

Kenneth Peters, b. 1939 Regina. Univ. of Saskatchewan. Emma Lake workshops with Ferren, Greenberg, Olitski, Alloway. CC grants 1962, 1968. VII. *49*

Bodo Pfeifer, b. 1936 Dusseldorf. To Canada 1956. Ecole des Beaux Arts, Montreal, in Hamburg and Vancouver School of Art. CC grant 1966. VII. Edinburgh 1968. Canada 68. Lives Vancouver. *70*

J E Poklen, b. 1934 Carmel, California. To Canada 1963. Univ. of Southern California and Cornell Univ. Taught in Regina and now at Mount Allison Univ., New Brunswick. VI. VII. Lives Sackville, New Brunswick.

Christopher Pratt, b. 1935 St John's, Newfoundland. Mount Allison Univ. with L P Harris and Alex Colville. Painter. VI. VII. Lives St Mary's Bay, Newfoundland. *94*

David Rabinowitch, b. 1943 Toronto. Univ. of Western Ontario. Sculptor. First one-man exhibitions Pollock, Toronto and 20/20, London, Ontario 1968. Canada 68. *100*

Royden Rabinowitch, b. 1943 Toronto. Univ. of Western Ontario. Ontario College of Art. Sculptor. First one-man exhibition 20/20 Gallery, London, Ontario. CC grants 1967, 1968. *100*

Gordon Rayner, b. 1935. Toronto. Painter and sculptor. First exhibition, Toronto 1960. CC award 1961. VI. Canada 68. Lives Toronto. *37*

Walter Redinger, b. 1940 Wallacetown, Ontario. Detroit and Ontario College of Art. Sculptor. First one-man exhibition Isaacs, Toronto 1963. Canada 68. Lives West Lorne, Ontario. *100*

Donald Reichert, b. 1932 Libau, Manitoba. Univ. of Manitoba where he now teaches, and Mexico. Artist in

residence, Univ. of New Brunswick 1961–2. CC scholarship to St Ives, Cornwall, 1962–3. VII. Lives Winnipeg.

Jean-Paul Riopelle, b. 1923 Montreal. One of the group around Borduas, he first exhibited with the Automatistes of Montreal. Visited Paris and Germany in 1945 and has lived in Paris since 1947. Venice 1962. Tate 64. VI. Expo 67. Paris 68. *20*

Milly Ristvedt, b. 1942 Kimberley, BC. Vancouver School of Art with Roy Kiyooka. First exhibition 1958. VII. Canada 68. Lives Toronto.

Goodridge Roberts, b. 1904 Barbados into a distinguished New Brunswick family. Ecole des Beaux Arts, Montreal, and Art Students' League, New York. A leader in the Montreal movement. Has taught in Ottawa, Kingston, Montreal, Univ. of New Brunswick. War artist. Venice 1962. Tate 64. VI. Expo 67. *23*

Otto Donald Rogers, b. 1935 Kerrobert, Saskatchewan. Univ. of Wisconsin and in New York. Painter and sculptor. Teaches at Univ. of Saskatchewan, Saskatoon. CC fellowship 1967. VI. Lives Saskatoon. *50*

William Ronald, b. 1926 Stratford, Ontario. Ontario College of Art and in New York with Hans Hofmann. Member of Painters Eleven. Lived in New York and returned to Toronto 1965. VII. *74*

David Samila, b. 1936 Winnipeg. Univ. of Manitoba. Slade School, England, on a Leverhulme Canadian Painting scholarship. Travelled in Europe. First exhibition, Vancouver 1967. Taught Mount Allison Univ., now lives and teaches in Calgary. VII. Canada 68. *91*

Jerry Santbergen, b. 1942 Holland. To Canada 1954. Univ. of Saskatchewan, Regina. First one-man exhibition Pollock, Toronto 1967. Paris 1968. Canada 68. *38*

Tamiyo Sasaki, b. 1945 Vernon, BC. Alberta College of Art, San Francisco Art Institute, California College of Arts and Crafts. Large groups of life-size figures in papier maché, yet to be exhibited. Lives San Francisco.

Robert Savoie, b. 1939 Quebec. Ecole des Beaux Arts, Ecole des Arts Graphiques, Montreal and Chelsea School of Art, London. Painter and printmaker. CC grants to Paris 1963. Works mainly in Europe. Expo 67. Lives Montreal.

Henri Saxe, b. 1937 Montreal. Ecole des Beaux Arts, Montreal. First exhibition, Montreal 1962. Member of Fusion des Arts. VI. Paris 1968. Canada 68. Lives Montreal. *97*

Dallas Selman, b. 1941 Alberta. Univ. of BC. Has exhibited in Vancouver since 1966. Lives Vancouver. *68*

Tom Seniw, b. 1941 Toronto. Ontario College of Art. Painter. First one-man exhibition Pollock, Toronto 1966. CC grant 1967. Lives Toronto.

J L Shadbolt, b. 1909 Shoeburyness, England. To Canada in childhood. Euston Road School, London, with Pasmore and Coldstream, Paris with Lhote and Art Students'

League, New York. For many years taught at Vancouver School of Art. Leading figure in development of arts in Vancouver. São Paulo 1953. Venice 1956. Tate 64. VI. Lives Vancouver. *58*

Gordon Smith, b. 1919 Hove, England. To Canada 1934. Winnipeg, Vancouver School of Art and California School of Fine Art. CC fellowship 1961. Taught Vancouver School of Art, 1946–56, and Univ. of BC. São Paulo 1961. VI. Lives Vancouver. *58*

John Ivor Smith, b. 1927 London, England. To Canada 1940. McGill Univ., Montreal Museum School of Fine Arts. Sculptor. In Rome 1957–8. First one-man exhibition Isaacs, Toronto 1962. Exhibited City Hall, Toronto 1967 and in grounds of Expo 67. Canada 68. Lives Piedmont, Quebec.

Michael Snow, b. 1929 Toronto. Ontario College of Art and Europe. First exhibition, Toronto 1957. CC award 1959. Began the Walking Woman series in 1961 and continued to 1967. Also sculptor and film maker. VI. Expo 67. Paris 1968. Edinburgh 1968. Lives New York. *38, 73*

Charles Stegeman, b. 1924 Holland. The Hague, Brussels and Antwerp. To Canada 1951. Settled in Vancouver. Since 1954 an influential teacher at Banff School of Fine Arts. Taught at Art Institute of Chicago 1962 to 1969. Now at Haverford College, Pa. *94*

Francoise Sullivan, b. Montreal. Ecole des Beaux Arts, Montreal. Studied modern dance in New York and taught in Montreal. Choreographer and, since 1959, sculptor. Was signatory of *Refus global* 1948. Lives Montreal. *97*

George Swinton, b. 1917 Vienna. To Canada 1939. Vienna, McGill Univ., Montreal Museum of Fine Arts and Art Students' League, New York. Has taught at Smith College, Northampton, Mass., at Queen's Univ. and, since 1954, at Univ. of Manitoba. CC fellowship 1959. VI. Lives Winnipeg.

Terence Syverson, b. 1939 Kincaid, Sask. Alberta College of Art, Calgary; Banff School of Fine Arts, Brooklyn Museum. Emma Lake workshop with Barnett Newman. VI. VII. Since 1962 lives in New York.

Takao Tanabe, b. 1926 Prince Rupert, BC. Winnipeg, Brooklyn Museum and with Hans Hofmann; Central, London, Banff School of Fine Arts, Univ. of Fine Arts Tokyo. CC fellowship 1959. VI. Lives Vancouver. *70*

Tony Tascona, b. 1926 St Boniface, Manitoba. Univ. of Manitoba, first exhibition, Winnipeg 1961. Montreal 1962–4. Murals for Manitoba Centennial Arts Centre. VI. VII. Lives St Boniface.

André Théroux, b. 1938 Crabtree Mills, Quebec. Ecole des Beaux Arts, Montreal. VII. Canada 68. *76*

Tom Thomson, 1877–1917 b. Claremont, Ontario. Commercial artist in Seattle who later became an influential early associate of the painters of the Group of Seven. Painter of the northlands. Drowned in Canoe Lake. *20*

Jacques de Tonnancour, b. 1917 Montreal. Ecole des Beaux Arts, Montreal. With Goodridge Roberts, Brazil 1945–6. Teaches at Ecole des Beaux Arts, Montreal. C C fellowship 1958. VII. Lives St Lambert, Quebec. *88*

Glenn Toppings, b. 1930 Saskatchewan. Vancouver School of Art. Europe 1956–7. First one-man exhibition New Design, Vancouver 1962. 3rd Biennial. Paris 1963. Painter. Sculptor and technician. Lives Vancouver. *68*

Fernand Toupin, b. 1930 Montreal. Mont Saint Louis Montreal and with Jean-Paul Jérome. Founder member of the Association des Artistes non-figuratifs de Montréal, 1955. Retrospective at Musée d'art contemporain, Montreal, 1966. Lives Montreal.

Claude Tousignant, b. 1937 Montreal. Museum of Fine Arts, Montreal and Paris. Member of the Association des Artistes non-figuratifs de Montréal and Association des Arts Plastiques. CC grant 1968. A leading hard-edge and op painter in Montreal. VI. Expo 67. Paris 1968. Edinburgh 1968. Canada 68. VII. Now lives New York. *32*

Serge Tousignant, b. 1941 Montreal. Ecole des Beaux Arts, Montreal and Slade School, England on Leverhulme Canadian Painting scholarship. Painter, printmaker, sculptor. First exhibition, Montreal 1963. VI. Canada 68. Lives Montreal. *96, 97*

Harold Town, b. 1924 Toronto. Western Technical Institute, Ontario College of Art. Member of Painters Eleven. Has painted a number of murals, is also printmaker, sculptor and critic. Venice 1957 and 1964. São Paulo 1961. Tate 64. VI. Expo 67. Edinburgh 1968. VII. Lives Toronto. *36, 40, 41, 44*

Gerald Trottier, b. 1925 Ottawa. Ottawa and Art Students' League, New York. France and England 1952–3. CC grants 1958, 1962. VII. Lives Ottawa.

Richard Turner, b. 1936 Edmonton. Vancouver School of Art. Sculptor. CC award 1964. Commission Expo 67. First one-man exhibition, Bau-Xi, Vancouver 1968. *94*

Tony Urquhart, b. 1934 Niagara Falls, Ontario. Albright School of Art, Buffalo and Univ. of Buffalo. Painter and sculptor. Artist in residence, Univ. of Western Ontario 1960–3. First exhibition, Toronto 1958. CC grant 1963. VI. Canada 68. Lives London, Ontario. *84*

Armand Vaillancourt, b. 1932 Black Lake, Quebec. Ecole des Beaux Arts, Montreal. Founder member of l'Associa-tion des Arts Plastiques, Montreal. Sculptor and organizer of happenings. Large commissions at Expo 67 and elsewhere. Lives Montreal.

Dennis Vance, b. 1940 Hamilton, Ontario. Univ. of Tulsa, Oklahoma. Formerly a professional dancer. Sculptor, maker of electronic constructions. Since 1962 has lived in Vancouver. Associated with Intermedia, Vancouver.

Roger Vilder, b. 1938 Beirut, Lebanon. To Canada 1957. Sir George Williams University, Montreal. First one-man exhibition Galerie Libre, Montreal 1965. Designer of kinetic constructions, motorized. Canada 68. *101*

Shirley Wales, b. 1931 Quebec. Ecole des Beaux Arts, Montreal and Paris. Atelier 17 with Hayter. Printmaker.

Esther Warkov, b. 1941 Winnipeg. Univ. of Manitoba. One of the young generation of new figure painters. Expo 67. Lives Winnipeg. *92*

Joyce Wieland, b. 1931 Toronto. Central Technical School, Toronto. First exhibition, Toronto 1960. Painter and film maker. Painting associated with film and pop art. Married to Michael Snow. VI. Expo 67. Paris 1968. Edinburgh 1968. VII. Canada 68. Lives New York. *37, 73*

Elizabeth Willmott, b. 1928 Indianapolis. Univ. of Michigan. Studied with sculptor Hans Melis and subsequently with Eli Bornstein. Structurist. VII. Lives Toronto. *56*

York Wilson, b. 1907 Toronto. Ontario College of Art and Detroit, but mainly self-taught. Painter. Lives Toronto.

Jack Wise, b. Centreville, Iowa. New Orleans School of Fine Arts, Washington Univ., Florida State Univ. Lived Mexico and trained Indians in batik. To Canada 1963. First exhibition, Vancouver 1965. CC fellowship to study Tibetan art in India 1966. Lives Vancouver.

Paul Wong, b. 1933 Kwangtung, China. Hong Kong and Vancouver School of Art. Painter. Runs the Bau-Xi Gallery, Vancouver, where he lives. VI. Canada 68.

Walter Yarwood, b. 1917 Toronto. Western Technical School Toronto. Canadian Group of Painters. Painters Eleven. Lives Toronto.

Ed Zelenak, b. 1940. Beal Technical School London, Ontario. Sculptor. Lives and works West Lorne, Ontario. *100*

gallery moos ltd. 138 YORKVILLE AVE. TORONTO 185, ONTARIO, CANADA (416) 922-0627

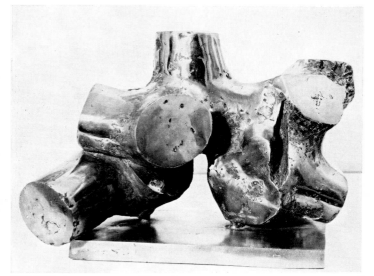

FILIPOVIC Augustin "Prose" – Ed. of 5 Bronze 1967 15 x 21"

DEUTSCH Peter, "Split Image" acrylic on canvas, 39 x 27½", 1967

DANBY Ken, Original Watercolour 1969 "Neil" 20 x 28"

ALSO WORKS BY . . .

BORDUAS	LORCINI		
CATTELL	McEWEN		
COHEN	REPPEN		
COMTOIS	RIOPELLE		
DALLEGRET	TEITELBAUM		
DANBY	THEPOT		
DEUTSCH	TOUSIGNANT	HARTUNG	PICASSO
ETROG	APPEL	JENKINS	POLIAKOFF
FILIPOVIC	BAJ	NEUJEAN	SCOTT
GAUCHER	BRAQUE	MARINI	DE SEGONZAC
GERVAIS	CHADWICK	MATHIEU	TAPIES
HAYDEN	CHAGALL	MIRO	THARRATS
ISKOWITZ	GROMAIRE	MOORE	VASARELY

ETROG Sorel, Original Bronze Sculpture "Metamorphosis II"

CATTELL Ray, Original Acrylic 1969 "Thirst of Decision" 39 x 50"

RIOPELLE Jean Paul, Original oil/canvas "Forterene" 1962

i

'Refractor', Peter Kolisnyk, smoked plexiglass,
6 ft × 8 ft.

'FIAC', Cathy Senitt-Harbison, oil on canvas,
5 ft × 5 ft.

YOUNG CANADIAN ARTISTS

Largest collection of international
graphics in Canada

Including:
Caulfield
Dine
Hamilton
Hockney
Judd
Kelly
Lichtenstein
Nicholson
Oldenburg
Paolozzi
Riley
Vasarely

. . . and many more

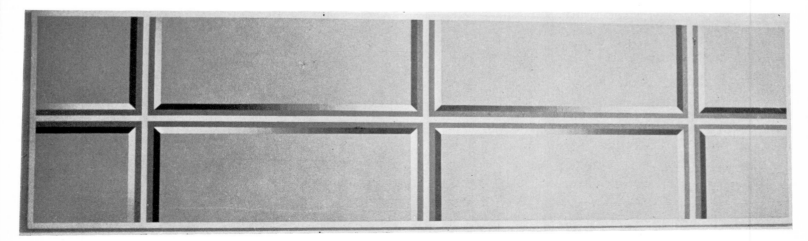

'Three Part Pink', Robert Jacks, acrylic on canvas, 2 ft × 8 ft.

THE POLLOCK GALLERY, 599 Markham Street, Toronto, Canada

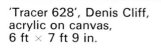

'Tracer 628', Denis Cliff,
acrylic on canvas,
6 ft × 7 ft 9 in.

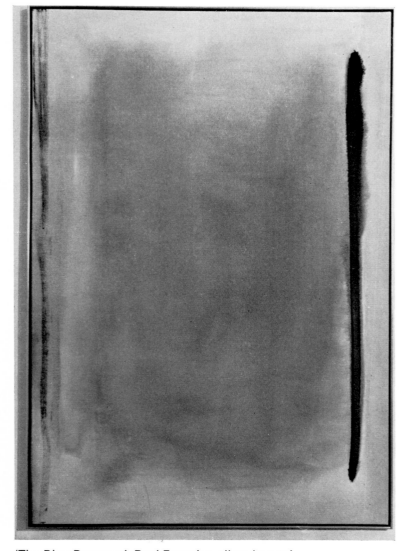

'The Blue Between', Paul Fournier, oil and pastel,
48 in. × 72 in.

'Verticle II', Thelma Van Alstyne,
oil on canvas,
24 in. × 60 in.

THE POLLOCK GALLERY, 599 Markham Street, Toronto, Canada

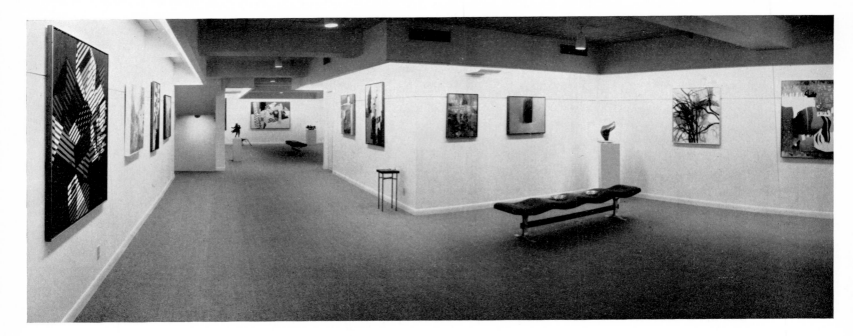

ROBERTS GALLERY
CANADIAN PAINTINGS AND SCULPTURE

Alfred Pellan	*Goodridge Roberts*	*A. J. Casson*	*York Wilson*
Will Ogilvie	*Alan Collier*	*Léon Bellefleur*	*Jack Nichols*
John Fox	*Grant Macdonald*	*John Gould*	*Bruno Bobak*
Leonard Brooks	*Marjorie Pigott*	*Molly Lamb Bobak*	*Carl Schaefer*
Wm. Roberts	*Gary Slipper*	*Wm. Winter*	*F. A. Johnston*
F. H. Varley	*Wm. McElcheran*	*John Stohn*	*Lewis Pagé*

641 YONGE STREET, TORONTO, CANADA

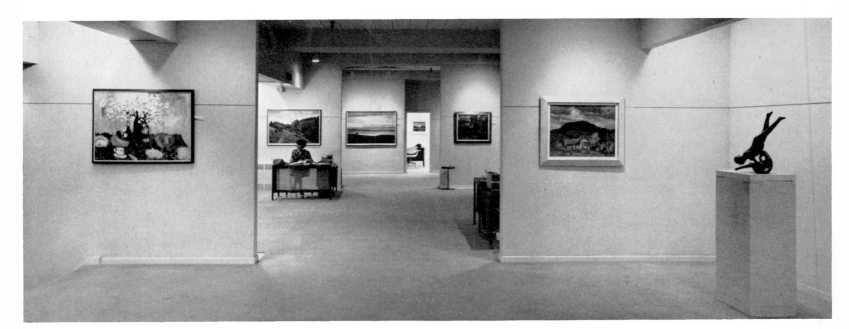

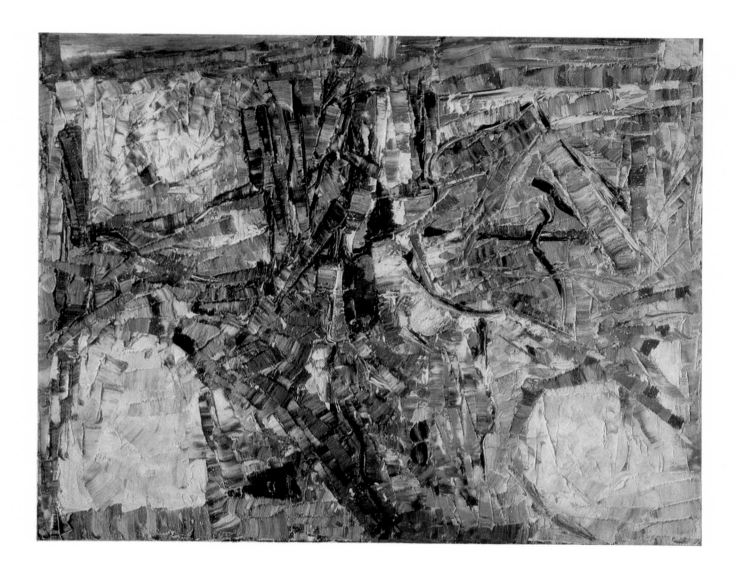

JEAN-PAUL RIOPELLE

Pour ne pas voir choir les roses d'automne. (oil) 1968

(sole representative for U S and Canada)

PIERRE MATISSE GALLERY
41 east 57th St., N.Y. 10022. Tel. 212 El. 56269. Cable: Piermati, New York

artscanada

the only english language art
magazine in canada — is essential
reading — offering a thematic
approach in a well designed,
beautifully printed bi-monthly

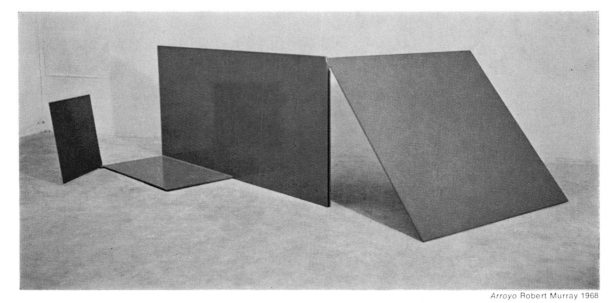

VIE DES ARTS

A MAGAZINE OF INFORMATION ABOUT
CANADIAN PLASTIC ART AND SEVERAL OTHER
FORMS OF ARTISTIC EXPRESSION

A quarterly where pictorial representation is carefully attended to: Illustrations in colour and black and white.
French and English texts.
Complete translations.
Each issue ranges from 84 pages to 104 for special issues.
Also combined with expert description and commentary that have established the reputation of a magazine of distinction and beauty.

Yearly subscription: $7.00. 2 years: $13.00
Publicity and subscription 1430 St. Denis st, Montreal, P.Q.

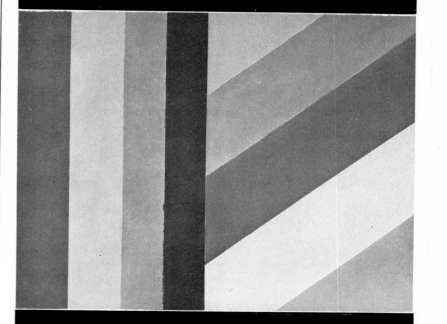